CHE GUEVARA tu y TODOS.

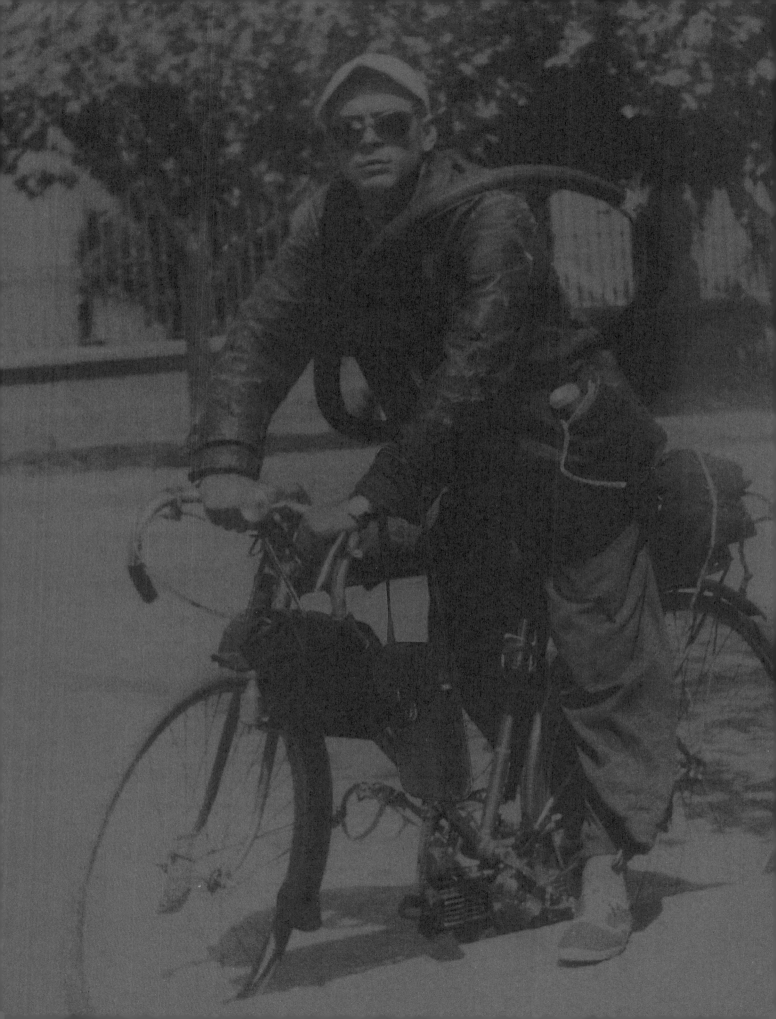

CHE GUEVARA

tu y TODOS.

SKIRA

Cover
Escambray, Las Villas, 1958

Editor
Massimo Zanella

Design
Marcello Francone

Editorial Coordination
Vincenza Russo

Editing
Valentina Rossini

Layout
Fayçal Zaouali

Translations
Sylvia Adrian Notini

First published in Italy in 2017
by Skira editore S.p.A.
Palazzo Casati Stampa
via Torino 61
20123 Milano Italy
www.skira.net

Printed and bound in Italy.
First edition

ISBN: 978-88-572-3740-4

Distributed in USA, Canada, Central
& South America by ARTBOOK I
D.A.P. 75 Broad Street Suite 630,
New York, NY 10004, USA.
Distributed elsewhere in the world by
Thames and Hudson Ltd., 181A High
Holborn, London WC1V 7QX, United
Kingdom.

CHE GUEVARA

tu y TODOS.

Milan, Fabbrica del Vapore
6 December 2017 – 1 April 2018

**Centro de Estudios
CHE GUEVARA**

Alma

President
Daniele Zambelli

CEO
Maddalena Sciolla

Director
Aleida March de la Torre

Scientific Coordinator
María del Carmen Ariet

Special Projects Coordinator
Camilo Guevara March

Researchers
Daína Rodríguez
Otto Alejandro Gonzales

Archivists
Aracelis Careaga
Maritza Piñero

President and Creative Director
Daniele Zambelli

Authors
Daniele Zambelli
Flavio Andreini

Product Manager
Beatrice Ravelli

Project Manager
Gaia Dall'Omo

Exhibition Art Director
Devis Gobbi
Andrea Fiorito

Video Art Director
Diego Loreggian
Nicola Lorenzo Rossi

**Archive, Research,
and Content Coordination**
Paola Romano

Editorial Staff
Flavio Andreini
Elena Croci
Emilio Cozzi

Technology Director
Filippo Nepote Andrè

Content Producer
Nicoletta Sinatti

Executive Producer
Diego Loreggian

Program Manager
Stefano Longhini

Exhibition curated by
Daniele Zambelli
Flavio Andreini
Camilo Guevara March
María del Carmen Ariet

Historical Consulting
Luigi Bruti Liberati
Massimo De Giuseppe
Enrico Palumbo

Exhibition Design
Andrea Fiorito

Music
Andrea Guerra

Sound Design
Rocco Petruzzi

Perceptual Artwork
Michael Murphy

Technical Direction
Blackengineering
Riccardo Muroni

Director of Lighting
MADE

Installation Manager
Stefano Ferrè

**Technical and
Executive Drawings**
Ottavio Sarcinella

Interaction
Videosoft
Tommaso Guiot

Graphic Art and Illustrations
Enrico Pasqualis
Maurizio Esposito
Giulia Ferrandi
Marco Turini
Francesco Gerbino
Alessandro Buffa
Marcella Savino

Video Production
Bonsaininja Studio
Moving Dot
Studio Yet
Studio Octopus

Translations
Dotwords

Administration
Monica Bortolani

Installation
Interfiere

Video and Projector Systems
Target Due

Lighting and Audio
MMS

Audio Engeneering
Domenico Carnuccio

**Head of Communications
and Promotion**
Beatrice Ravelli

Press Office
Villaggio Globale Int
Mediabeats
Leonardo Valente

Website
Nexus

Ticketing Service
MIDA

Conceived and realised by

Produced by

Co-produced by

Sponsored by

Technical Sponsor

SIMMETRICO cultura · Alma · RTV COMERCIAL · Centro de Estudios CHE GUEVARA · Comune di Milano · FABBRICA DEL VAPORE · INTERFIERE STANDS & EXHIBITIONS · TARGET DUE TECNOLOGIE PER COMUNICARE · MMS

Five decades have passed since the death of one of the twentieth century's most popular secular icons, one of the figures that helped to write a significant part of our recent history, a person who made many generations all around the world talk, discuss about him, debate, and converse: that figure is Ernesto Guevara, the revolutionary immortalised by Korda's camera lens who entered the collective imaginary of the young and the not-so-young.

We need to set aside the empty rhetoric of the legend and focus on the man: confident of the opportunity to use a new language to narrate a story in History, we take up the challenge to do so at the Fabbrica del Vapore, a place known for hosting both research and creativity, that has always made room for the cross-pollination between new languages, alternative expressions of what has been seen, known, and told in the past.

An interactive display in journalistic style accompanies us as we relive the crucial events in the story and the life of Ernesto Che Guevara, and as we discover at the same time the more personal side of the man, his preoccupations, his doubts, his thoughts, and his contradictions. We are allowed to go back together with him over the essential aspects of his thinking, his ideas, his ideals, and his choices.

The narrative uses an almost confidential tone, taking us by hand as we venture down a path that enables us to interact with both the man and the historical, cultural, and political context of his days. The figure of Ernesto Guevara is still debated today; research is carried out into the meaning and the languages that must at the present time be even more sensitive if we are to grasp the complexity and the contradictions of our world.

The exhibition conceived by Simmetrico Cultura moves along a corollary of narrative concepts never seen before, the rigor of the historical and scientific sources, and the integration of interactive content that invites the viewer to be a living and vital part of the story.

Anna Scavuzzo
Deputy Mayor City of Milan

Fifty years after Ernesto Guevara's death, *Che Guevara tú y Todos* aims to redeem his figure from the oblivion of the pop icon fuelled by posters and T-shirts, and to restore it to its more human, vital, and historical dimension; to tell the story of a crucial figure of the last century, characterised by the revolution and the struggle for civil rights around the world.

Conceived and realised by Simmetrico Cultura, the exhibition is co-produced with Alma, RTV Comercial de L'Avana, and the Centro de Estudios Che Guevara, with the support of the Department of Contemporary History of the University of Milan, of the IULM University, and of the University of Havana.

Following a philological order, the material exhibited is organised on three levels, each of them applying a different voice. Using the narrative style of media reporting, the first level describes the geopolitical context surrounding Che Guevara's actions. The aim of this section is to free the character from superficial opinions that have been the result of an incorrect comparison with today's contexts, and to foster a more precise understanding of the choices Ernesto Guevara made as a man and as a revolutionary.

The second level is of a biographical nature. Thanks to a vast and hitherto unpublished series of documents, it tells us about the young Ernesto's education in the years before the Cuban Revolution and, from 1959 onwards, about his public actions in Cuba and the rest of the world. This level is steeped in in-depth analyses dedicated to speeches, to political and social positions, to reflections on the international scene, and to Guevara's encounters with the protagonists and the intellectuals of his time.

The third level develops across the fragments of his personal writings: from the diaries and the letters to his family and to his friends, to the unpublished recordings of poems, in which doubts, weariness, enthusiasm, and reflections confer to the figure of Che a more multifaceted and complete dimension of the comrade and combatant, the son, the father, the friend, and the enamoured husband. A man who was always confronted with the choice between taking part in the revolution against social injustice and the painful sacrifice of his affections, and a safer and more peaceful life.

The title of the exhibition, *tú y Todos*, is taken from a poem written for his wife before leaving for Bolivia. It was chosen to underscore the conscious and intimate dimension of this person.

Dedicating a project to Ernesto Guevara means dealing with a figure who is controversial and complex, and it has taken two years of study and work.

Che is still an annoying figure, capable of dividing like not many can: a hero for many, a bad teacher for others, Che has shaped the imaginations of entire generations and has culturally influenced our recent history.

The fact that we cannot normalise, "metabolise" him without distorting events aimed more at reassuring ourselves is indicative. A romantic hero, a fanatical believer in utopias, the naive promoter of movements, these are all labels that speak volumes about our own ignorance more than offering an exhaustive picture of him.

What remains for me from an ideal dialogue with Ernesto Guevara is having discovered an intense man who put all of himself at the service of a "crazy" idea, the idea of a humanity whose moral imperative is the evolution towards a more just society.

Behind the character, icon of the revolution, I discovered a person who really felt on his own face the sting of power against the interests of a multitude of men and women stripped of dignity and hope. A man who tried to answer the question that anyone endowed with human solidarity or perhaps only reason might ask: "What is to be done? What position should be taken in a world in which social injustice, the exploitation of man against man are the practices of a financial capitalism that is destroying millions of families?" – it is significant that this is a question addressed to everyone by another famous Argentinian man, Pope Francis.

Che's story puts each one of us before the urgent need to take up a stance. Its intensity forces us to emerge from our intellectual comfort zone and to take on the responsibility to answer these questions. First for ourselves and then for the world.

The aim of the exhibition is not to emphasise the epic dimension of the figure. And even less so to take sides in a sterile debate on and ethical-moral judgement of his choices as both a public and a private man.

Rather, the three areas of the exhibition try to arouse a reflection on the story of a man who was undoubtedly out of the ordinary, on his questions, his drives, and on a crucial historical period that can help us to understand today's world.

Daniele Zambelli
President of Alma
President of Simmetrico Cultura

We are looking at a project that gives the public the chance to gain access to the most complete series of information currently available on Che's thinking, work, and life.

Thanks to the audio-visuals on display, visitors will be able to fully immerse themselves, without any need for intermediaries, in the documents and in the information preserved by the Centro de Estudios Che Guevara, funded by the prestigious international UNESCO Memory of the World Programme.

Our work, a collaboration lasted over two years, involved several institutes and bodies to achieve a methodological organisation of the contents, accompanied by a contemporary aesthetic, in the hope of helping the public to understand the legacy that they encompass.

Alma, Simmetrico, RTV Comercial, and the Centro de Estudios, which form the very heart of this project, wish to express their infinite gratitude to the University of Milan and the University of Havana for their priceless collaboration and enthusiastic participation.

Our hope is that the exhibition will be capable of paving the way for growth, thanks to an exchange of opinions and the consequent enrichment of our knowledge. It is fair to state, however, that the exhibition structure ought to be submitted to continuous changes, with the revision and the correction of involuntary omissions and errors, or in the event that part of its content should need to be modified. Indeed, from the very moment this project began to take shape and throughout its development phases, there has been a great opening up to any suggestions that might contribute to its improvement or fine-tuning, as we wanted it to become an instrument of dissemination and interaction.

Che's history is both enigmatic and surprising. Hence, the interest and the curiosity of the public in any initiative that presents it in part or, as in this case, without

skimping on the details, are assured. Our work, more than the work of others, is interesting because it openly traces the story of a life that began in the most ordinary way and then became the symbol of an absolutely unique principle of being. This path, at every stage, is often shown to us by Ernesto or Che himself, who takes us by the hand and leads us inside his intimacy, his deepest thoughts, his most glorious epic adventures, allowing us to transcend time and to accompany our host through the museum of his life, which still inspires the hearts of many.

As always in these cases, we have worked on writing a catalogue that could contain the most significant aspects of the exhibition in order to give visitors a substantial idea of the content they will discover, as well as something to take home with them after having seen the exhibition – to me, an audacious and virtual museum. Or else we can look at the catalogue as a concise summary of the project based on an extensively illustrated chronology documented with professionalism that thus fulfils any didactic need about Che Guevara.

Either way, it conceals a fundamental objective: to unveil the result of many years of study in the hope that it will represent a reliable source, useful for approaching or delving into Che's works.

This result stems from scientific rigor, from objectivity, and from our constant respect for historical truth, which can only be verified by means of a vertical methodology of investigation, and thanks to the access to the documentation and to other sources that, today, we make available to the public.

I wish you a marvellous experience.

Camilo Guevara March
Special Projects Coordinator, Centro de Estudios Che Guevara

Che Guevara tú y Todos is an exhibition elaborated with apparent simplicity. Its strength lies in the conceptual rigor and wealth of details with which it puts forth the life and works of Che. A man who throughout his life acted and thought in a coherent and determined way.

It is the first time ever that an extensive and content-filled exhibition such as the one organised by Simmetrico Cultura together with the Centro de Estudios Che Guevara in Havana has been dedicated to Guevara. Indeed, one of its essential qualities is the capacity to integrate documents, images, voices, and texts within the historical framework in which the crucial events of the life of Ernesto Guevara unfolded, from his birth on 14 June 1928 until his assassination in Bolivia on 9 October 1967.

To be able to favour a specific order based on visuals and content, the working methodology developed by the Centro was here used: i.e. the determination of essential and specific circumstances and stages in Che's biography, a retrospective pathway across his past and his permanent transformation materialised in the form of a deeply mature wilfulness and humanism.

Those stages have been respected and enriched with previously unpublished material that aims to tell us more about Guevara's dreams and his aspirations through a predominant element of intimacy and personal experience. The result is a journey towards hope, interspersed with discoveries and thoughts related to a dynamic and ever-changing presentation.

From another point of view, Che is shown in his different functions and perspectives, elements that are constantly being researched. The goal is to know and offer convincing answers about the action of a man who, as he wrote to his parents in his

farewell letter, aimed for a higher level with an *artist's delight*, and ventured into complex scenarios to accomplish a lofty purpose: the improvement of humankind.

This crucial resolution is underscored by Che's interest in a better understanding of the environment and of its complexity, as well as by the experiences he collected during his lifetime. This is already clearly evident in the stories from his early trips, when the young Ernesto's intent to revolutionise society and mankind acquired a new dimension, one that was triggered deep from the inside.

The sense of humanity that characterised Guevara right to the end reached its highest point when his life became reconciled with his selfless solidarity for the whole of humanity. First of all, with his participation in the struggle for the liberation of Cuba, and later on in the internationalist battle on a broader scale.

The ability to reflect this perception of the world is what makes this exhibition a rather special success, as it manages to combine, in Che's words, his personal mission and his willingness to sacrifice his life for the people of the world, a twofold goal expressed through ambitions and projects, doubts, contradictions, indecision, and victories. But above all through the profuse commitment to build a qualitatively superior identity.

Aimed at the universal.

All of which is summed up perfectly in the words *tú y Tod*os, which, for this very reason, have been chosen as the title of this exhibition.

María del Carmen Ariet
Scientific Coordinator, Centro de Estudios Che Guevara

Fifty years after his death, the figure of Ernesto Che Guevara is still so present that it is regarded as the icon of the struggle of the oppressed people for their own rights and freedom. It is not by chance that *Time* magazine nominated him in the list of the one hundred most influential people of the twentieth century, and that the famous photograph by Alberto Korda, entitled *Heroic Guerrilla Fighter*, is one of the most recognisable images in the world. After all, Che's story contains all of those elements that can arouse feelings and emotions in a public that has not chosen to live the peaceful life of conformism. Like a "perfect knight", Che left behind his relatively wealthy life in Argentina to embrace a life of political engagement in Latin America and to be involved in what may have seemed a desperate adventure, his landing in Cuba in 1956 alongside Fidel Castro, resulted instead in the victory of the revolution in 1959. Lastly, albeit celebrated in Cuba and in most of the world as a symbol of the fight against imperialism, Che chose to go back to the beginning and, as usually happens to heroes in the novels, after a hopeless fight in a remote corner of Bolivia, he died alone. It is precisely for all of these reasons that the historical figure of Che Guevara has often been distorted and presented in a rhetorical and merely laudatory way, transforming him into a timeless man and a sort of object for mass consumption.

Che Guevara led a complicated existence and, given the period he lived in, obviously filled with contradictions. In the end, it is not easy to come to terms with this figure without being influenced by rhetoric and superficiality. Daniele Zambelli and Simmetrico

Cultura decided to take up the challenge and conceived an exhibition that unfolds on several levels, offering a multifaceted vision of the man and of his time without falling into the temptation of developing a pure hagiography or a simple biographical reconstruction. Most of the materials used are primary sources, and of particular importance and originality are the archive documents from the Centro de Estudios Che Guevara in Cuba.

It is for this reason that, as professor at the University of Milan, promoter of this event, I am pleased to contribute to its realisation. The layout of the exhibition denotes a stimulating and modern cultural approach; not a simple sequence of images and events but a multimedia journey that immerse visitors in both Che Guevara's life and the history of the second half of the twentieth century. I personally coordinated a work group involved in one of the key sections of the exhibition that illustrates the geopolitical context in which Che Guevara operated in order to make it easier to understand the world scene. Visitors, especially young students, will find themselves facing a type of communication and language they are very familiar with; they will take part in the events to the extent that they will be emotionally involved in the story of the character and of the world he lived in. Nonetheless, the scientific rigor of the historical and cultural introduction to the life of Che Guevara and to his period remains one of the basic features of this exhibition.

Luigi Bruti Liberati
University of Milan

Contents

tú y Todos

Flavio Andreini

Coherence

When approaching to the study of Che Guevara the man – beyond the legend – it is essential to refer to the various environments in which he has lived and that were the settings of his life (from the Argentina of the 1930s and the 40s first, to the entire Latin American continent later, and, lastly, to the whole world), to the changing context of his life (from the protective love of a middle-class family to the guerrilla warfare on the Sierra Maestra), and to the different circumstances (materialising in encounters, interests, friendships, loves, travels, battles, roles, and responsibilities), which influenced his way of viewing reality, providing him with an existential vision that he was always faithful to. It is an undeniable fact, supported by the historical reports and the huge amount of handwritten material comprising diaries, letters, essays, speeches, poems, that there was great coherence, doggedly pursued between theory and practice, between what he thought and how he acted.

He himself did not fear disavowal, stating: *Your father has been a man who acted according to his beliefs, and certainly has been faithful to his convictions.* These were his words in the farewell letter he wrote to his children in 1965.

His choices were conscious ones, the result of an ongoing interior dialogue. With discipline he courageously asked himself the questions that most people hide from in dismay. *The world is prey to pain and injustice, what must I do? Turn my head or deal with the problem? And how? Help one as a doctor or all of them as a revolutionary?* He sought an answer to these questions, and once he had found it he sought another better one in his never-ending journeys, during the guerrilla warfare he took part in, in the thick forest as well as behind a writing desk, before the United Nation General Assembly as well as in a forest in the Congo until his final moments in Bolivia.

Not a succession of random circumstances, but a concatenation of actions with a specific goal: choosing his own destiny and becoming a New Man.

Sartre's words about him were: "I believe that the man was not only an intellectual but also the most complete human being of our age."

The End of the Roaring Twenties

You were born in Argentina into a middle-class family, an erudite and unconventional one: your mother smokes, travels, crosses her legs! From when you were a

little child, you have a violent form of asthma. You learn about the precariousness of life right away. You are surrounded by affection and attention. You cannot attend school. So your mother is your teacher at home. Bedridden you read ever so much. Above all adventure books.

You grow up. You take an interest in philosophy. By the time you're fourteen you've already read Freud.

You do sports. You manage to live with the disease. Girls like you. The teachers like you. You aren't particularly interested in politics. You'd like to become an engineer.

Your dear grandmother falls ill and you look after her. You change your mind and enrol in the Faculty of Medicine.

You get engaged to a beautiful girl, a member of one of the most important families in the area.

A very normal, safe and marvellous future lies ahead of you.

Perhaps with your own clinic, perhaps as a famous allergy doctor, or a travel writer.

Then something shakes you up. Physically and mentally.

You travel and you meet the Other, the *America with a capital A* with its poor people, the vagabonds, the Indios, the lepers, the peasants. Those responsible for the mess are outspoken and aren't afraid to exert violence.

You learn about an outside scenario based on desperation that changes your inner world. The poor old lady suffering from asthma like you will die without anyone to comfort her. Why?

The couple of miners to whom you give a blanket will disappear swallowed up by the earth or assassinated by the police. Why? No one cares for the lepers of San Pablo. Why?

Each step in your endless journey is marked by a question: Who am I? Who are they? Why is their fate different from mine?

Until a very strong interior answer is formed: I am them, they are me. Your fates now intersect.

You want them to intersect.

Your wish becomes the same as that of the patriot José Martí: *I want to share my fate with the poor of the earth.*

From the very beginning, you do not fear having to choose the hardest road.

Other questions will arise.

The world is sick. The world suffers.

Who is the doctor? What is the cure?

I am not Me

There was something physical in his way of dealing with life, a struggle with the flowing of time. A ravenous truth-seeker, a restless traveller. When he was still very young, the very serious asthma attacks made him experience the pain, the fear, the fragility of being a human being. As he grew up he would recognise them in the gazes of others, in the eyes of the weakest and the humblest. Not different from him, beyond social class, race, beauty, and the ugliness. Ernesto did not avoid them, actually, he looked for them. He was not afraid to touch their bodies, he treated them, he shook the hands of the lepers, he embraced them.

Certain encounters that took place during his motorcycle trips in 1951-1952 are emblematic, as told in the diary *Notas de Viaje*. In Valparaíso in Chile he described his encounter with an elderly woman who was asthmatic just like him, and close to the end of her life: *The poor thing was in a pitiful state, breathing the acrid smell of concentrated sweat [...]. It is there, in the final moments, for people whose farthest horizon has always been tomorrow, that one comprehends the profound tragedy circumscribing the life of the proletariat all over the world. In those dying eyes there is a submissive appeal for forgiveness and also, often, a desperate plea for consolation which is lost to the void!*

Again, during the journey, he met a couple of Chilean workers: (The man) *told him about his three months in jail, his wife reduced to hunger who had followed him with true loyalty, about his children, whom he had left with a charitable neighbour, about his aimless wandering in search of work, his companions who had mysteriously disappeared, whom people said had been tossed into the sea. The couple, numb with cold, huddling against each other in the desert night, was a living representation of the proletariat in any part of the world. They had not one single miserable blanket to cover themselves with, so we gave them one of ours and Alberto and I wrapped the other one around us as best we could. It was one of the coldest times in my life, but also one which made me feel a little more fraternal toward this strange, for me at least, human species.*

At the end of the journey Ernesto wrote in his diary: *The person who wrote these notes passed away the moment his feet touched Argentine soil again. The person who reorganises, polishes them, me, is no longer, at least I am not the person I once was. All this wandering around 'Our America with a capital A' has changed me more than I thought.*

The old "I," the one perhaps tied to the old social class, to the career and to the concept of "personal affirmation," vacillated before the vision of a world where fear, pain, and injustice reigned.

In 1960, after the triumph of the Revolution, in a speech to the Ministry of Health entitled *On Revolutionary Medicine*, with intellectual honesty Ernesto admitted: *Like everyone, I wanted to succeed. I dreamed of becoming a famous medical research scientist, [...] of working indefatigably to discover something which would be used to help humanity, but which signified a personal triumph for me. I was, as we all are, a child of my environment. [...] After graduation, due to special circumstances and perhaps also to my character, I began to travel throughout America, and I became acquainted with all of it. [...] First as a student and later as a doctor, I came into close contact with poverty, hunger and disease; with the inability to treat a child because of lack of money; with the stupefaction provoked by the continual hunger and punishment, to the point that a father can accept the loss of a son as an unimportant accident, as occurs often in the downtrodden classes of our American homeland.*

Ernesto was always present, with a sensitivity and an intensity that allowed him to find in every occasion the sense of his own personal journey, in his attempt to answer the pressing existential question. I, the other, others...what is the relationship that binds us to this earth? What is the difference?

Trying to understand oneself by encountering the other, understanding the other, encountering oneself. Until the solution: the I and the other intersect, I am with you, with your truest needs. The need for care, for solidarity, for closeness, the need for tenderness and for comfort, for a hand that clenches yours as you are dying. Power

divides, the races, the rich and the poor, men and women, whites and half-castes, until only one remains, tragically alone, lost in his tribulations to survive or in his anxiety to consume, seeking to avert the irksome question on the meaning of life. Power, insensitive, starves, tortures, kills.

Ernesto instead knew the value of every single breath: [It] *is worth a million times more than all the property of the richest man on earth*. To set oneself the aim of feeling, of being the other. And making sure that everyone makes the other their own. Feeling *on one's own face a slap across the face of any other man.*

Che Guevara's project was truly a pedagogical one, in which everyone had to be their own master, in a never-ending process of self-consciousness.

A process that started right away with the literacy of the people as they rose up against dictatorship, successfully continuing to do so in the years to come. Educating the people to educate themselves. To feel inside themselves – as if they were naturally their own – the ideals of the revolution.

From I to We

The encounter with the injustice and the pain of a continent, discovered during the first journey, produced a great change in Ernesto's "I" and in his identification in the pain of a continent. But it was just the start of a profound inner journey.

1956. This is what he wrote to his mother from jail while in Mexico: *During these prison days* [...] *I have identified totally with my comrades in the cause. I remember a phrase that once seemed to me idiotic or at least bizarre, referring to such a total identification among the members of a fighting body that the very concept of the 'I' disappeared and gave way to the concept of the 'we.' It was a communist morality and may, of course, appear to be a doctrinaire exaggeration, but in reality it was (and is) a beautiful thing to be able to feel that stirring of we.*

An "I" that discovers the "other" is identified to then leave room for "we." To discuss this passage means discussing Ernesto's compassion, his feeling with the other. The concept of "we" was embodied in the guerrilla warfare. Not a fight of the few but of an entire people. Guerrilla fighters and farmers together. Che constantly risked his life with his men, the leader of his companions. He was not a pseudointellectual, not a rearguard general, but someone who constantly placed his mind, his heart, and his body at stake. Wounded, sick, bloody, his feet covered with sores and his body torn like those of the guerrilla fighters and of the *campesinos*, the peasants, all around him. He was with them. More than that: he was them. He was each one of them. For this reason he was magnetic, for this reason his companions followed him consciously even in the riskiest situations. It was not his role as commander that gave him authority. It was his authority that gave him the role.

The New Man

During the years of his maturity, in Cuba, Che took another step forward: he believed that the inner quest, the evolution of man had to proceed relentlessly and in

parallel with the country's industrial and economic development. Che's ideal humanity began to take shape, what he would call *Hombre Nuevo*, the New Man.

These were the words he said on October 1962 at the awards ceremony for the winners of the competition of the Circulos de Estudio at an industrial level: *We need to work to perfect our inner selves almost obsessively, with constant commitment; to analyse every day in an honest way what we have done, to correct our mistakes, and to start over again the following day.*

On 20 October of the same year in the speech entitled *Que debe ser un joven comunista*: [...] *Every young communist must essentially be human and be so human that he draws closer to humanity's best qualities, that he distils the best of what man is through work, study, and through ongoing solidarity with the people and all the peoples of the world. Developing to the utmost the sensitivity to feel anguished when a man is murdered in any corner of the world and to feel enthusiasm when a new banner of freedom is raised in any corner of the world. [...] If someone says we are just romantics, inveterate idealists, thinking the impossible, that the masses of people cannot be turned into almost perfect human beings, we will have to answer a thousand and one times: Yes, it can be done, we are right. The people as a whole can advance.*

The Sacrifice

Inherent in the idea of Guevara's New Man is that of "sacrifice". What the others, the people, "everyone" demands from the single individual and from every revolutionary.

1963. During a workers' assembly Che clarified his concept of sacrifice: *New Party members ought to be intimately acquainted with all the new truths and should welcome them naturally. What ordinary people regard as sacrifice, they must regard as everyday chores, as what needs to be done and is the right thing to do.*

The most commonplace and boring things change [...] with effort from inside [...] they must focus on relevant and substantial things, on things they cannot fail to do without feeling bad: in what is called sacrifice. The failing to sacrifice actually becomes a sacrifice for a revolutionary. [...] All this means feeling the revolution, it means that man is the revolutionary within himself, who feels like a revolutionary. That's when the concept of sacrifice takes on a new meaning.

But the sacrifice, the forsaking of one's own individuality for the common good has a very high price. It involves the loss of something very precious, that can never be recovered. Caresses, kisses, embraces lost forever.

1965. These are his words in the story *The Stone*, when he received the news of his dying mother, during his guerrilla fighting in the Congo: *The saddest news of the whole war. Telephone calls from Buenos Aires reported that my mother was very ill, leading me to expect the worst [...] Does one not cry because one must not or because one cannot. Is there no right to forget, even in war? Is it necessary to disguise a lack of feeling as machismo? I don't know. I really don't know. I know only that I feel a physical need for my mother to be here so that I can rest my head in her bony lap. I need to hear her call me 'My son,' with such tenderness, to feel her clumsy hand in my hair.*

You and Everyone

1965. This is the tone of a letter that Che sent to his wife from the Congo: *Don't try to blackmail me. You can't come now or in three months' time. Maybe in a year it will be different and then we'll see. […] A good part of my life has been like that: having to hold back the love I feel for other considerations. That's why I might be regarded as a mechanical monster. Help me now, Aleida, be strong, and don't create problems that can't be resolved. When we married, you knew who I was. You must do your part so that the road is easier; there is still a long road ahead.*

And again, in another letter, at the end of his unfortunate adventure in the Congo: *You know I'm a combination of an adventurer and a bourgeois, with a terrible yearning to come home, while at the same time, anxious to realise my dreams. When I was in my bureaucratic cave, I dreamed of doing what I have begun to do. Now, and for the rest of my journey, I will dream of you, while the children inevitably grow up.*

Sacrificing oneself, doing something one believes in, means giving up something that is a part of you. Pieces of flesh, as he refers to his children. Something that bleeds. What follows is an excerpt from the last letter Che wrote to Aleida from Bolivia: *To my only one […] There are days when I feel so homesick, it takes a complete hold over me. […] You can't imagine how much I miss your ritual tears, under a star-filled sky that reminds me how little I have taken from life in a personal sense. […] I am losing weight, partly from longing and partly from the work. Give a kiss to the little pieces of my flesh and blood and to the others. For you a kiss filled with signs and sorrows, from your poor, bald Husband.*

Sacrificing the love and the warmth of a normal life in the name of revolutionary ideals. Is it worth it? Che gave a poetic answer to the question in an untitled composition he wrote for Aleida before leaving for Bolivia.

> *My only one in the world:*
> *I secretly extracted from Hickmet's [sic] poems*
> *This sole romantic verse, to leave you with the exact*
> *dimension of my affection.*
> *Nevertheless, in the deepest labyrinth of the taciturn shell*
> *the poles of my spirit are united and repelled:*
> *you and EVERYONE.*
>
> *Everyone demands complete devotion from me*
> *so that my lonely shadow fades on the road!*
> *But, without ridiculing the rules of sublime love*
> *I hide you in my saddlebags.*
> *(I carry you in my insatiable saddlebags,*
> *like our daily bread.)*
> *I leave to build the springs of blood and mortar*
> *and I leave in the vacuum of my*
> *absence this kiss with no fixed address.*

But the reserved seat was not assured
in the triumphant march of victory,
and the path that guides my travels
is overcast by ominous shadows.

If my destiny is an obscure seat of honour in the foundations,
just place it in the hazy archive of your
memory, to use during nights of tears and dreams...

How distant Che's words and enamoured verses are, in their restlessness blended with a tenderness tinged with the rhetorical image of the superhero, with the legend that is after all so convenient for the consciences in its astral unattainability.

Not just the heroic warrior then, not just a coherent revolutionary, but also a husband, a father, and a son, a human being wounded by his piercing love for his distant affections, impassioned, enamoured, painfully tested by his austere ideal choices.

Not a robot, but a person just like each one of us, endowed with sensitivity and feelings. And this bestows even more value on his choices, on his thinking, and on his actions.

And on his sacrifice, that is, his being deeply coherent until the very end with his own love for humanity.

This is what he wrote on 8 August 1967 in his Bolivian diary: *This is a moment when great decisions are made. Guerrilla warfare gives us the opportunity to become revolutionaries, the highest level of the human species. And it allows us to graduate as men. Those who cannot reach either of those two stages should say so now, and they will be permitted to leave the struggle.*

Finally, the last page of Che's Bolivian diary, which he seems to have written as if in a bubble, as though time had stopped, says this: *Today marks eleven months since our guerrilla inauguration. The day went by without complications, bucolically.*

Then in a flash everything ended. Once again, grouped together with those poor, humiliated, and offended people with whom he identified. Che was executed and his tortured body was buried in a place without a name.

Thus ends his poem to Aleida:

Adiós, my only one,
do not tremble before the hungry wolves
nor in the cold steppe of absence;
by my heart I will carry you
and together we will continue until the road fades away...

Discovering Che

Paola Romano

When you walk into an archive, you do so carefully. Almost on tiptoe. You take a look at everything, you take notes, and you wonder what you are going to discover and how you are going to describe what you find.

Going to the Centro de Estudios Che Guevara, recognising the house where Ernesto lived the last years of his life with his family, was like giving a face and a body to what until then I had only been able to see in photographs.

Thus began my journey through Che's archive, in search of information about his life in pictures, written thoughts, letters, the surprising reading lists, the notes.

The amount of material that has been preserved is simply astounding: not just because of its sheer quantity and variety, but also because of the way it continues to grow: it is a living archive, Che's own archive, which continues to gather the testimony of those who knew Che personally. Many interviews document, to the very end, the life of a man who died young. Many are the anecdotes described in great detail.

The mission of the Centro de Estudios Che Guevara – which entered UNESCO's International Organisation for the Memory of the World in 2015 – is that of promoting the knowledge of documents as a direct historical witness to Che Guevara's choices, thinking, and way of living.

One is especially impressed by the variety and wealth of Che's countless writings: when looking at some of the portraits it is impossible not to notice his pockets filled with small notes and the camera always hanging around his neck, instruments he used to fulfil his urgent need to jot things down, keep them in mind.

This correspondence between the image and the need to write, to never lose sight of what was happening around him is evident. These are not just pictures. They tell the story of a man's life.

Amid the great number of testimonies, we tried to detach ourselves from the famous portrait of Che made by Alberto Korda, the picture that turned him into the icon of the century. This meant bringing to light photographs that may not always be perfect, but that are capable of telling us the whole story of the life of Ernesto Guevara.

It was remarkable to discover the more than two thousand images collected, portraying his childhood, his youth, his speeches, the guerrilla fighters in the Sierra Madre at first, and in the Congo and Bolivia later. The private pictures at his children's birthday parties, Che at school, Che on his wedding day. However, perhaps the most powerful photograph is the one taken just before his execution: handcuffed standing between two guards,

his eyes hollow, his hair unkempt and uneven in length, his eyes expressing resignation and yet at the same time filled with dignity.

This image corresponds to the last pages of his *Bolivian Diary*, written in a notebook manufactured in Germany, a daily diary in which to accumulate the everyday things of his life, the ideas he worked long and hard to compile.

In that moment too, the symmetries between the pictures and the written lines are many; such as during his official trips, when he himself photographs and signs letters or postcards to his wife Aleida and to their children. Che often used the camera as though it were a pen. In his pictures we do not find a search for formal perfection, he does not aspire to creating a harmonious composition. There is instead the presence of a gaze that hungers for what it looks at and wants to make sure he never forgets it.

During his first diplomatic trip, in 1959, Guevara had his inseparable camera with him, and he took a photograph that appears to be emblematic.

When he was in Hiroshima to pay tribute to the fallen, he wrote a postcard to his wife Aleida in which he indicated the number of deaths and ended with words that emphasised the strength of the struggle for peace. In that picture he himself took he depicted a place of sadness, in a rarefied, suspended landscape where the light flattens the few visible elements. It is an intention. A reading of the real.

This is why, although a lot of attention is devoted to the many images of Che, the most striking shots are his self-portraits: taken from the time he was young they are like a short diary and a clear representation of himself. They are a mirror, the means that allowed him to record his own face and how it changed, alone before the camera lens with no filters. Looking straight at himself and restoring the perception of self through his own eyes.

Che was only thirty-eight when, in order to reach Bolivia under a false name, he was forced to disguise himself to look like someone over fifty. The disguise was perfect. The self-portraits taken during that period tell the story of a man who awaits something, they are a rigorous study of false aging. A fleeting, pitiless man on a par with his very own gaze.

It is hard to discern the true dividing line between the character and the person. The decisions made in public life explode in the private sphere. This is attested to the choice and tone of the writings, increasingly aimed at leaving a mark, a word that serves as an omen… There it is: the future, the growth of the person, the attention towards the other and for his or her needs. These are the stolen principles and the true legacy of Ernesto Guevara, better known simply as Che.

1928-1956

"¿Qué veo yo?"

,en ese lapso pu
cuyo relato indiscriminado co
,la moneda fué por el aire,dió muchas volteretas;cayo
otra "seca"("canto"es una forma de equilibrio que el
o cuando es como la moneda,hacia la al
alquiera)..."El hom las cosas,habla a
les solo vi una que mis oj lo mejor
ta en mi lengu "seca",o viceversa,es y no hay
rra lo que mis ojos le contaron. Nuestra vista nunca
y no siempre equitativamente informada,los juici
, de acuerdo,pero ésta es la interpretación que u
tes de los impulsos que llevaron a apretar las teclas y
han muerto. No hay sujeto sobre quien ejercer el pe
naje que escribió estas notas murió al pisar de nuevo
erior,Ese vagar sin rumbo por lo menos
que las ordena y pule yo,"yo",no soy yo,por lo menos
de lo que creí. En cualquier libro de técnica fotog
un nocturno en el que brilla la luna
revela el secreto de esa seguridad
sensitivo conque está cubierta mi retina
modo que no se pue hacer c
en que fué sacad
con

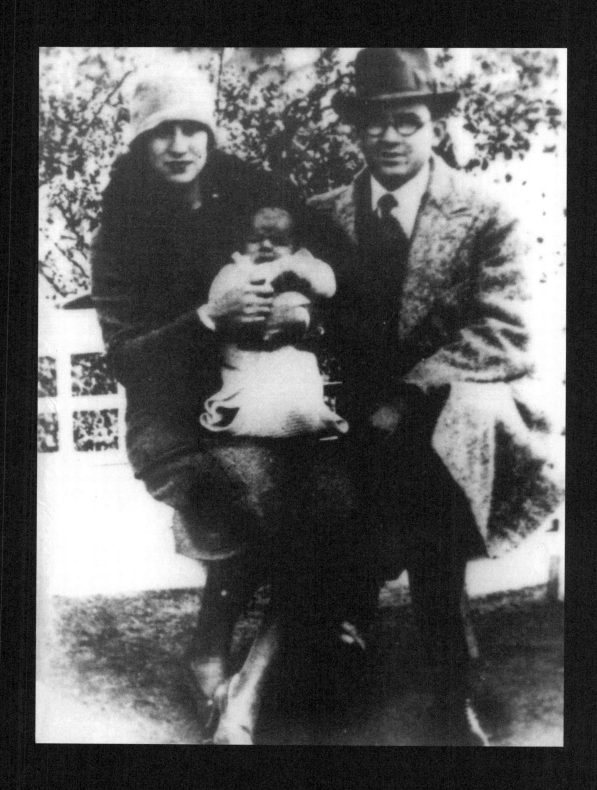

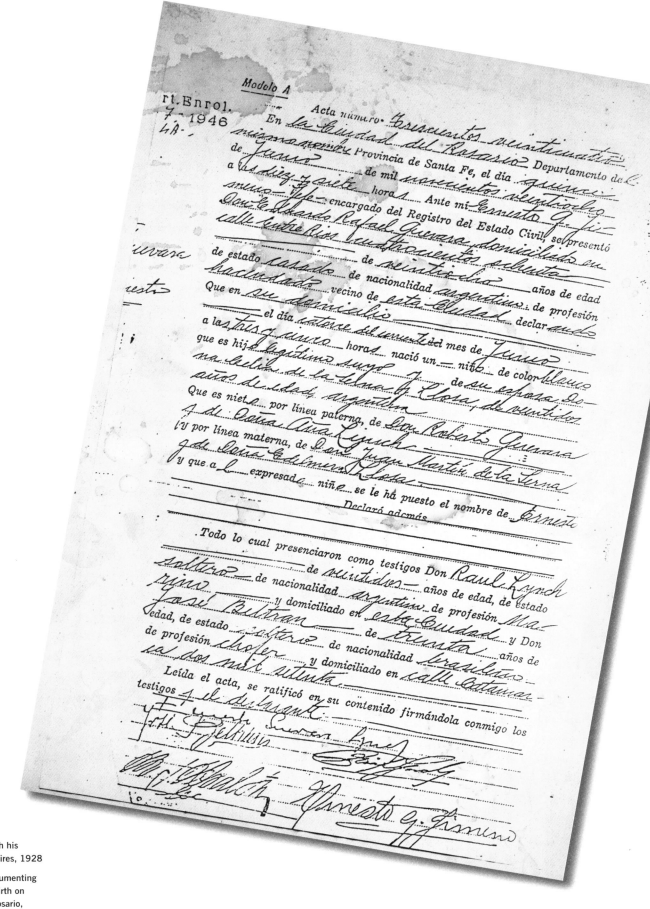

Ernesto Guevara with his
parents in Buenos Aires, 1928

Birth certificate documenting
Ernesto Guevara's birth on
14 June 1928 in Rosario,
Argentina

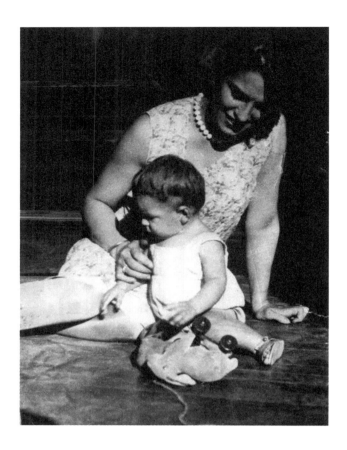

Fifteen days old, Ernesto fell seriously ill with pneumonia, an event that perhaps was the true origin of his soul. […] He was very sick for seven, eight days, […] we were all worried […] he would eat nothing, he wouldn't drink any milk […] then finally he took his mother's breast. It was a moment of great joy and the baby was saved.

Ernesto Guevara Lynch, Ernesto's father

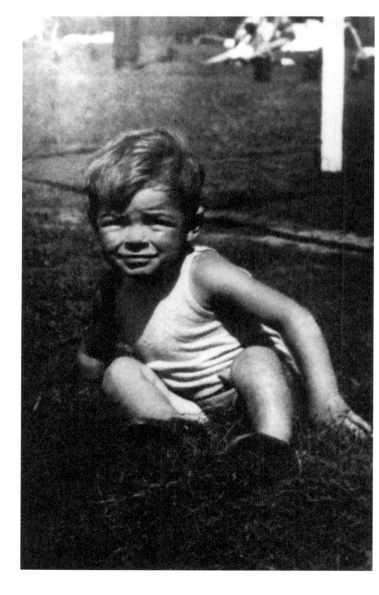

Ernesto with his mother Celia de la Serna in Caraguatay, Misiones, 1929

Buenos Aires, 1930

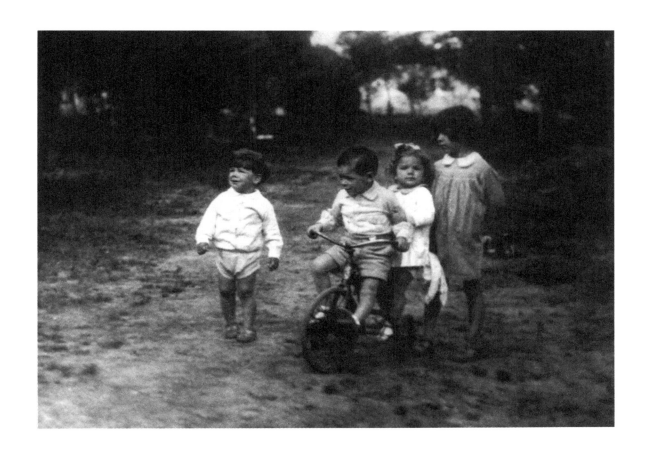

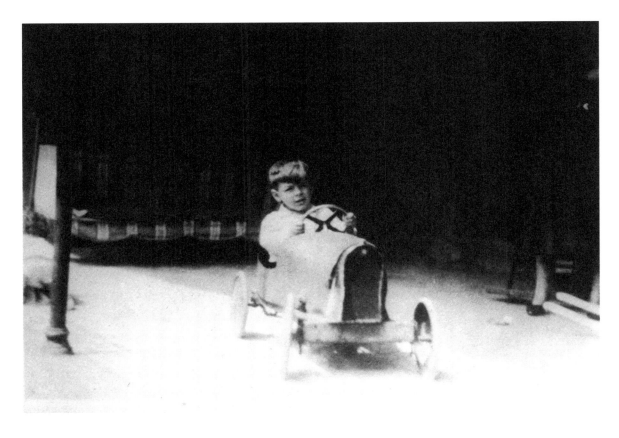

Ernesto playing with his
siblings, 1933

On a toy pedal car, 1933

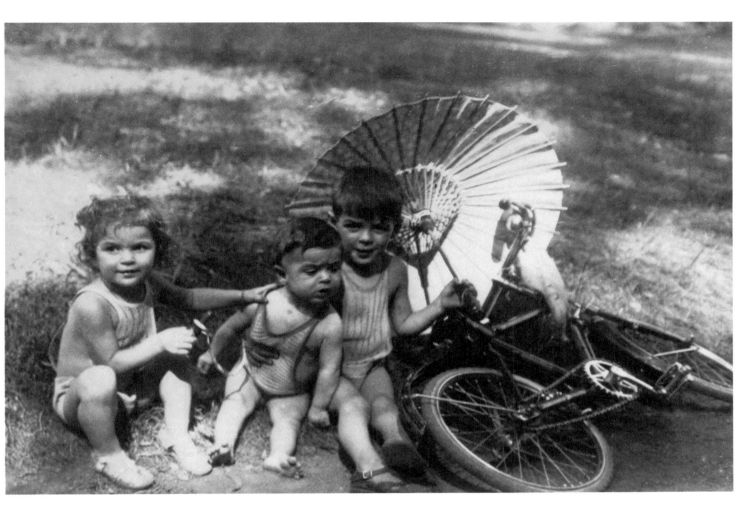

When in good health, Ernesto was very enthusiastic, very keen [...] on running, climbing, eating everything he wanted to eat and sleeping peacefully, like his companions. [...] He felt better [...] and our house was filled with joy.

Ernesto Guevara Lynch, Ernesto's father

On his bicycle, 1935

Ernesto with his siblings
Roberto and Celia, 1935

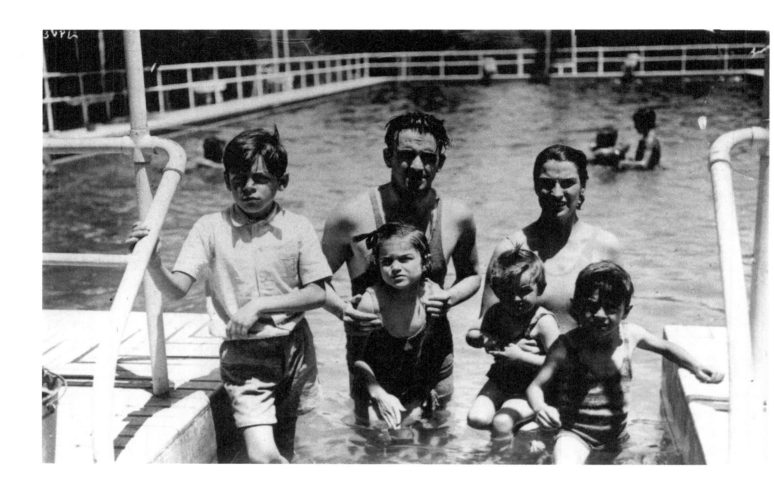

The Guevara family spending
some free time at the
swimming pool of the Sierras
Hotel in Alta Gracia, Córdoba,
1936

Ernesto with his sister Ana
Maria at the swimming pool
of the Sierras Hotel in Alta
Gracia, Córdoba, 1937

Ernesto with his mother and
his siblings Celia, Roberto,
and Ana Maria, in their home
in Alta Gracia, Córdoba, 1938

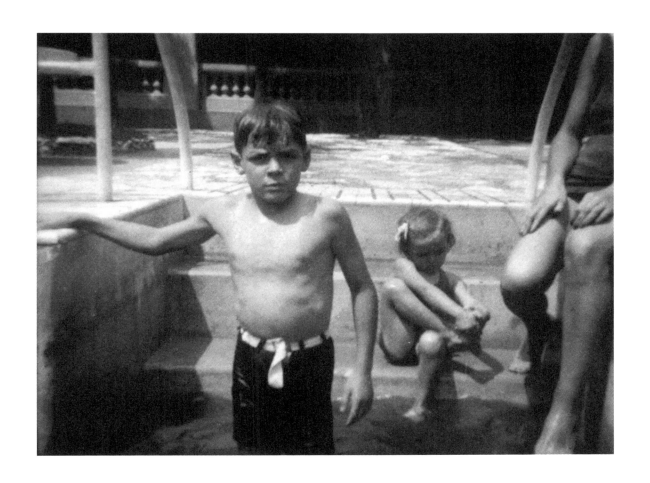

Alta Gracia, Córdoba, 1938

Ernesto has always been very mature for his age, the eldest brother, a little bit of a father, the one who tirelessly has taken care of me and my education.

Ana Maria, Ernesto's sister

Ernesto and Ana Maria playing in their family home in Alta Gracia, Córdoba, 1940

*I remember when my father, a doctor, was
surprised because Ernesto was reading Freud.
In those days he was 14 or 15 years old.*

Ernesto José "Pepe" Aguilar, a friend

Ernesto with his mother and
his sisters Celia and Ana in
Alta Gracia, Córdoba, 1942

Page from the *Index of Books*,
the list of books read by
Ernesto. Started in his teenage
years to keep record of all
the different subjects he was
interested in, it covers whole
Ernesto's life

Índice de libros

Ameghino, Florentino. Doctrinas
 y descubrimientos (Palart)

Alarcón, Pedro A. de (Español)
el capitán Veneno y el escándalo.
el sombrero de tres picos.
 Alighieri, Dante (Italiano)
La Divina comedia.
Anuario socialista 1937
Auerchenko, Arcadio (Ruso)
 Cuentos.
Alekhine, Alejandro (Ruso)
Mis mejores partidas de ajedrez.
Amadeo, Octavio R. (Argentino)
Vidas argentinas (biografías)
Azorín (Español)
Confesiones de un pequeño filósofo (España)
 Alarcón, Luis de (Español).
La verdad sospechosa.

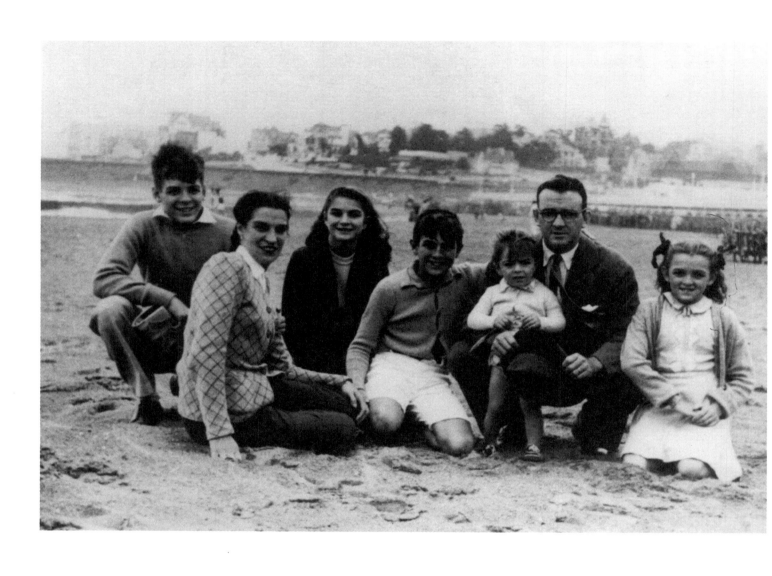

The Guevara family in Mar del
Plata, Buenos Aires, 1945

Birthday party for Pedro de
la Serna, Ernesto's cousin,
Buenos Aires, 1946

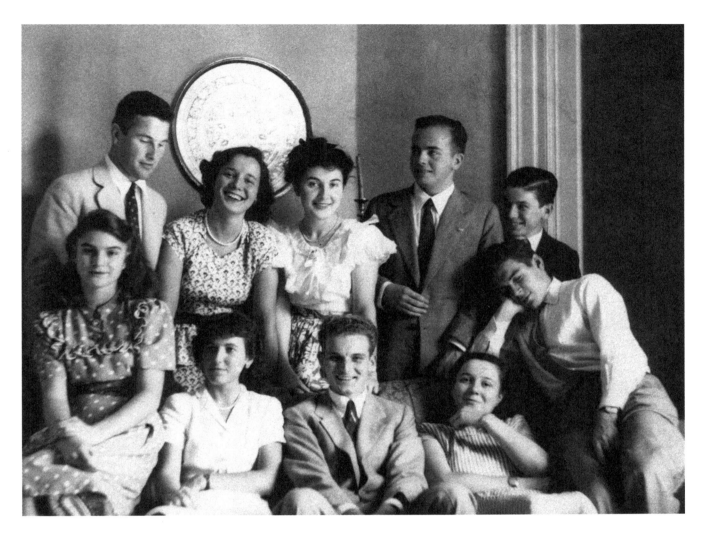

When Ernesto started to frequent another social environment, he also liked those youth meetings where dancing, listening to music, or conversation were involved.

Ernesto Guevara Lynch, Ernesto's father

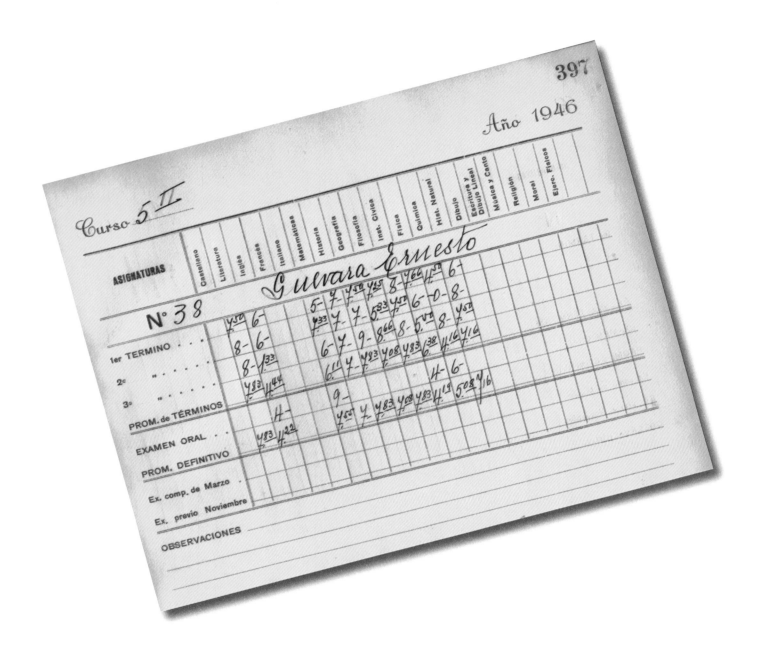

Ernesto's report card issued by the "Deán Funes" Secondary School, Córdoba, 1946

Ernesto Guevara, *Self-Portrait on the Balcony at Home*, Buenos Aires, 1947

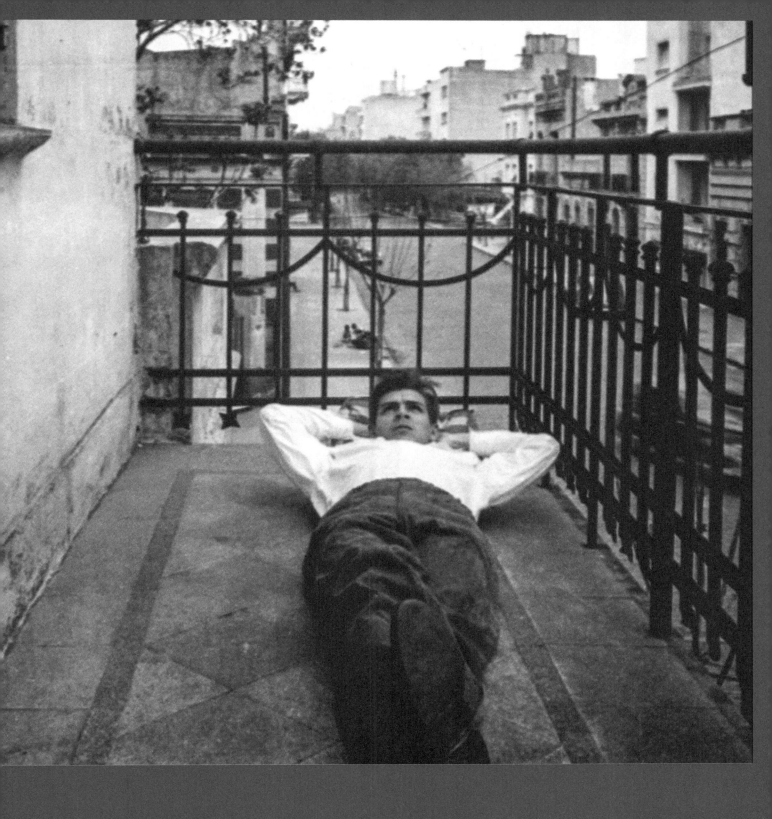

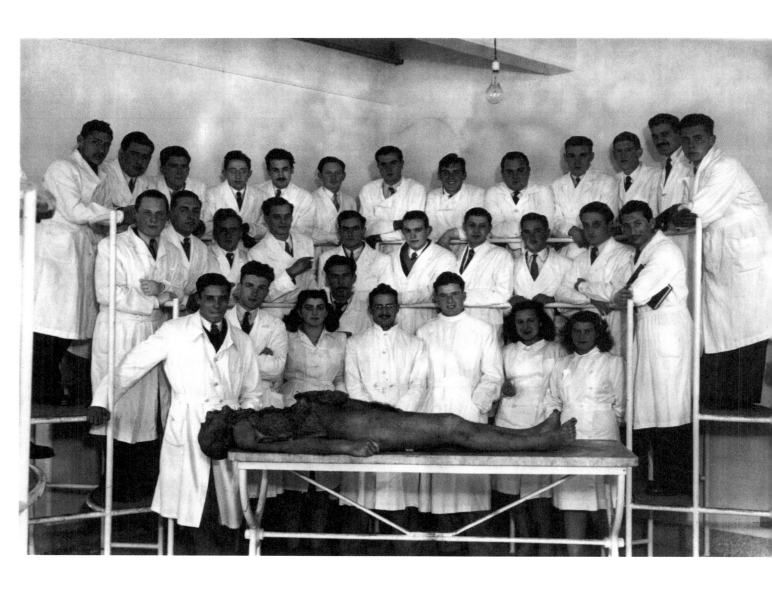

Anatomy lesson at the Faculty
of Medicine, University of
Buenos Aires, 1949

Ernesto's military documents
certifying his bronchial asthma
and containing his fingerprints.
Issued in 1949, his fingerprints
were sent by the government
of Argentina to Bolivia when he
was captured in 1967

In an anatomy room of the Faculty of Medicine, several times I heard a warm, deep voice that with irony encouraged himself and the others before a spectacle that shook even the most insensitive of those future doctors. From his accent, he must have come from the provinces too; from his appearance, he was a handsome and confident young man.

Tita Infante, a friend

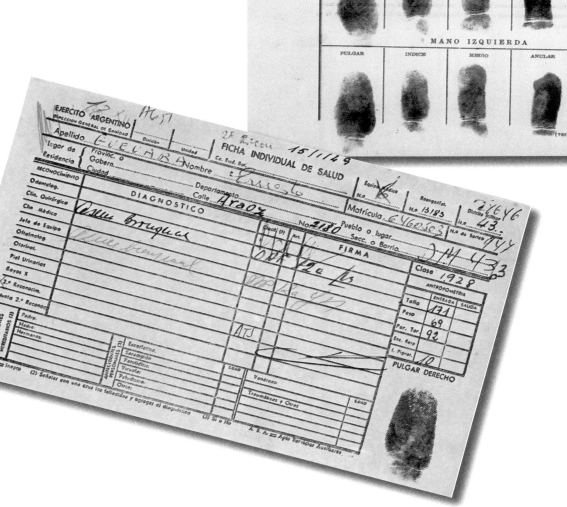

47

At least I am not nourished in the same ways as the tourists, and I find it strange to find, on the tourist brochures [...] the Altar of the Fatherland, the cathedral where the national ensign was blessed [...]. No, one doesn't come to know a country or find an interpretation of life in this way. That is a luxurious façade, while its true soul is reflected in the sick of the hospitals, the detainees in the police stations or the anxious passersby one gets to know, as the Río Grande shows the turbulence of its swollen level from underneath.

Ernesto Guevara, travel notes

At the age of 22, on 1 January, Ernesto had left for the northern provinces of Argentina on a bicycle modified with a small motor. […] A journey of over four thousand five hundred kilometres.

Ernesto Guevara Lynch, Ernesto's father

Ernesto Guevara, *Self-Portrait on His Bicycle before Leaving for His Trip across the Provinces of Argentina,* 1950

Ernesto with Chichina Ferreyra, his girlfriend at the time of his bicycle trip, 1950

Ernesto during one of the stops of his bicycle trip across Argentina, 1950

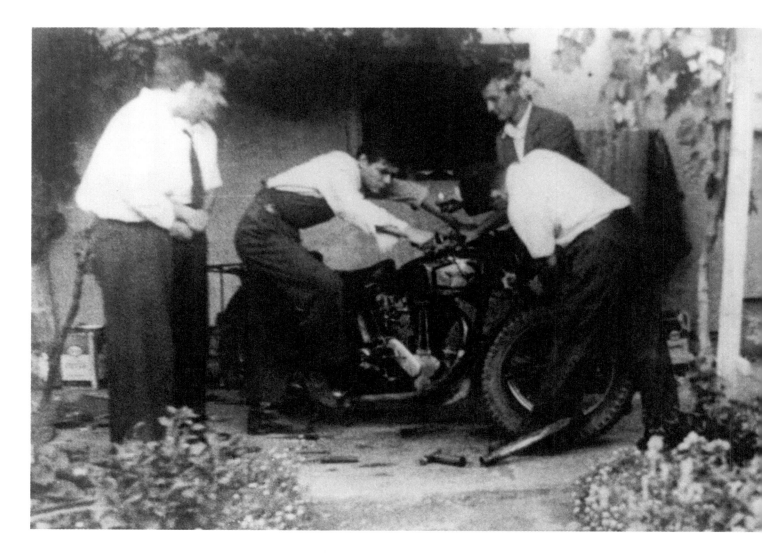

Guevara crossed the continent for the first time in the company of Alberto Granado on a motorbike called Poderosa II (December 1951 – June 1952). It was a journey rich in discoveries and adventures, a first approach to Latin America laden with meaning, during which Che started to grasp the most authentic part of his roots. He combined his experience and reflections with his freshness of youth, trying to find answers to that concern that marked the start of an authentic Latin American thinking, as well as the future of a revolutionary man to the marrow.

María del Carmen Ariet, Centro de Estudios Che Guevara

Ernesto with the Granado
brothers while getting
the motorbike Poderosa II
ready, Córdoba, 1951

Ernesto Guevara, *Self-Portrait*,
Buenos Aires, 1951

The person who wrote these notes passed away the moment his feet touched Argentine soil again. The person who reorganises, polishes them, me, is no longer, at least I am not the person I once was. All this wandering around "Our America with a capital A" has changed me more than I thought.

Ernesto Guevara, *Notas de Viaje*

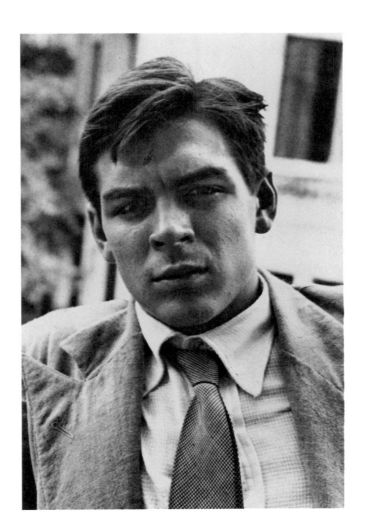

Ernesto while travelling
with Alberto Granado
at the border between
Colombia and Venezuela, 1952

In 1952, in the first page of *Notas de Viaje*,
Ernesto's travel diary in Latin America, he writes:
*This is not a story of heroic deeds, nor the simple
tale of a cynic – at least I do not mean it to be.
It is a segment of two lives taken in the very
moment they walked together on the same path
with similar ambitions and dreams.*

No és este el relato de hazañas impresionantes;no es tampoco mera-
mente un"relato un poco cínico"; no quiere serlo,por lo menos. Es un trozo
de dos vidas tomadas en un momento en que cursaron juntas un determinado tre-
cho, con identidad de aspiraciones y conjunción de sueños. Un hombre
en nueve meses de su vida puede pensar en muchas cosas que van de la más ele-
vada especulación filosófica al rastrero anhelo de un plato de sopa,en total
correlación con el estado de oscuridad de su estomago; y si al mismo tiempo
es algo aventurero,en ese lapso puede vivir momentos que talves interesen a
otras personas y cuyo relato indiscriminado costituiría algo así como estas
notas.

Así,la moneda fué por el aire,dió muchas volteretas;cayó una vez
"cara"y alguna otra "seca"(su "canto"es una forma de equilibrio que el hombre
no adopt sino cuando está en fuga,con la moneda,hacia la alcantarilla de u-
na calle cualquiera). El hombre,medida de todas las cosas,habla aquí por mi
boca y relata en mi lenguaje lo que mis ojos vieron; a lo mejor sobre diez "ca
ras" posibles solo vi una "seca",o viceversa,es probable y no hay atenuantes;
mi boca narra lo que mis ojos le contaron. Nuestra vista nunca fué panorámica,
siempre fué y no siempre equitativamente informada,los juicios son demasiado
terminantes? de acuerdo, pero ésta es la interpretación que un teclado da al
conjunto de los impulsos que llevaron a apretar las teclas y esos fugaces im-
pulsos han muerto. No hay sujeto sobre quien ejercer el peso de nuevo tierra Argentina. El
personaje que escribió estas notas murió al pisar la ley. El
el que las ordena y pule "yo",no soy yo;por lo menos no soy el mismo yo
interior.Ese vagar sin rumbo por nuestra "Mayuscula América" me ha cambiado
mas de lo que creí. En cualquier libro de técnica fotográfica se puede ver la
imagen de un nocturno en el que brilla la luna llena y cuyo texto ex-
plicativo nos revela el secreto de esa oscuridad nocturno a plena sol, pero la naturale-
za del baño sensitivo conque está cubierta mi retina no es bien conocido por nadie,
apenas yo la intuyo,de modo que no se puede hacer correcciones sobre la pla-
ca para averiguar el momento real en que fué sacada. Si presento un nocturno
créanlo o revienten,poco importa;que si no conocen personalmente el paisa-
je fotografiado por mis notas,dificilmente conoceran otra verdad que las que
les cuento aquí. Ahora Los dejo con migomismo,el que fuí...

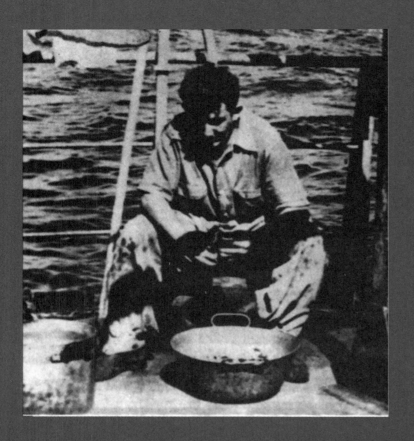

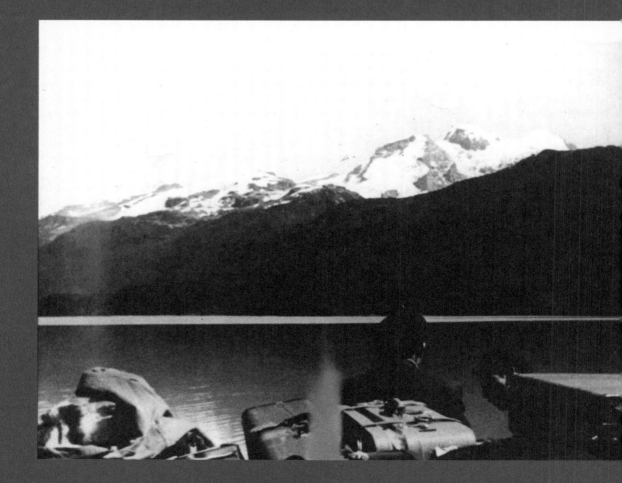

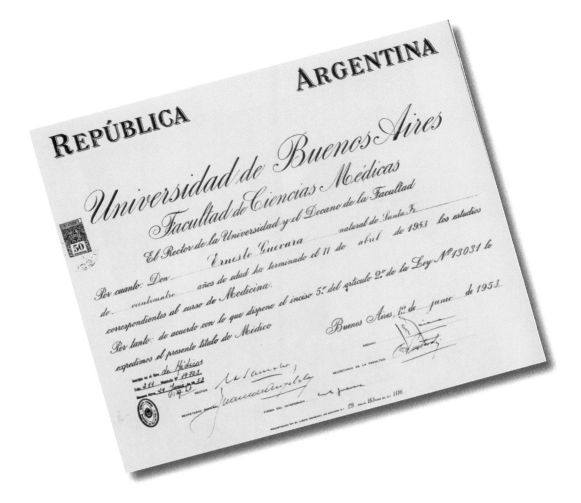

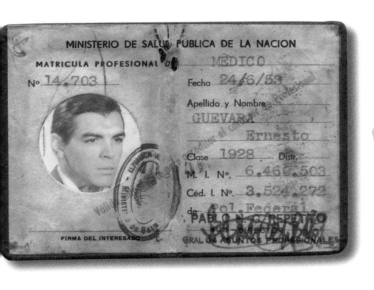

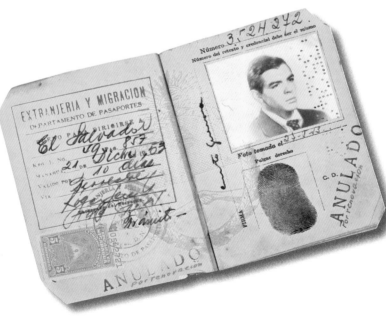

Ernesto Guevara, *Alberto Granado Peeling Potatoes in Valparaíso, Chile*, 1952

Ernesto Guevara, *Nahuel Huapi Lake, Argentina*, 1952

Ernesto's medical degree, 1953

Ernesto's medical license, 1953

Ernesto's passport issued in 1953 and used for his second trip to Latin America

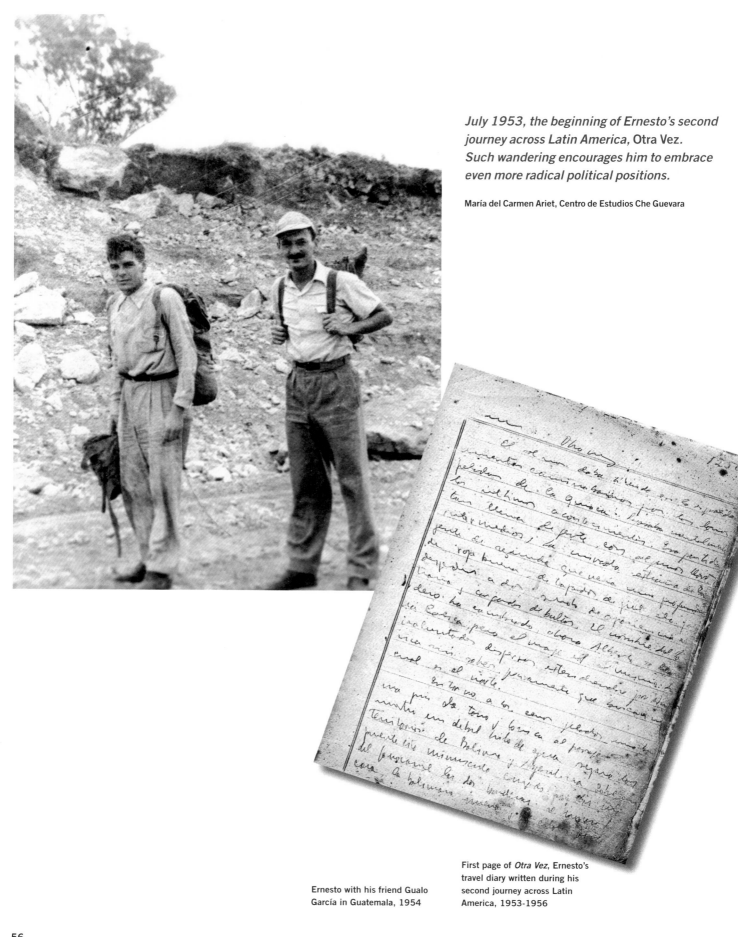

July 1953, the beginning of Ernesto's second journey across Latin America, Otra Vez. *Such wandering encourages him to embrace even more radical political positions.*

María del Carmen Ariet, Centro de Estudios Che Guevara

Ernesto with his friend Gualo García in Guatemala, 1954

First page of *Otra Vez*, Ernesto's travel diary written during his second journey across Latin America, 1953-1956

A terrible cold shower has fallen
on all those who admire Guatemala. On the
night of Sunday, 28 June, President Árbenz
announced that he was resigning.
He publicly denounced the fruit company
and the United States as being directly
behind all the bombing and strafing
of the civilian population.

Ernesto Guevara, *Otra Vez*

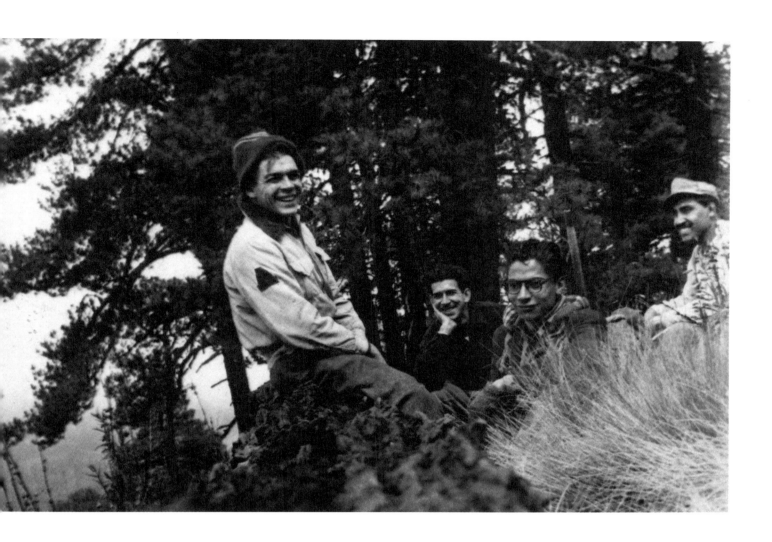

In September 1954, Ernesto
decides to go to Mexico, where he
will marry Hilda Gadea, a Peruvian
exile he met in Guatemala.

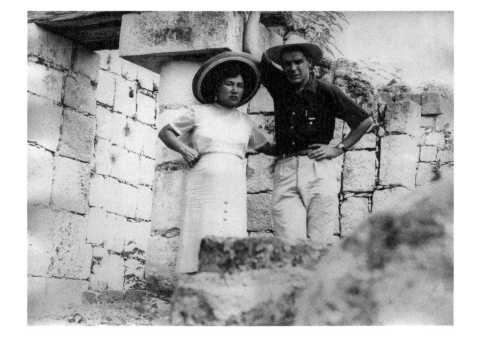

With a group of friends while
climbing the Popocatépetl
volcano, Mexico, 1955

Ernesto Guevara, *Local
Market in Santo Tomás
Chichicastenango, Guatemala*,
1954

With his wife Hilda Gadea
amidst the Mayan Ruins,
Mexico, 1955

15 February 1955, Mexico City. Ernesto's first
daughter Hilda Beatriz Guevara Gadea was
born. This is how he describes her in a letter to
his mother: *The creature* […] *cries when she's
hungry, she pees often... the light bothers her
and she sleeps most of the time; and yet there is
something that immediately makes her different
from every other creature: her father's name is
Ernesto Guevara.*

Hired as photographer by
Agencia Latina, for the second
edition of the Pan American
Games, Mexico City, 1955

Some time ago [...] a young Cuban leader invited me to join his movement, a movement which sought the armed liberation of his country. Of course, I accepted. [...] In the mid-term future, I'll be linked to Cuba's liberation. I'll either triumph with it or will die there...

Ernesto Guevara, letter to his mother

Fidel Castro, leader of the 26th of July Movement, meets Ernesto in Mexico in 1956 while in exile after the failed assault at the Moncada Barracks. Ernesto immediately embraces the ideals of the revolution and for months, the two of them train with a group of rebels with the aim of overthrowing the dictatorship of Fulgencio Batista. In June 1956, a tip-off to the police leads to the capture of Ernesto, Fidel, and the rebels. Once out of jail, Fidel and Ernesto speed up the expedition and on 25 November they leave from the port of Tuxpan on the yacht Granma with a group of 82 insurgents. On 2 December they arrive on the shore of Las Coloradas in eastern Cuba.

Ernesto Guevara, *Calixto
García, Member of the 26th
of July Movement, in Mexico
City Jail*, 1956

Ernesto with Fidel Castro
in Mexico City jail, 1956

1957-1958

"Buscando mi verdad"

en Jefe de la direcc...
edidas por la direc...
instrucciones precisas de ...
r del mismo,

...que es derecho inalienable de todo habitan...
o: propietario de la tierra que trabaja; que hay grandes
tierra ~~sin cultivar~~ pertenecientes a enemigos declarados
e otras ~~tierras~~propiedades están dedicadas a producci...
con daño de la economía del pueblo; que muchos habitant...
stán con...tra... trabajar para otro o simplemente, a n...
carecer del ... pedazo de tierra ~~como~~ ordena, c...
onario del "26 de ... bajo administración del ejér...

Primero- Toda propiedad mueble in... ...ido...
gun servi... de la dictadu... ...confiscad...
sa a manos de la comisión de la reforma agrar...

...jeta a la investigación de la citada comis...
dictaminará sobre la procedencia o no de ...

Segundo: Toda propiedad mayor de treinta caballería...
a un método de aprovechamiento extensivo q...

Artículo Tercero- Todo individuo que haya pagado renta por
no superior a cinco caballerías durante
mayor de dos años, queda excento de tod...
...dra derecho a reclamar la propiedad de ...
ante la comisión nombrada arriba la que ...
sobre cada caso.

Artículo Cuarto- Todo habitante de la zona que pueda de...
vivido los últimos cinco años en ella ...
piedad alguna tiene derecho a dos cab...
...rreno, siempre que los haya disponibles, ...

Artículo Quinto- la Entrega de la tierra se efectuara co...
de posesión y sera completamente gr...

Artículo Sexto- Se reconoce el derecho de los antig...
recibir el valor de las tierras exp...
do con la tasación del impuesto de ...
...timo-Se crea la comisión de la reforma...
r los reglamentos generales y ...

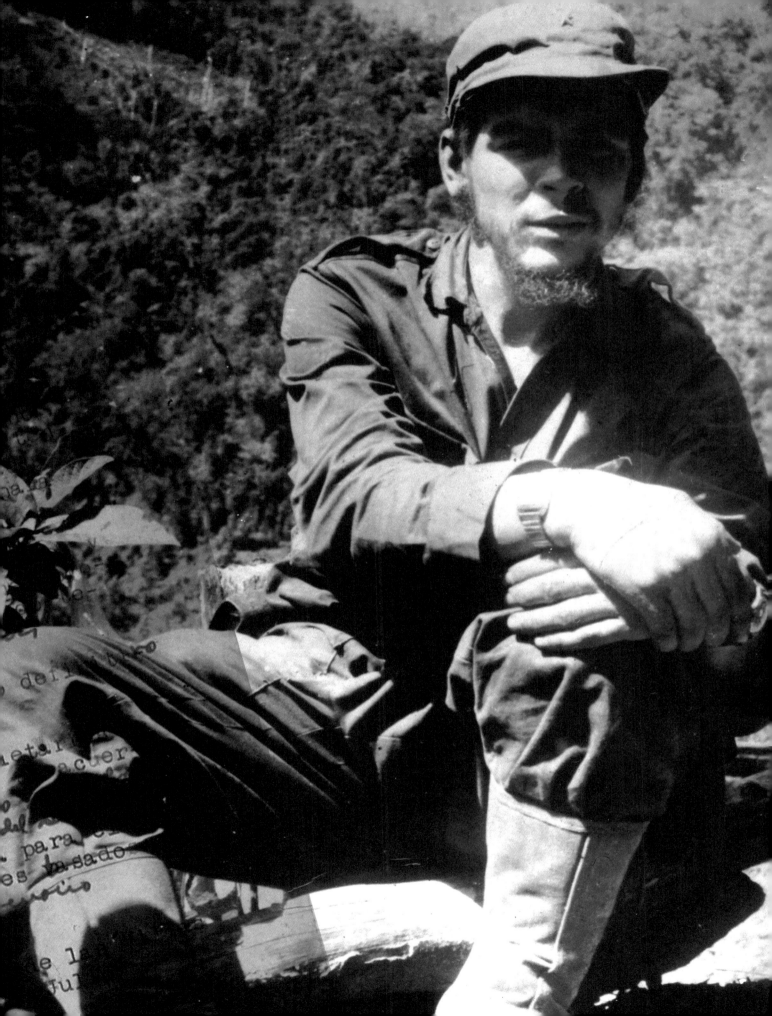

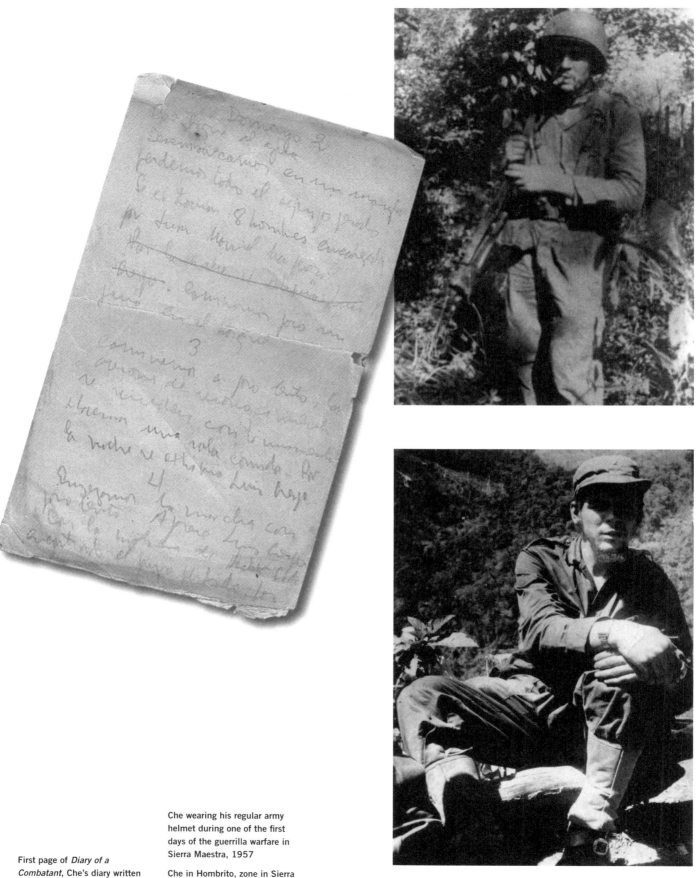

First page of *Diary of a Combatant*, Che's diary written during the guerrilla warfare in Sierra Maestra, 1956-1958

Che wearing his regular army helmet during one of the first days of the guerrilla warfare in Sierra Maestra, 1957

Che in Hombrito, zone in Sierra Maestra where he had his column, 1957

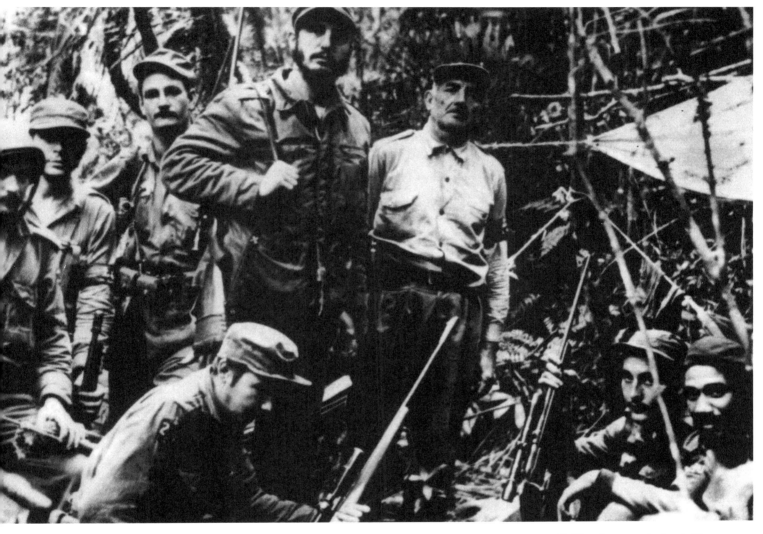

Fidel Castro, his brother Raúl, and Che Guevara together with a group of guerrillas in Sierra Maestra, 1957

The guerrilla will last a little more than two years, from the arrival on the shore of Las Coloradas on 2 November 1956 until 1 January 1959 when Batista's regime collapses and the revolution triumphs. In the meanwhile, the majority of the Cuban population end up identifying themselves with the ideals and the purposes of the 26th of July Movement.
Indeed, thanks to their behaviour, the rebels garner consensus and approval among the civilian population, in particular the rural one. Unlike the army indeed, the *barbudos* do not loot villages, they do not rape and they do not commit gratuitous violence; rather, they pay for supplies and any other good needed for the cause.
In Minas del Frio, in the Sierra Maestra, Guevara creates the first guerrilla school *al aire libre*: the number of people joining the school to learn to read and write continues to grow, to the extent that in two years' time 30 rebel schools are established.

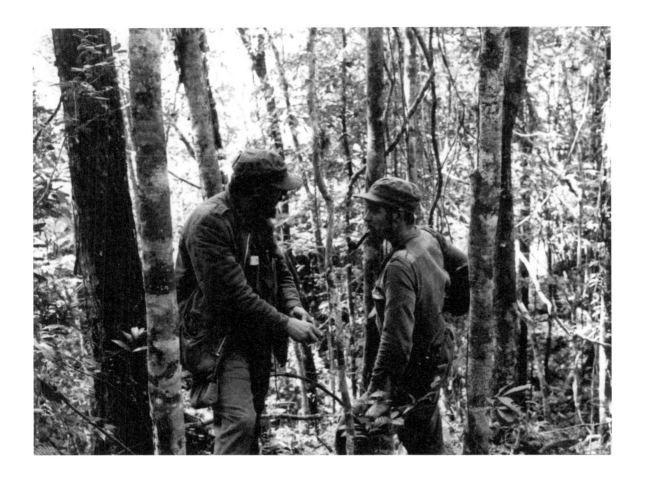

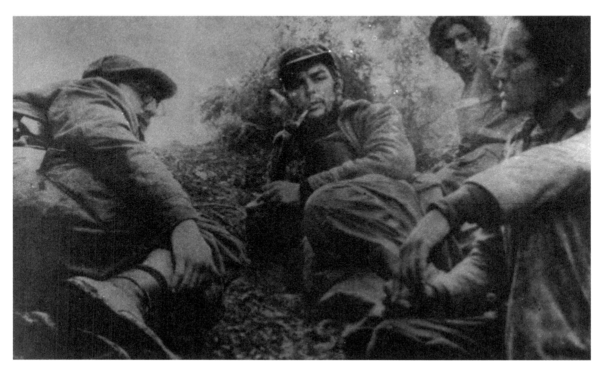

With Fidel Castro in Sierra Maestra, 1957

Fidel and Che with some guerrillas, 1957

With his friend and guerrilla Camilo Cienfuegos, 1957

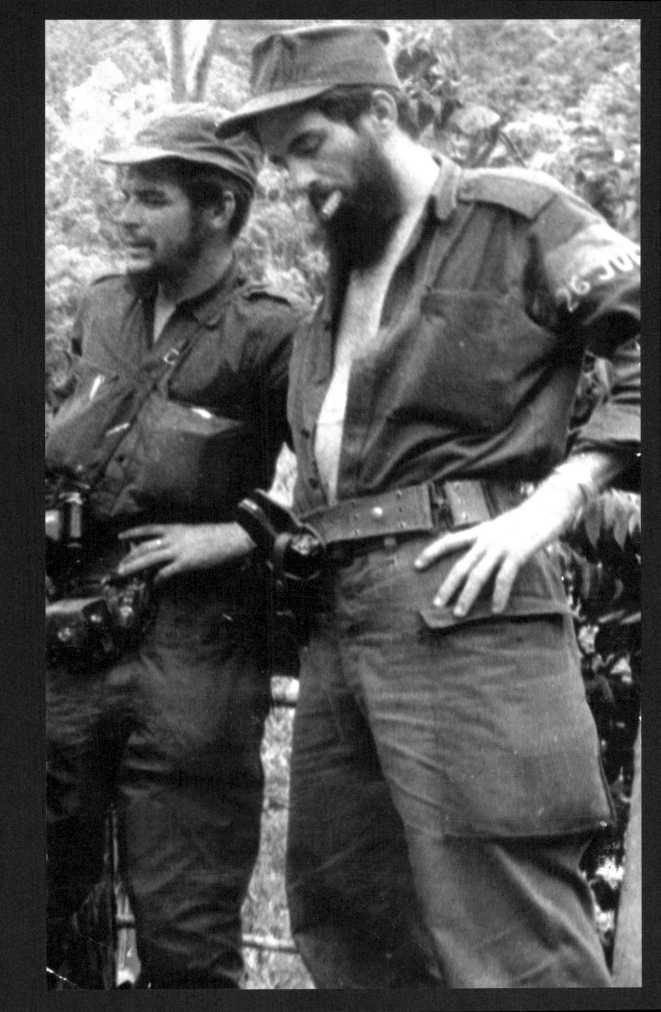

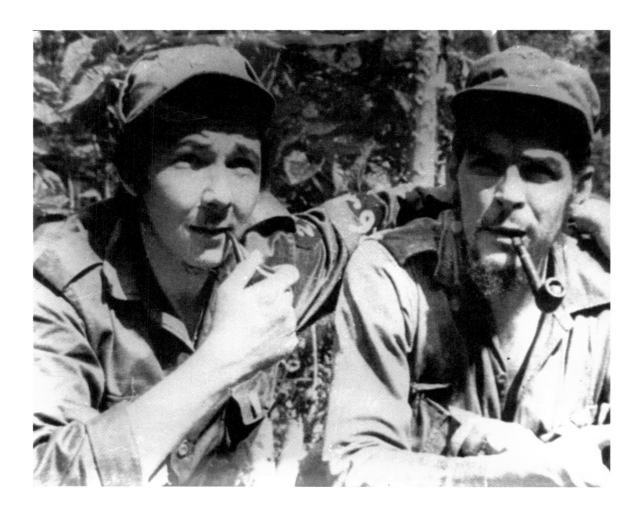

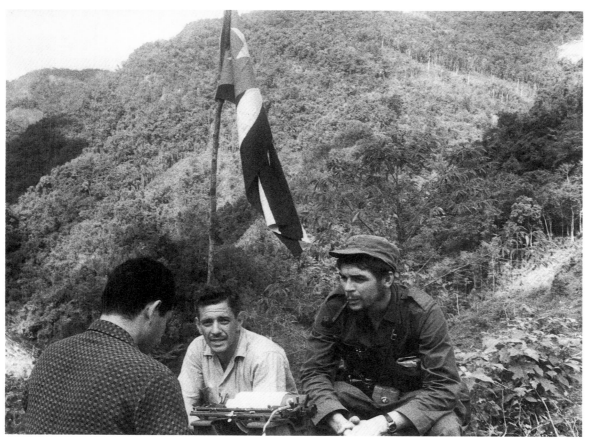

With Raúl Castro, 1957

Guevara while interviewed
by some Cuban journalists
in Sierra Maestra, 1958

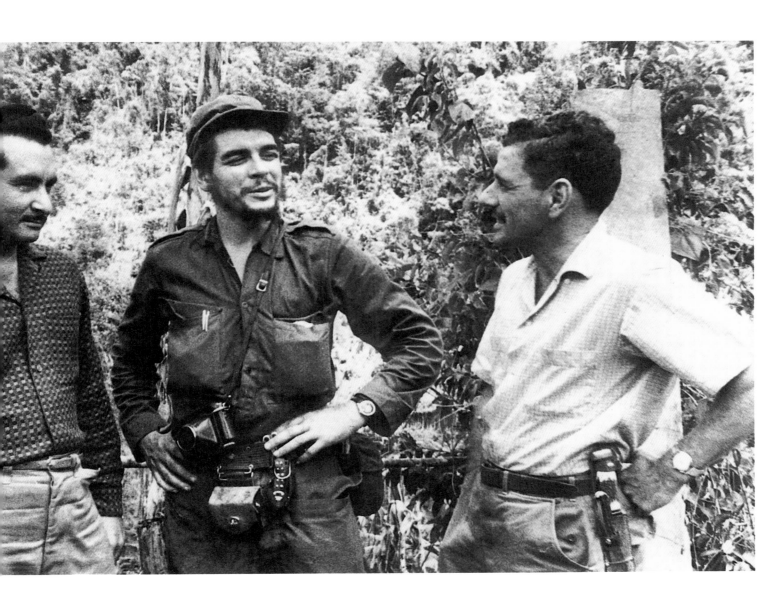

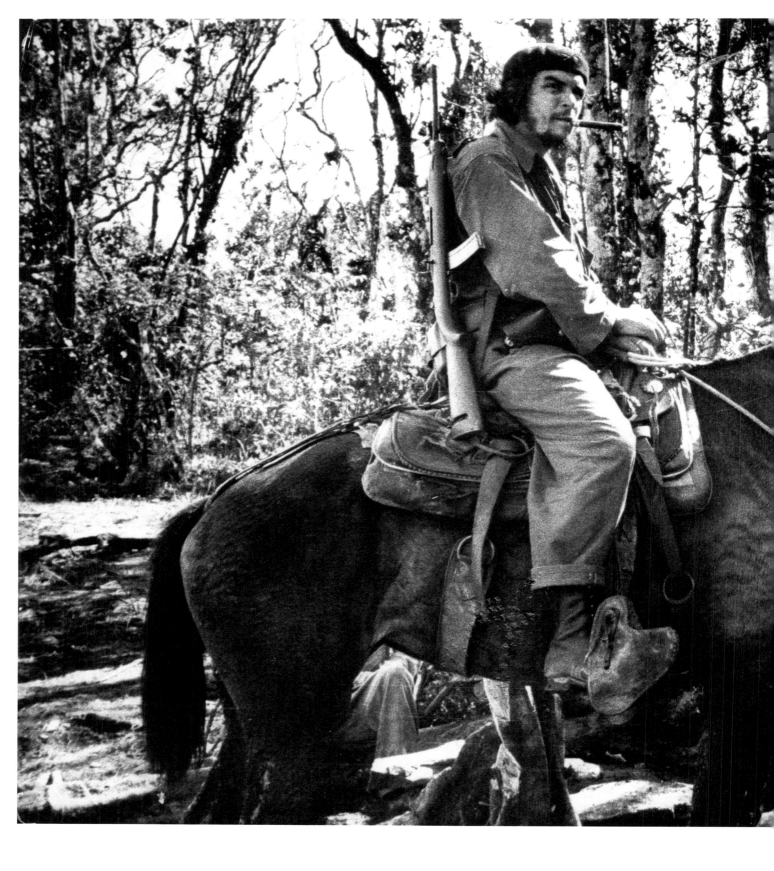

Che Guevara riding a horse
in the Escambray forest,
Las Villas, 1958

The positive quality of this guerrilla warfare is precisely that each one of the guerrilla fighters is ready to die, not to defend an ideal, but rather to convert it into reality. This is the basis, the essence of guerrilla fighting. Miraculously, a small band of men, the armed vanguard of the great popular force that supports them, goes beyond the immediate tactical objective, goes on decisively to achieve an ideal, to establish a new society, to break the old moulds of the outdated, and to achieve, finally, the social justice for which they fight.

Ernesto Che Guevara, *Guerrilla Warfare*

Escambray, Las Villas, 1958

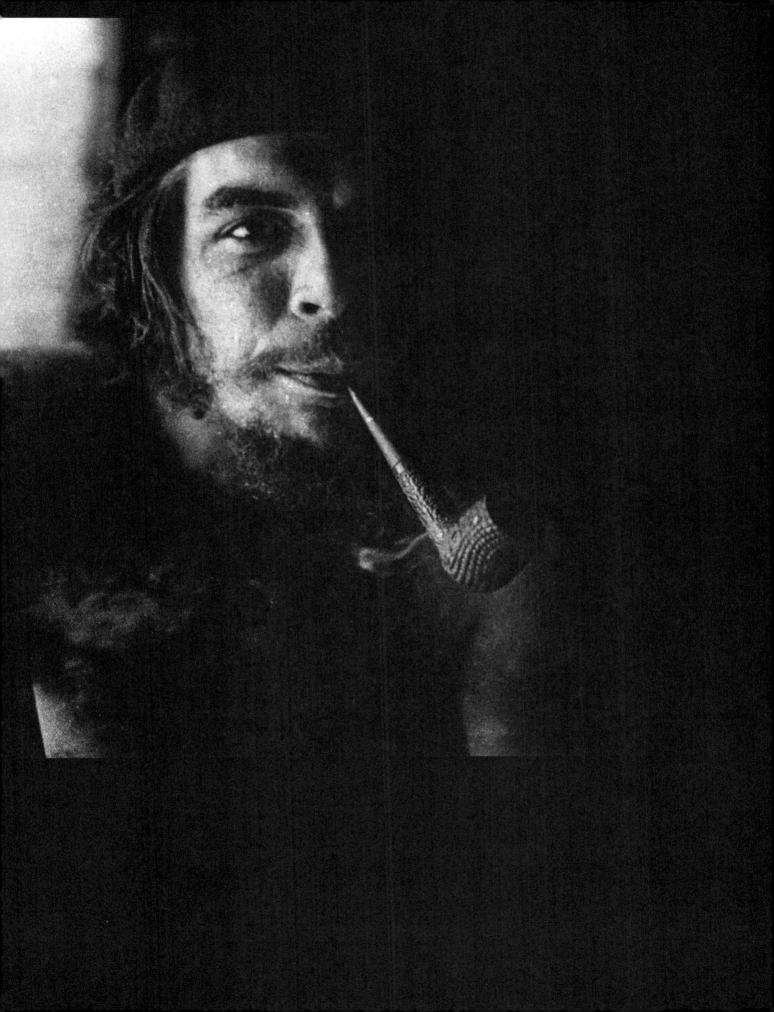

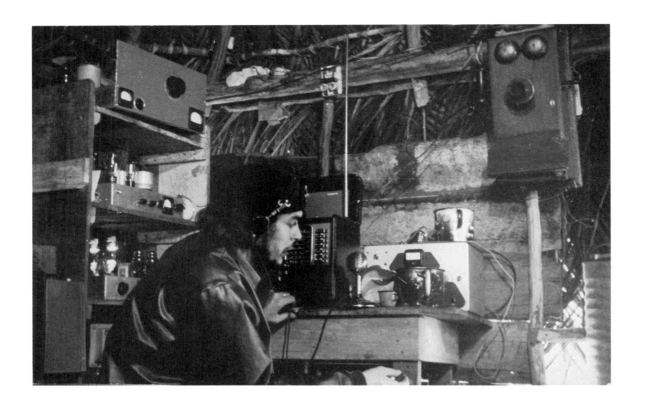

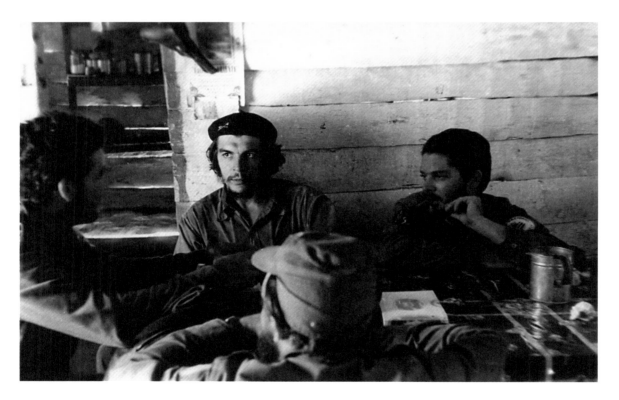

Che while talking on Radio
Rebelde, founded by himself
in his command zone in
Sierra Maestra to inform the
combatants about the actions
of the guerrilla warfare, 1958

A meeting with the combatants
of the Second Front in
Escambray, 1958

Escambray, Las Villas, 1958

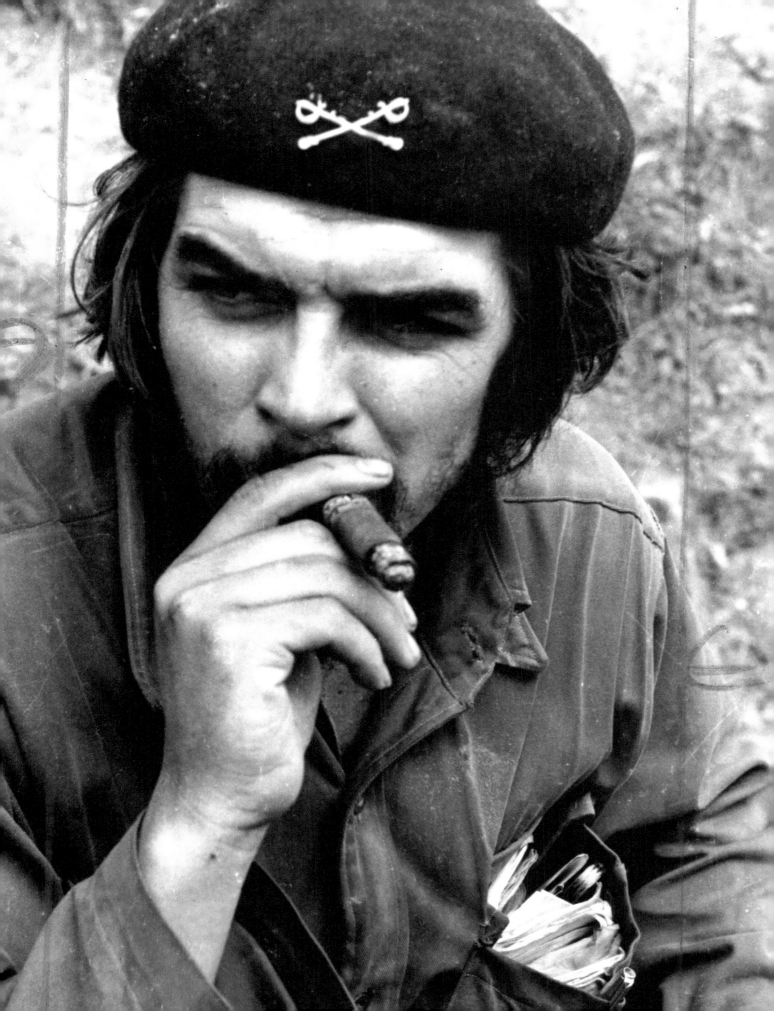

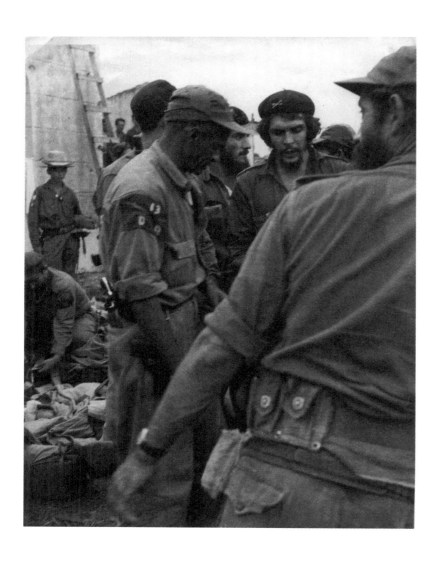

Che in Fomento, near
Cabaiguán, the first town
liberated during the campaign
in Las Villas, 1958

Noro Enomoto Sekura, Orlando
Pantoja Tamayo, and Che
in Fomento, 1958

With Victor Bordón Machado
in Fomento, 1958

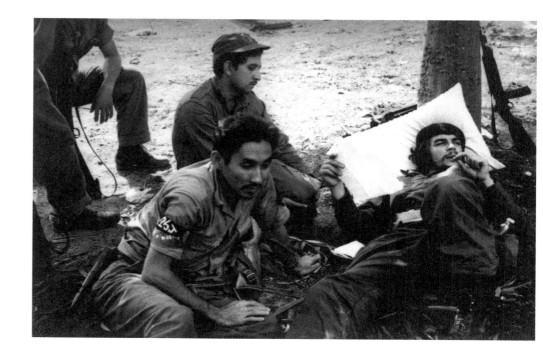

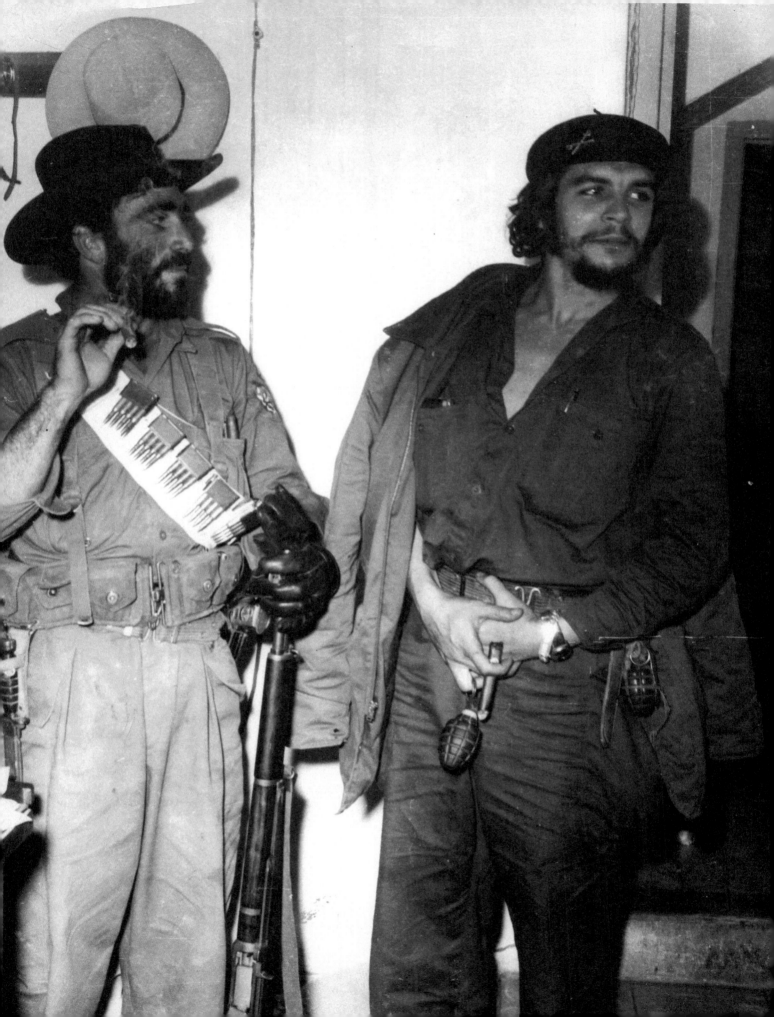

The guerrilla [...] is the pre-eminent freedom fighter, elected by the people, the fighting vanguard of the of the people in its struggle for freedom. Because guerrilla warfare is not, as one might think, a small war, the war of a minority group against a powerful army; no, guerrilla warfare is the struggle of all the people against the dominant oppression. The guerrilla is its armed vanguard, the army is made up of all the inhabitants of a country. This explains its strength and sooner or later its triumph against any power that attempts to oppress it...

Ernesto Che Guevara,
"A Revolution Begins", in *Revolución*,
4 December 1959

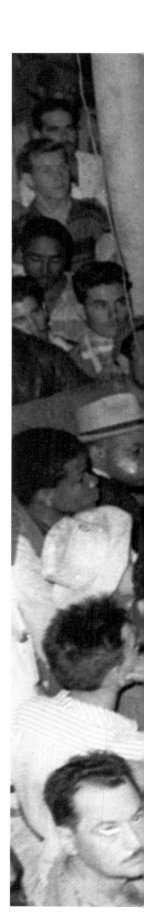

Che making a speech to the
people in Fomento, 1958

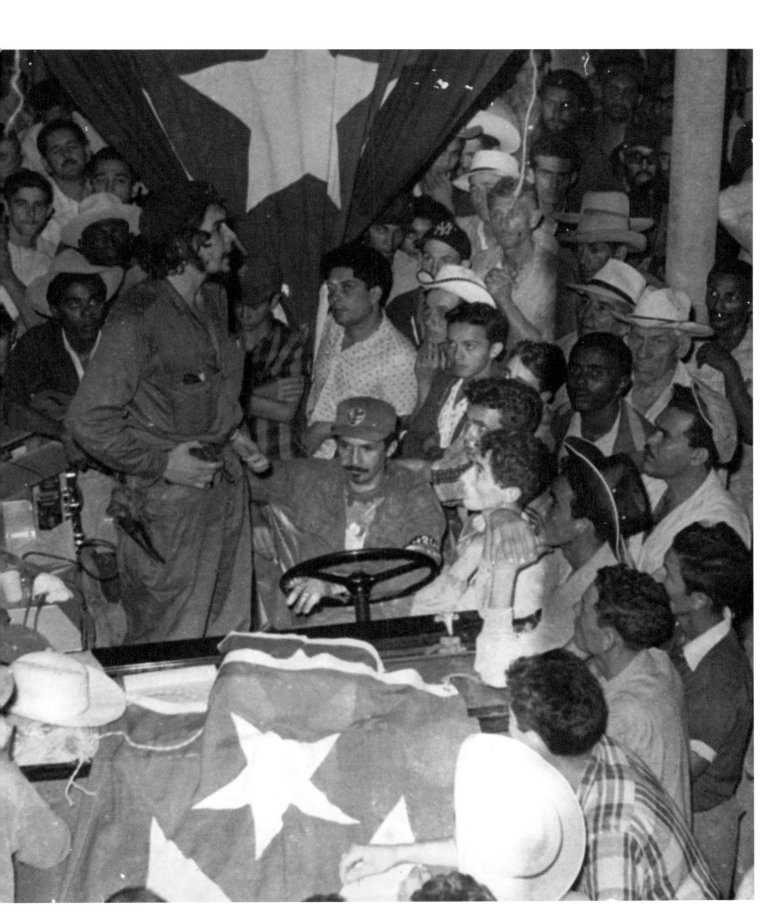

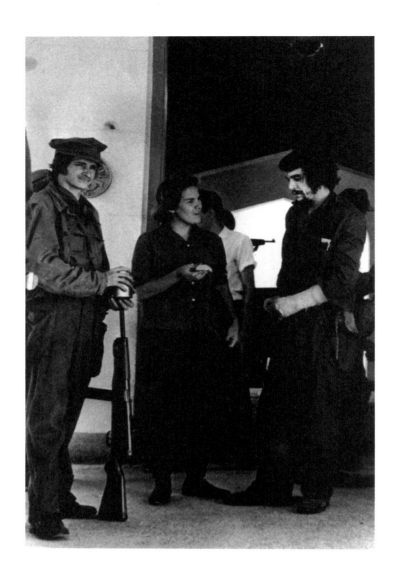

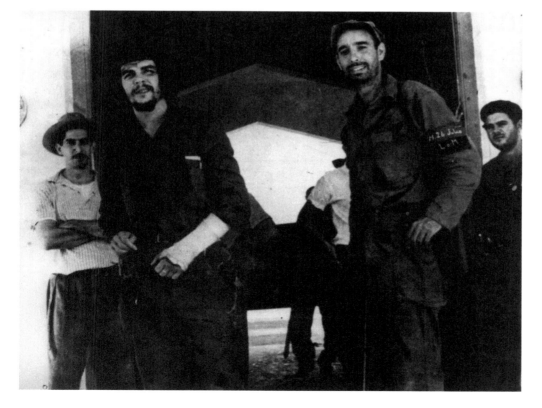

Che and Aleida March, his
future wife, during the taking
of Remedios, 1958

In Remedios, 1958

Pages 83-84
Che in Placetas, after being
wounded during the taking of
the town of Cabaiguán, 1958

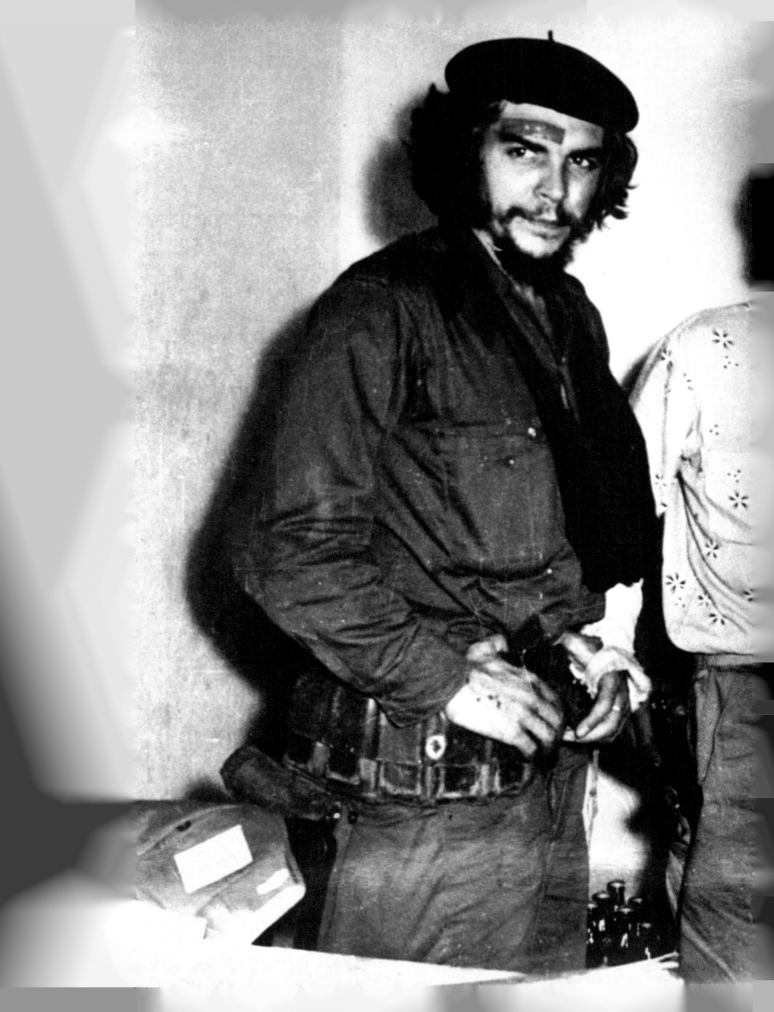

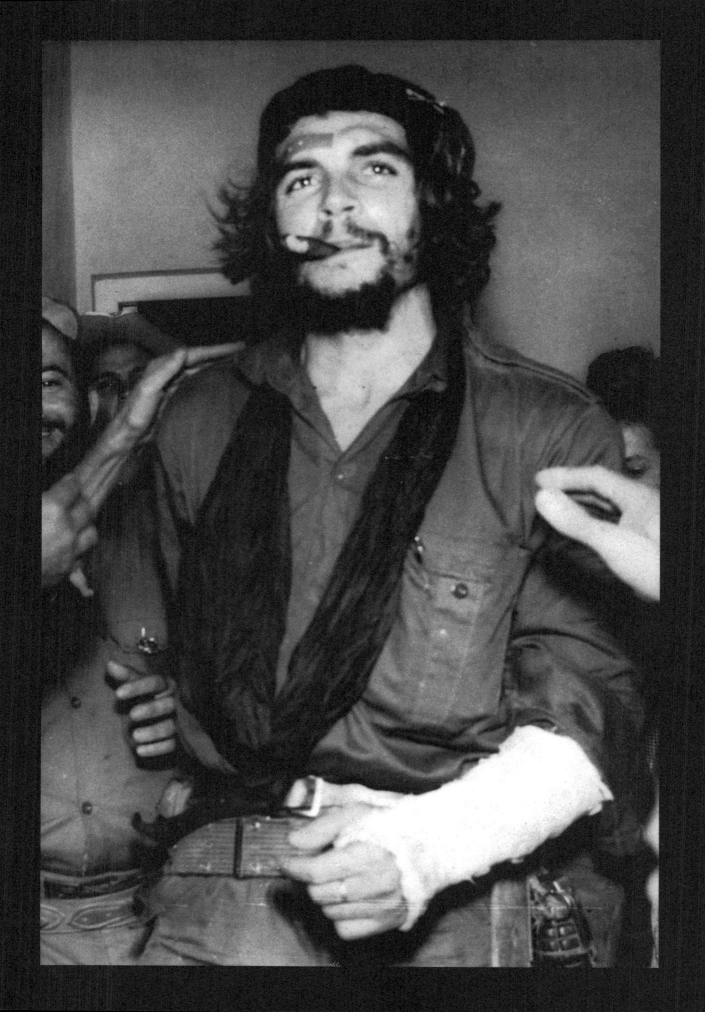

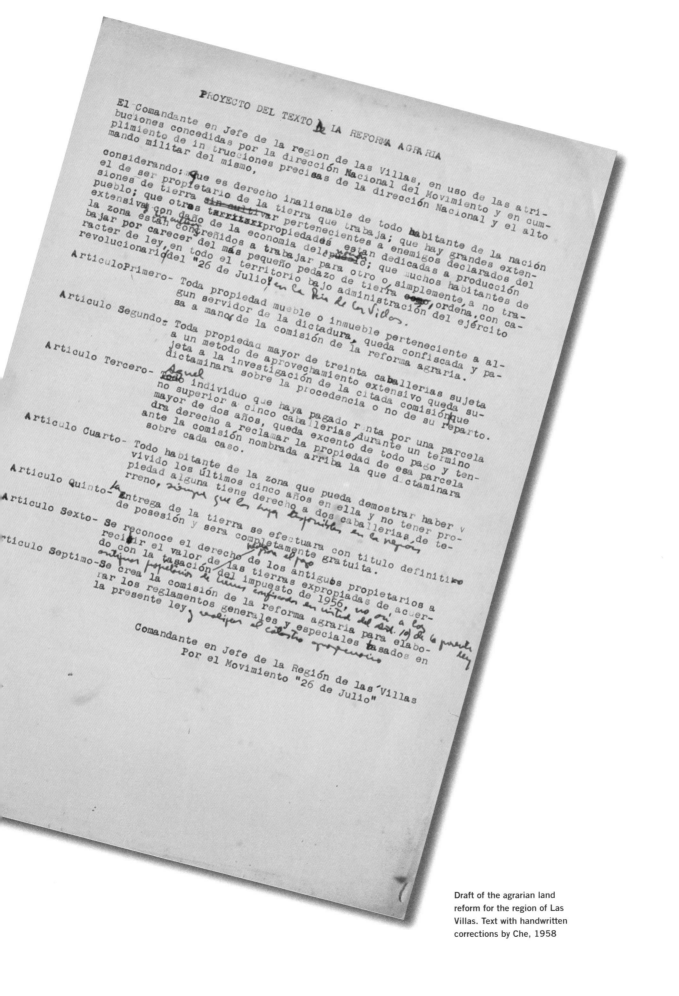

Draft of the agrarian land reform for the region of Las Villas. Text with handwritten corrections by Che, 1958

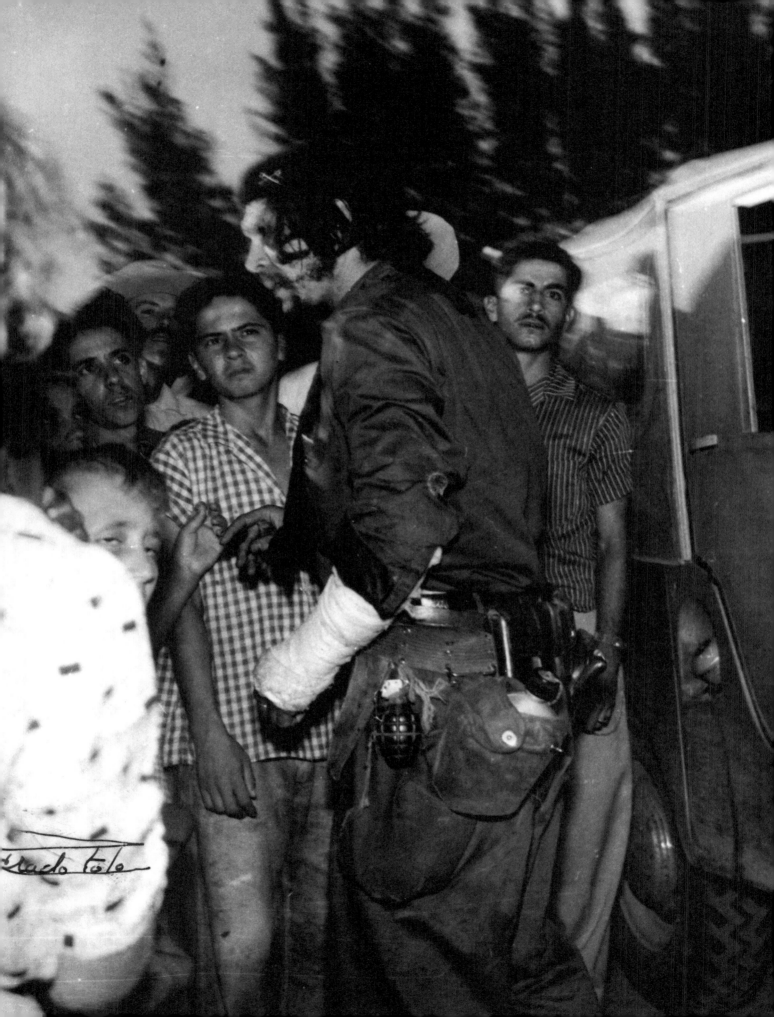

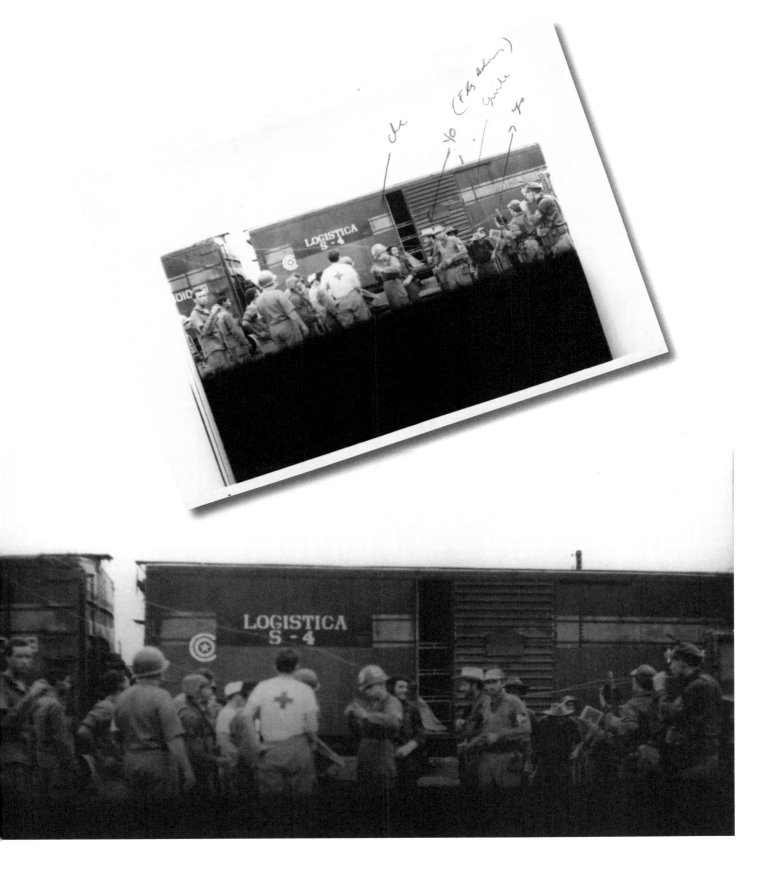

In Santa Clara, 1958

Capture of the armoured
train transporting weapons
of Fulgencio Batista's army

Above
Picture with notes
by Aleida March, Santa Clara,
30 December 1958

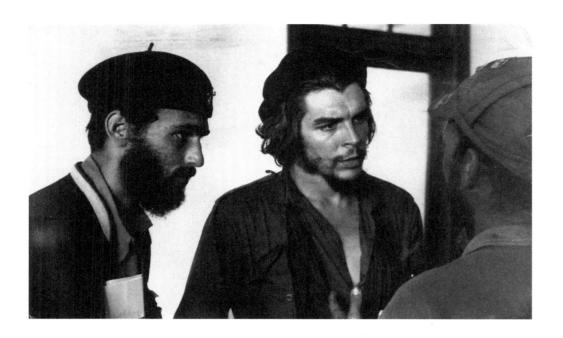

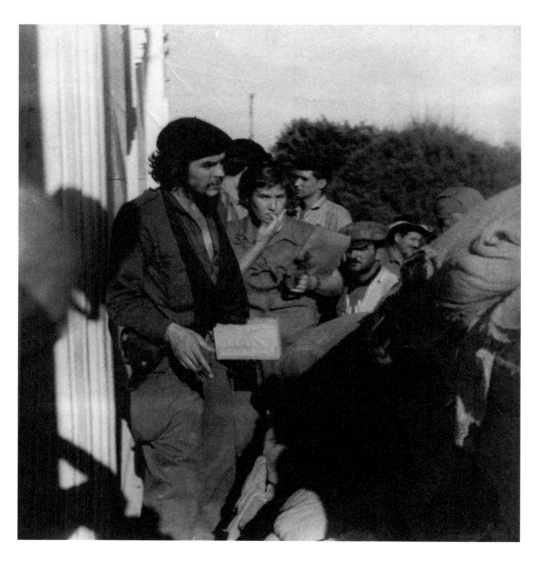

With the combatant René Rodriguez, 1958

With Aleida March in Santa Clara while checking the weapons taken from Batista's army, 1958

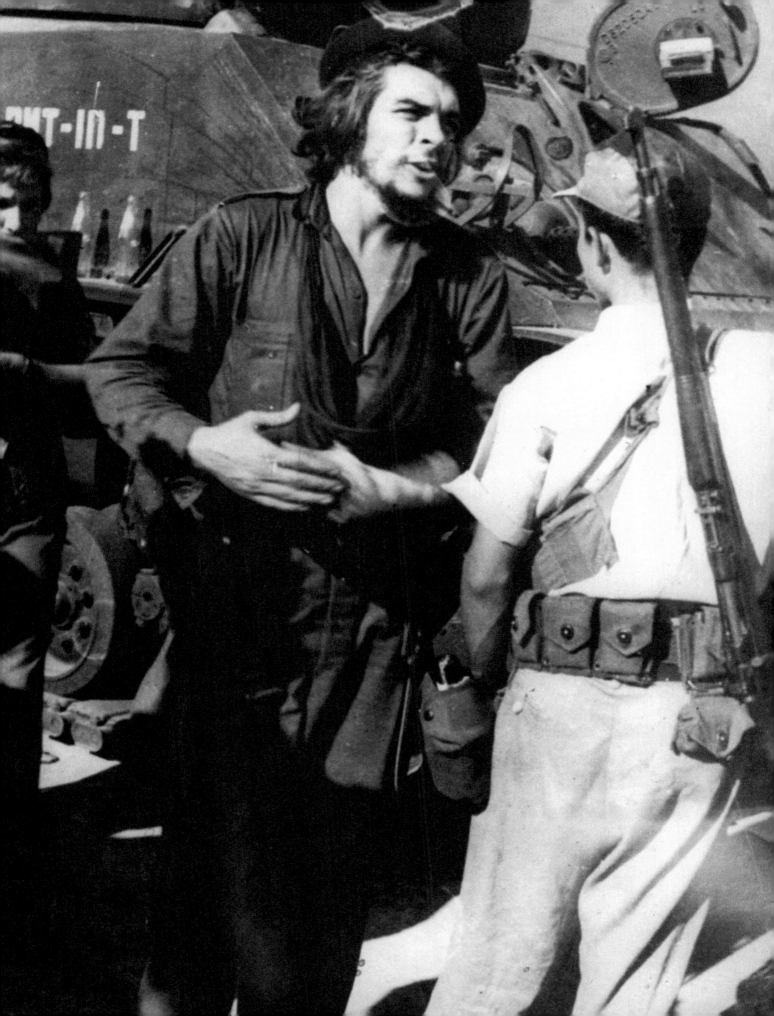

We went on the air to announce that Santa Clara was almost in the hands of the revolution [...].

The police station fell next [...] and in rapid succession number 31 garrison surrendered [...] the jail, the courthouse, the provincial government palace, and the Grand Hotel, where snipers on the 10th floor had kept up fire almost until the end of combat. [...] The results that followed are known to everyone: [...] the order to march on the city of Havana, [...] the seizure of camp Columbia by Camilo Cienfuegos and of La Cabaña fortress by our Column 8; and the final installation, within a few days, of Fidel Castro as Prime Minister of the provisional government. All this belongs to the country's present political history.

Ernesto Che Guevara,
"A Revolution Begins", in *Revolución*,
4 December 1959

The days of Victory,
Santa Clara, 1958

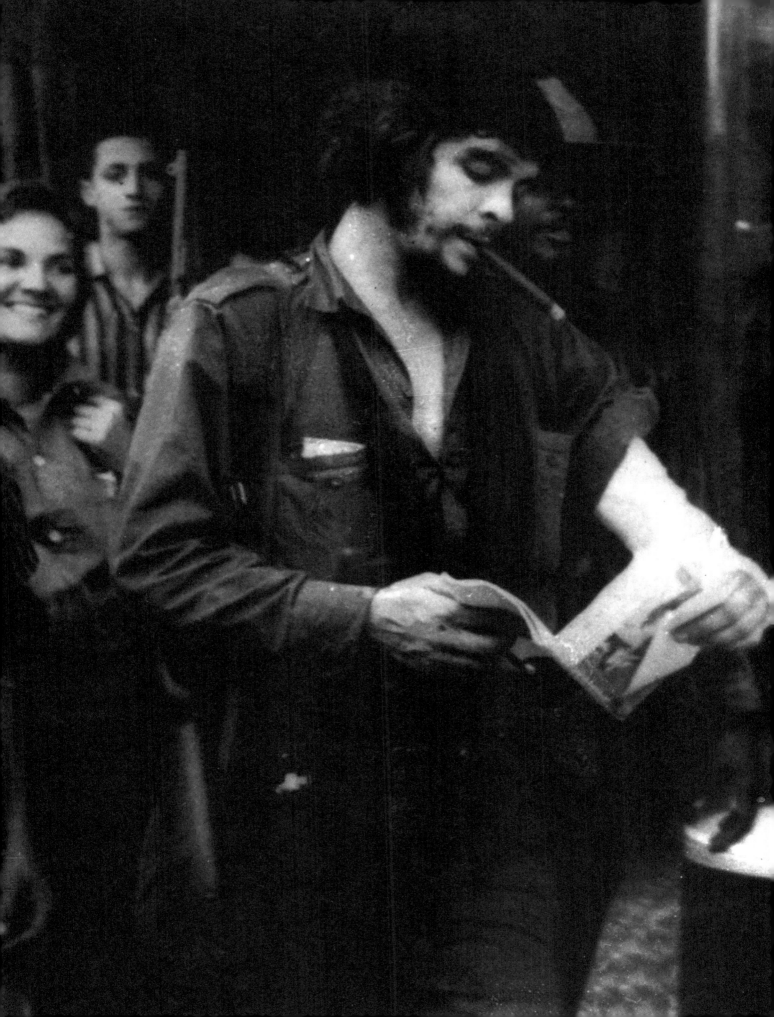

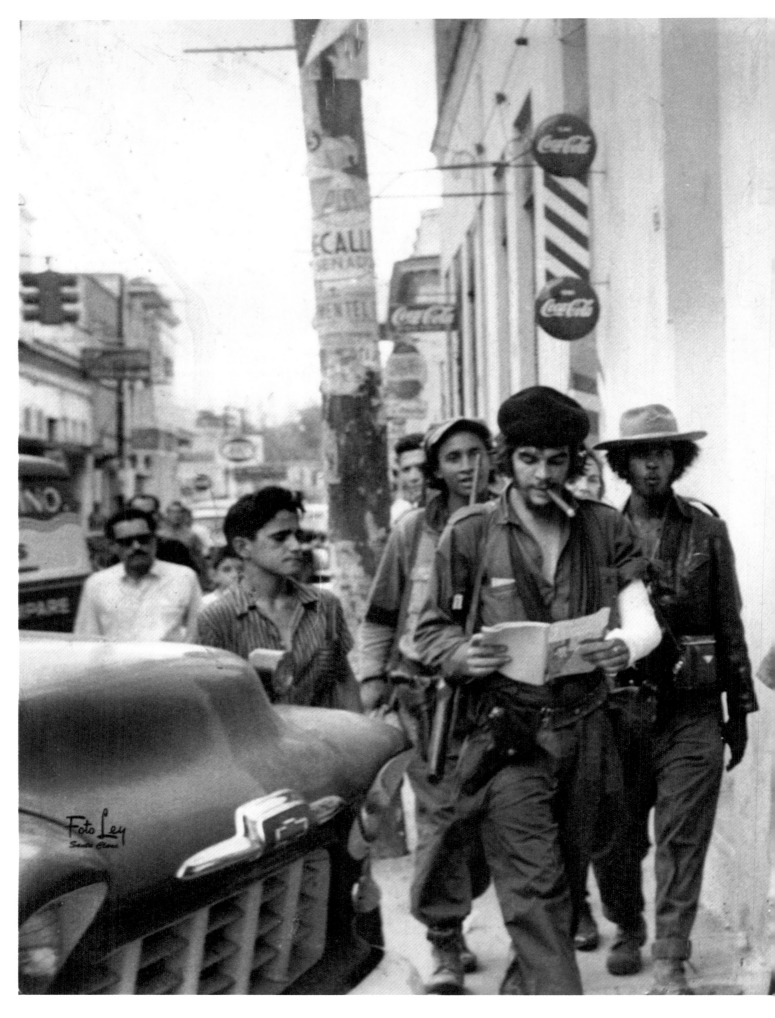

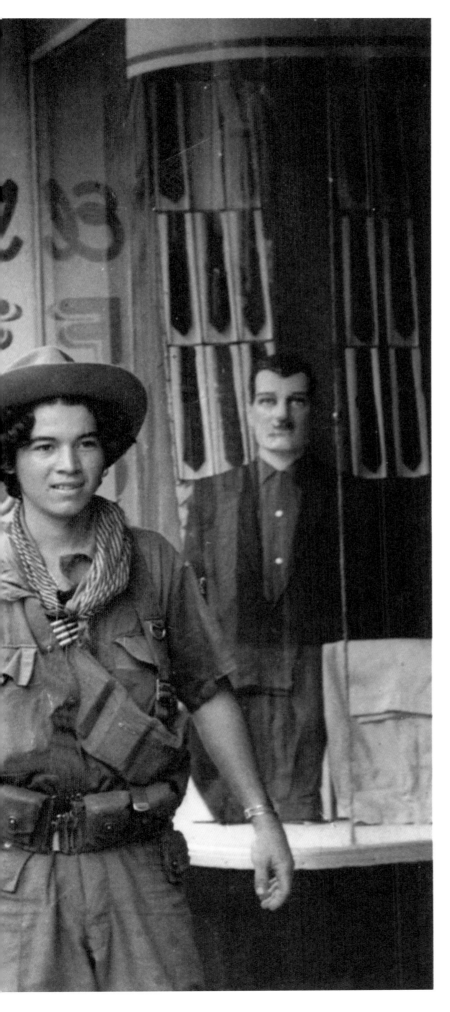

Che in Santa Clara after
the taking of the city, 1958

1959-1965

"Fabricador de esperanzas"

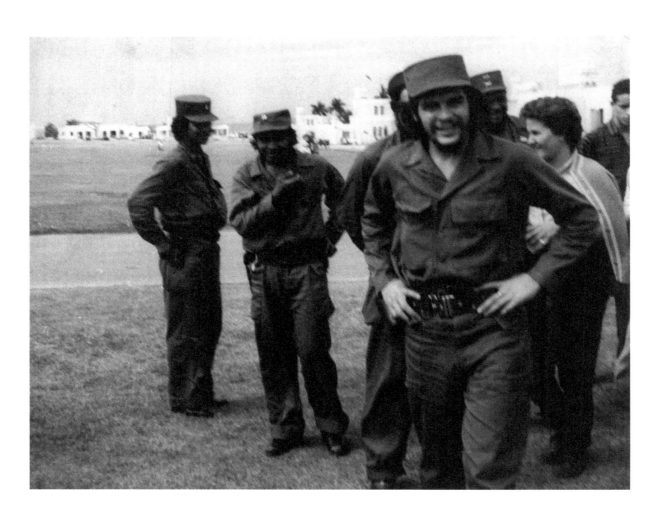

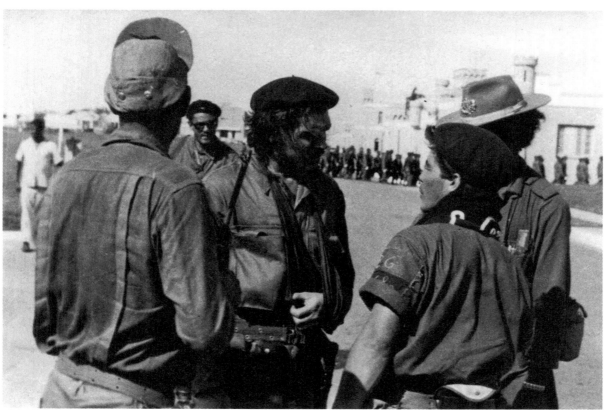

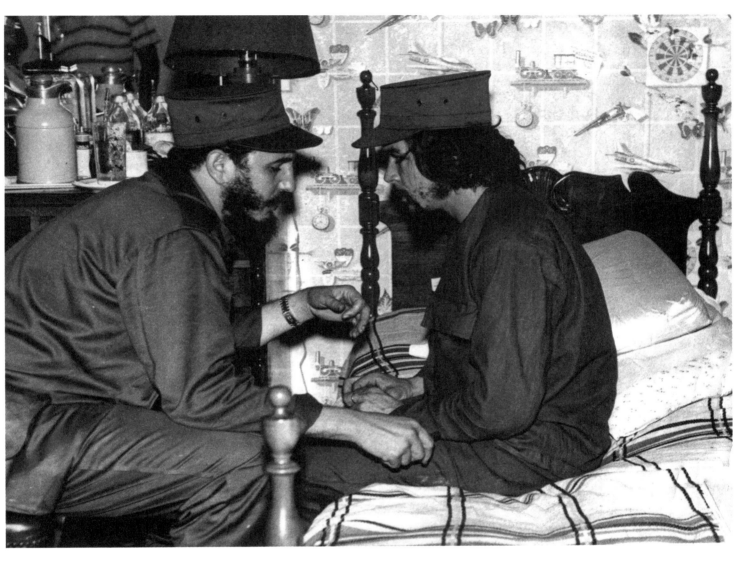

1 January 1959. Triumph of the Cuban
Revolution. Fulgencio Batista y Zaldívar flees
from Cuba. In a declaration transmitted on Radio
Rebelde, Fidel Castro proclaims a general strike
and disowns the military junta supported by the
United States, which tries to maintain power in
Cuba.

The guerrillas Hermes Peña
Torres, José Argudin, Guevara,
Rodríguez de la Vega, Pablo
Rivalta, and Aleida March in
the Fort of La Cabaña, 1959

With and a group of guerrillas
in La Cabaña, 1959

Speaking with Fidel
Castro following the victory
in La Cabaña, 1959

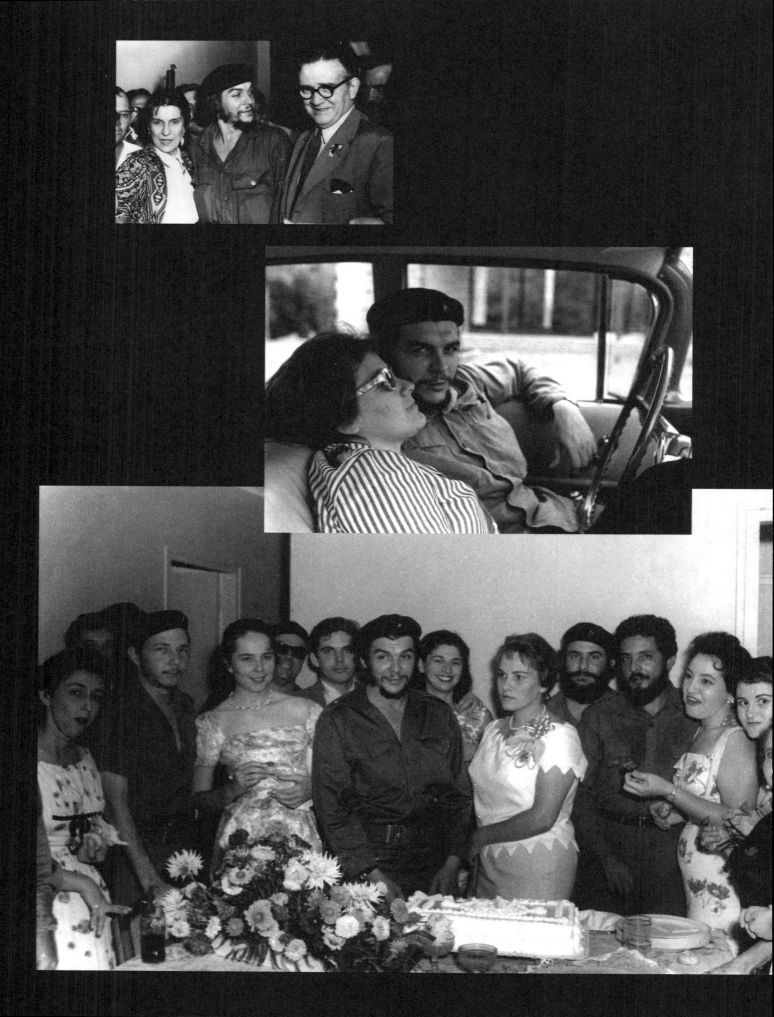

Tuesday 2 June:
¡¡ Wedding !!

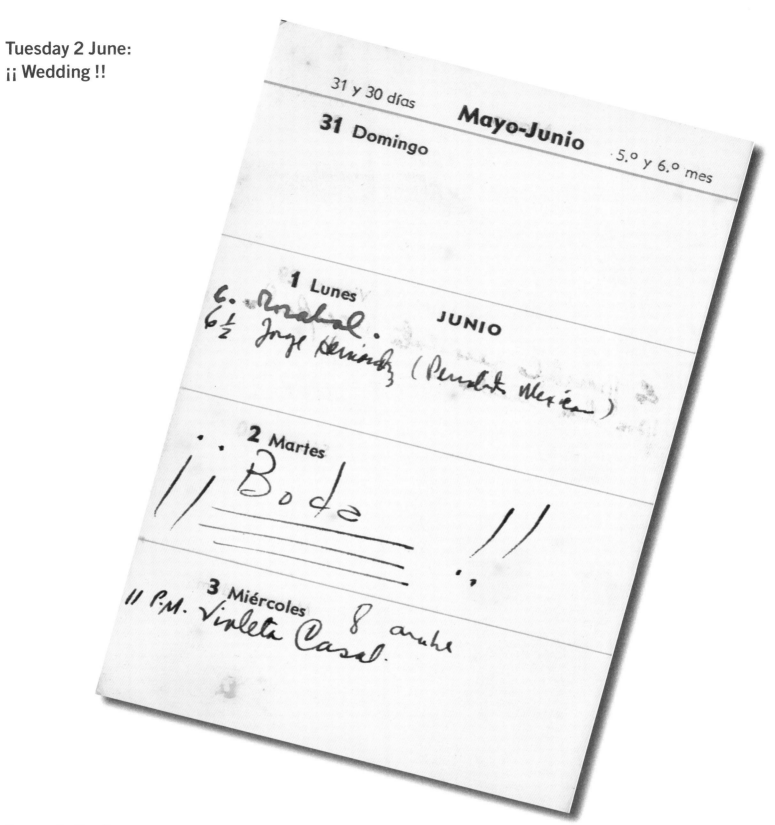

31 y 30 días

Mayo-Junio

.5.º y 6.º mes

31 Domingo

1 Lunes

JUNIO

6. _Moraleda._
6½ _Jorge Hernández (Periodista Mexicano)_

2 Martes

¡¡ Boda !!
8 noche

3 Miércoles

11 P.M. Violeta Casal.

Guevara meeting his mother
and his father for the first time
after having been away for six
years, Havana, 1959

With Aleida March, 1959

Che Guevara and Aleida
March's wedding, Havana,
2 June 1959

Our spirit of brotherhood can challenge the immensity of the sea. [...] Beards, long hair, olive-green uniforms [...] these men [...] are America, the new America, which shakes its limbs, sleepy from having spent too much time on their knees.

Ernesto Che Guevara,
"America from the Afro-Asian Balcony",
in *Humanismo*

17 May 1959. Fidel Castro announces
the passage of the Agrarian Reform Law that
regulates the expropriation and redistribution
of the land. The North American properties
are confiscated, triggering the reaction
of the President of the United States Dwight
Eisenhower, who approves a plan to destabilise
the Cuban government.

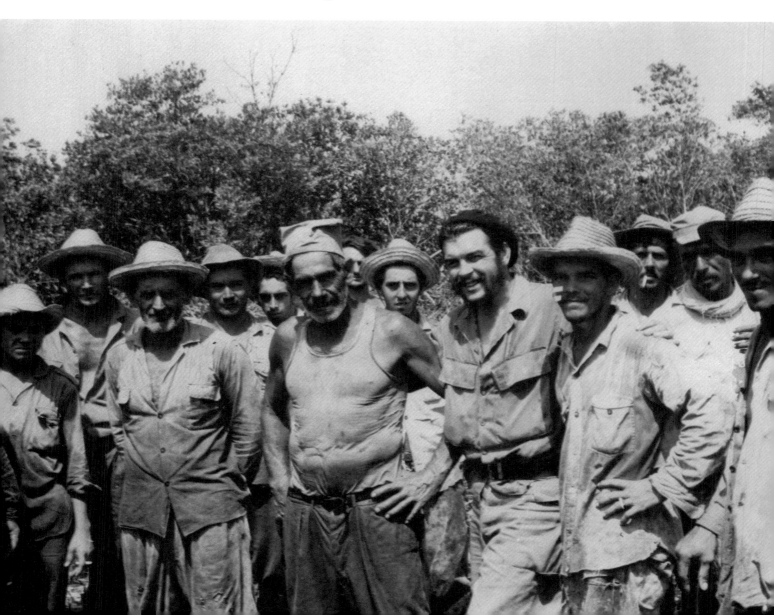

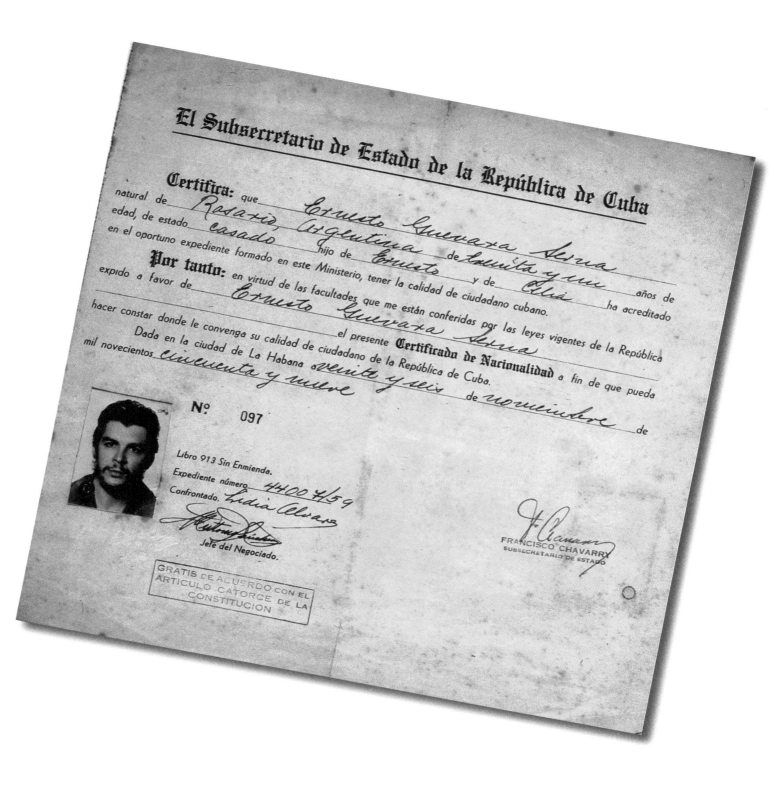

El **Subsecretario de Estado de la República de Cuba**

Certifica: que _Ernesto Guevara Serna_

natural de _Rosario, Argentina_ de _treinta y un_ años de

edad, de estado _casado_ hijo de _Ernesto_ y de _Celia_ ha acreditado

en el oportuno expediente formado en este Ministerio, tener la calidad de ciudadano cubano.

Por tanto: en virtud de las facultades que me están conferidas por las leyes vigentes de la República

expido a favor de _Ernesto Guevara Serna_ el presente **Certificado de Nacionalidad** a fin de que pueda

hacer constar donde le convenga su calidad de ciudadano de la República de Cuba.

Dada en la ciudad de La Habana _veinte y seis_ de _noviembre_ de

mil novecientos _cincuenta y nueve_

N.° 097

Libro 913 Sin Enmienda.

Expediente número _44004/59_

Confrontado. _Lidia Alvarez_

Jefe del Negociado.

FRANCISCO CHAVARRY
SUBSECRETARIO DE ESTADO

GRATIS DE ACUERDO CON EL
ARTICULO CATORCE DE LA
CONSTITUCION

With some peasants in Sierra
Maestra, 1959

Document of Cuban citizenship
awarded to Ernesto Guevara,
1959

Ernesto Guevara, *The Great Sphinx*, 1959

Che meeting the President of Egypt Gamal Abdel el-Nasser during his journey to the countries involved in the Bandung Conference, 1959

9 June 1959. Guevara is at the helm of a delegation of the Cuban government in its first mission abroad. The aim is to visit the countries of the Bandung Conference, the forerunner to the Non-Aligned Movement, to illustrate the objectives of the revolution and to establish new economic relations. At the age of 31, Che leaves Havana for 87 days and visits 12 countries.

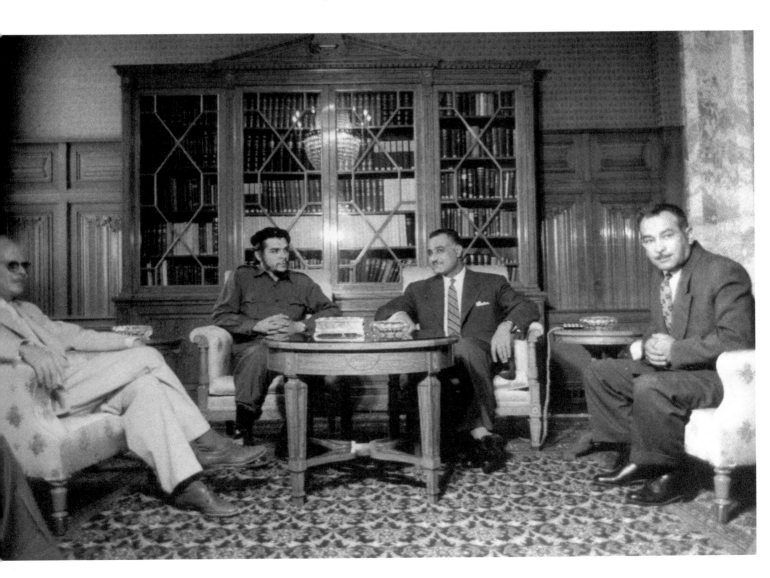

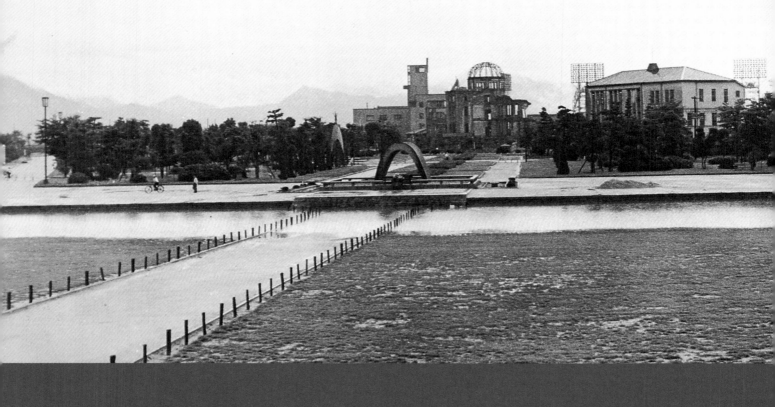

Ernesto Guevara, *Hiroshima
Peace Memorial*, 1959

Postcard sent to his wife Aleida
from Hiroshima, Japan, 1959

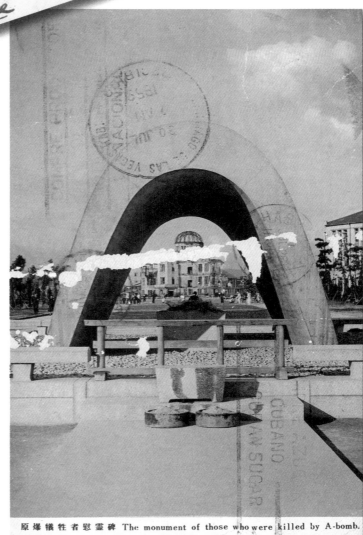

原爆犠牲者慰霊碑 The monument of those who were killed by A-bomb.

My darling:

Today I'm going to Hiroshima, the city where the bomb was dropped. On the monument you see, more than 78,000 names of those who died; the total number is estimated to be 180,000. It is good to visit this place so we can fight for peace with more energy.

Hug, Che

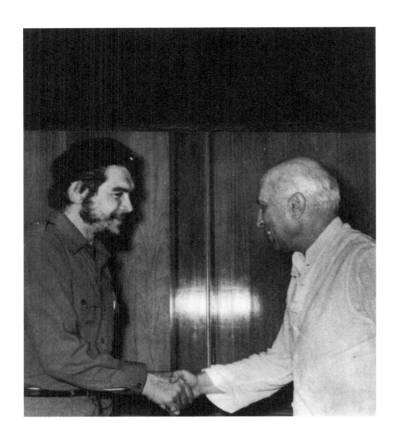

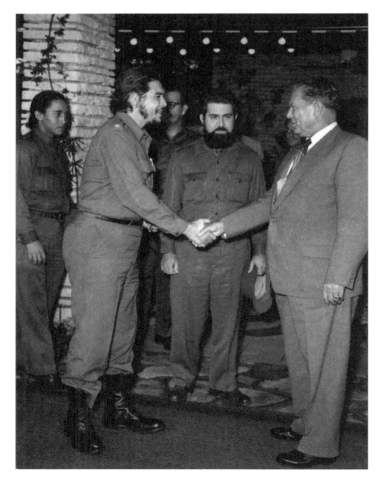

Che meeting the Prime
Minister of India Jawaharlal
Nehru, 1959

Che meeting the President
of Yugoslavia Josip Broz Tito,
1959

Che's election as President
of the Banco Nacional de
Cuba, 1959

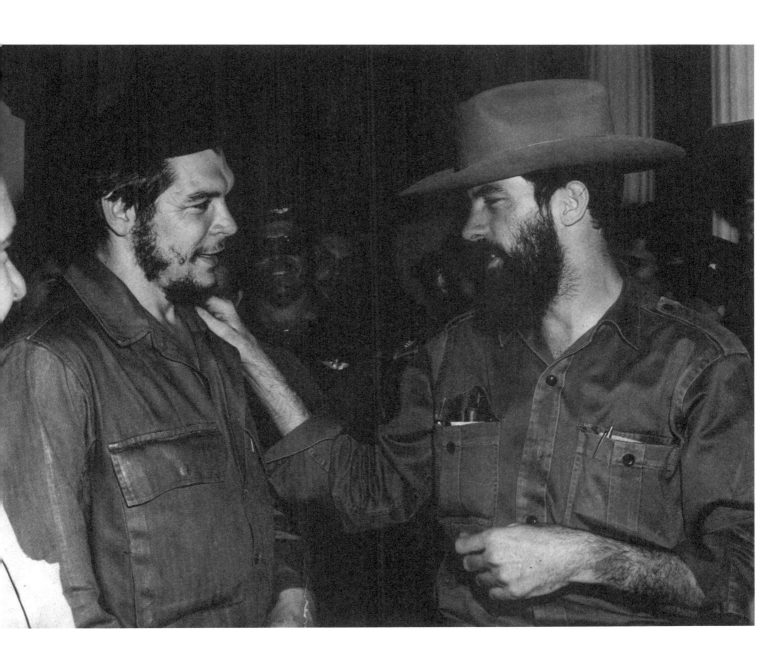

Che meeting his friend Camilo
Cienfuegos, a protagonist
of the Cuban Revolution dead
in a plane accident, 1959

First as a student and later as a doctor, I came into close contact with poverty, hunger, and disease. [...] I became aware, then, of a fundamental fact: to be a revolutionary doctor or to be a revolutionary at all, there must first be a revolution.

[...] We understood perfectly that the life of a single human being is worth a million times more than all the property of the richest man on earth.

Ernesto Che Guevara,
speech to the Havana Ministry of Health,
18 August 1960

Alberto Korda, *Che meeting
Simone de Beauvoir and
Jean-Paul Sartre*, Havana,
1960

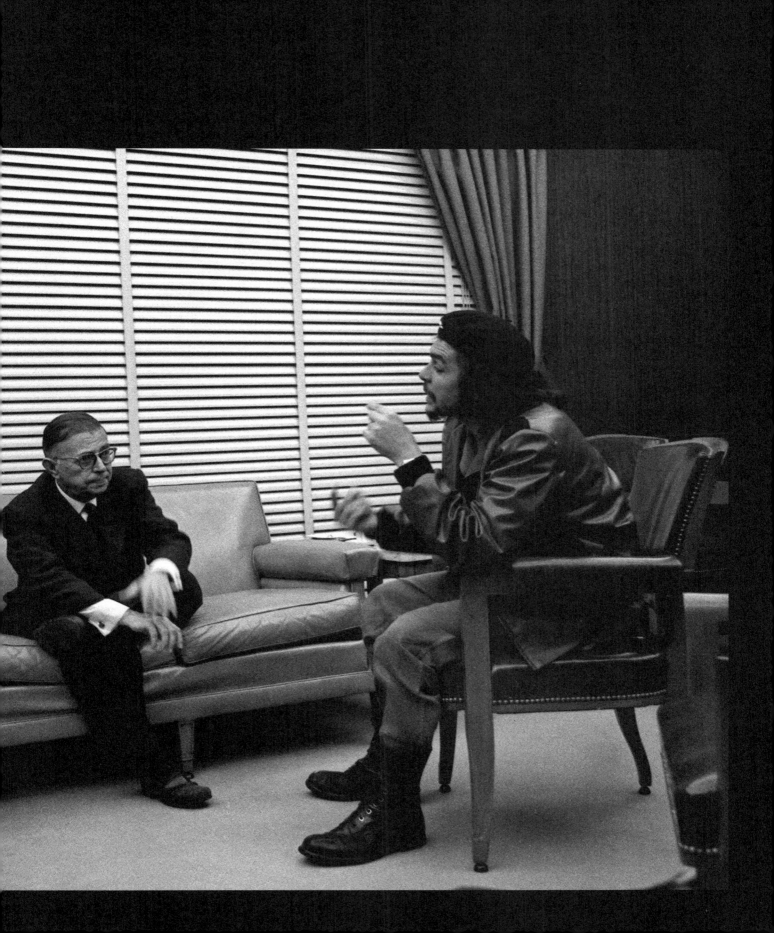

4 March 1960. A sabotage results in the
explosion of the French freighter La Coubre
loaded with munitions in the harbour of Havana,
causing 101 deaths and more than 400 injured
people. Cuba accuses the CIA to have put
explosive material in between the boxes
of grenades.

Che visiting the harbour
of Havana right after the
explosion of the French
freighter La Coubre, 1960

Alberto Korda, *Che during the
funerals of the victims of the
explosion of La Coubre*, 1960.
This portrait has become the
symbol of the "heroic guerrilla"
as well as the icon of an epoch

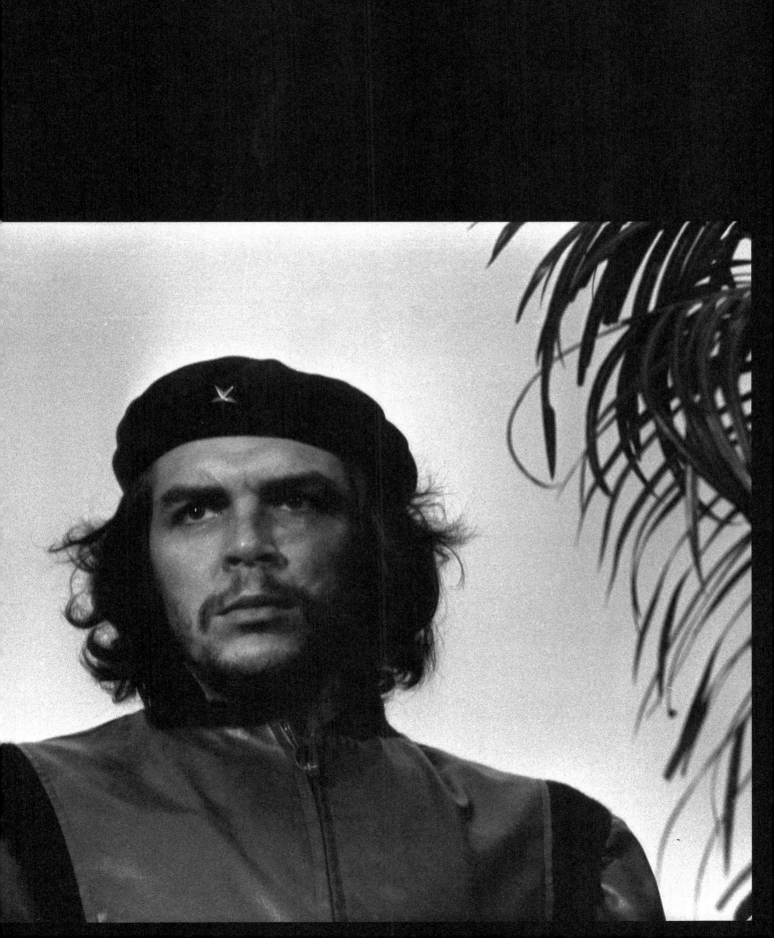

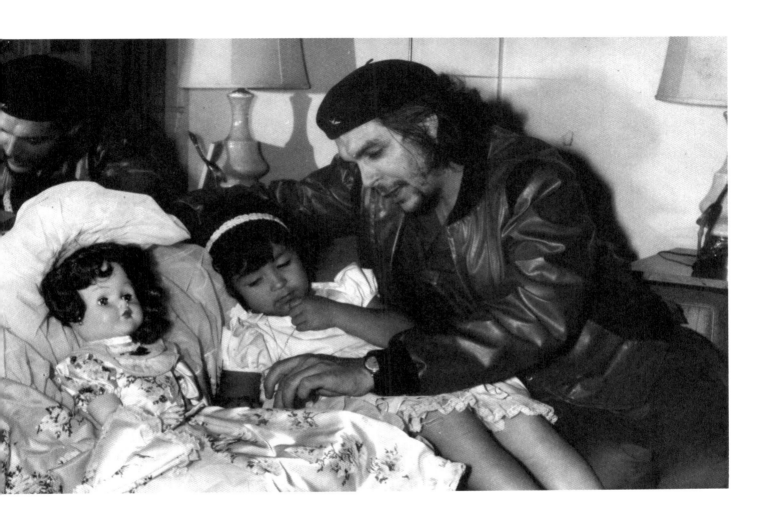

Ernesto Guevara, *Aleida Guevara March*, 1960. First daughter of Ernesto and Aleida

Che with his daughter Hildita on her birthday, 15 February 1960. Firstborn of Ernesto and Hilda Gadea

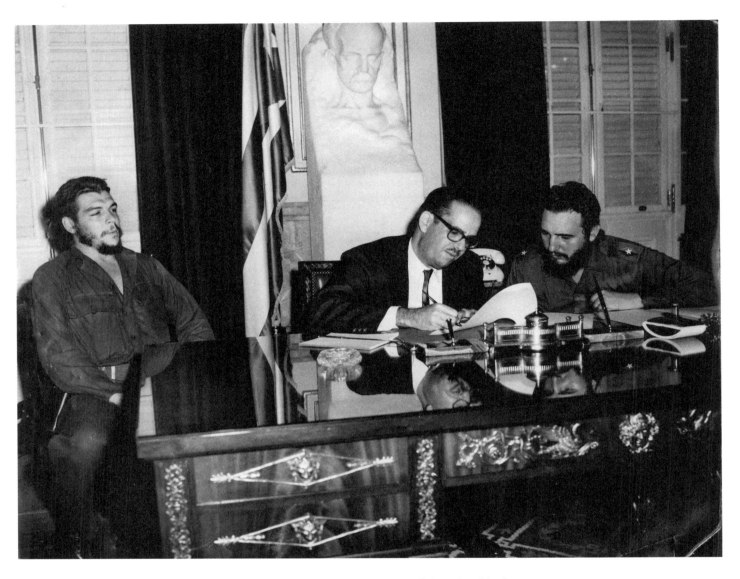

A presidential decree establishes that Che is at the helm of the economic mission in the socialist countries. At his return, following the flattering results obtained, he declares: *The Cuban delegation returns triumphant,* [...] *with the commitment of the Soviet Union and the socialist countries to purchase 4 million tons (of sugar) at 4 cents (Cuban Pesos) per pound* [...].

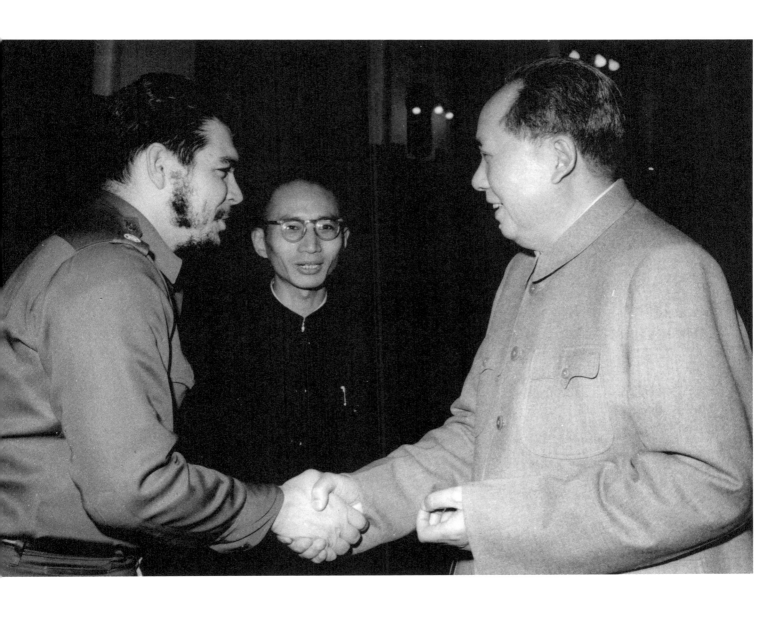

Ernesto Guevara is named
Representative of Cuba for
the economic mission in the
socialist countries, Havana,
1960

Che meeting the President
of China Mao Tse-Tung,
Beijing, 1960

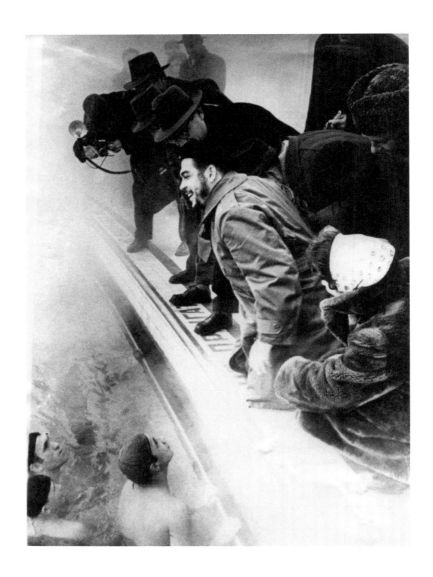

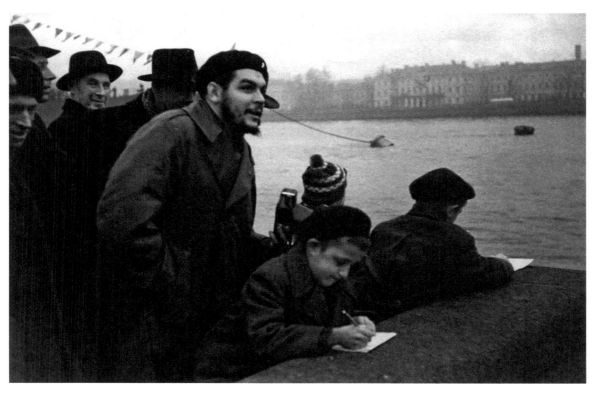

Walking by the river Moskva,
Moscow, 1960

Che Guevara, from behind,
during a speech to Cuban
doctors, Havana, 1960

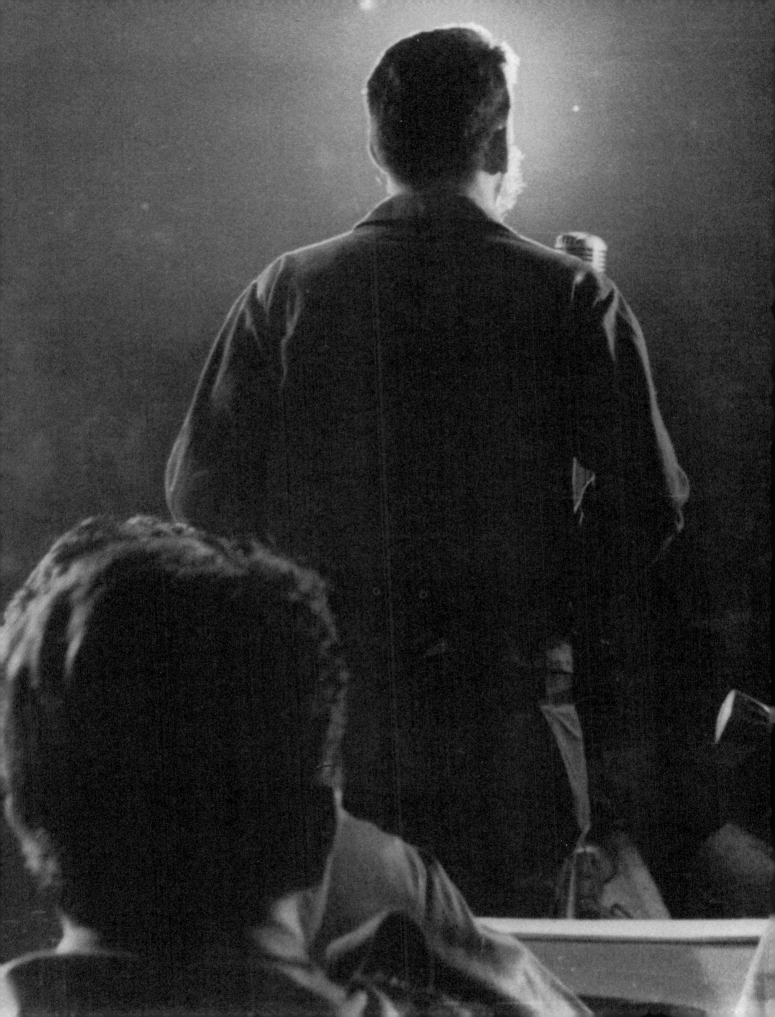

Why do we insist so much on volunteer work? What's important is that a part of the life of an individual be entrusted to society with no expectations, without any kind of retribution, and only as the fulfillment of his or her duty to society. This will lead to the realization of a higher model of humanity and [work] will be transformed into a social need.

Ernesto Che Guevara,
speech delivered on the occasion
of the volunteer work day in Havana

Che Guevara building
a school in Havana during
a day of volunteer work, 1961

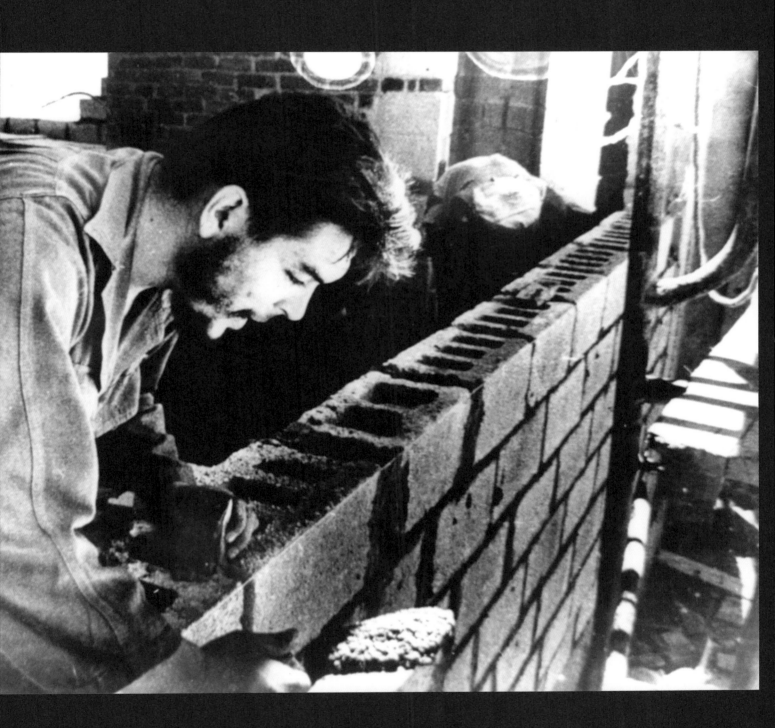

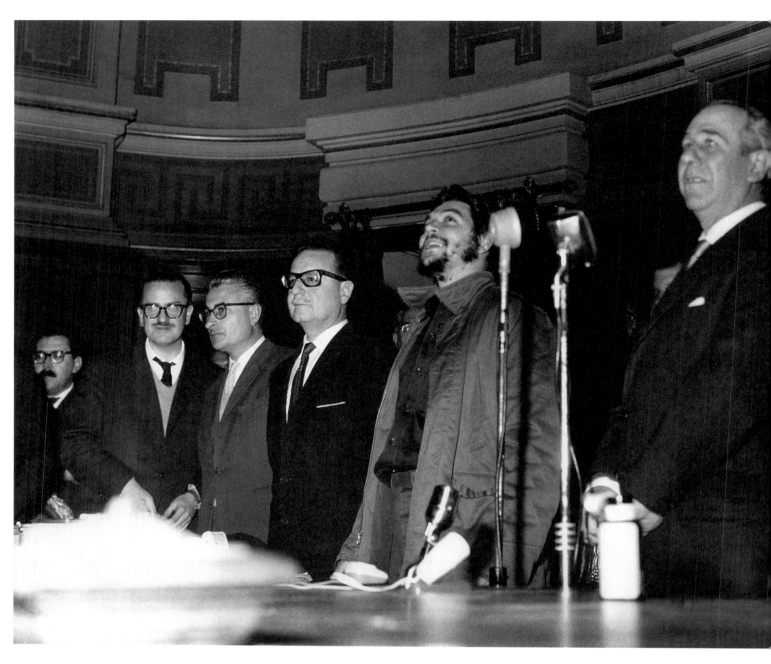

An economic conference of the countries of the Organisation of the American States is held in Punta del Este, Uruguay, with the ostensible purpose of giving a shape to a regional project called Alliance for Progress. Promoted by the United States, it is according to Guevara an attempt to stifle the Cuban Revolution. For this reason indeed, Cuba does not sign the final document.

Che with Salvador Allende during a speech at the University of Montevideo after the conference at Punta del Este, 1961

Guevara meeting the President of Uruguay Eduardo Víctor Haedo during a conference at Punta del Este, Uruguay, 1961

Ernesto Guevara is named Minister of Industries. His plan is to create a national industry to overcome the sugarcane cultivation, Havana, 23 February 1961

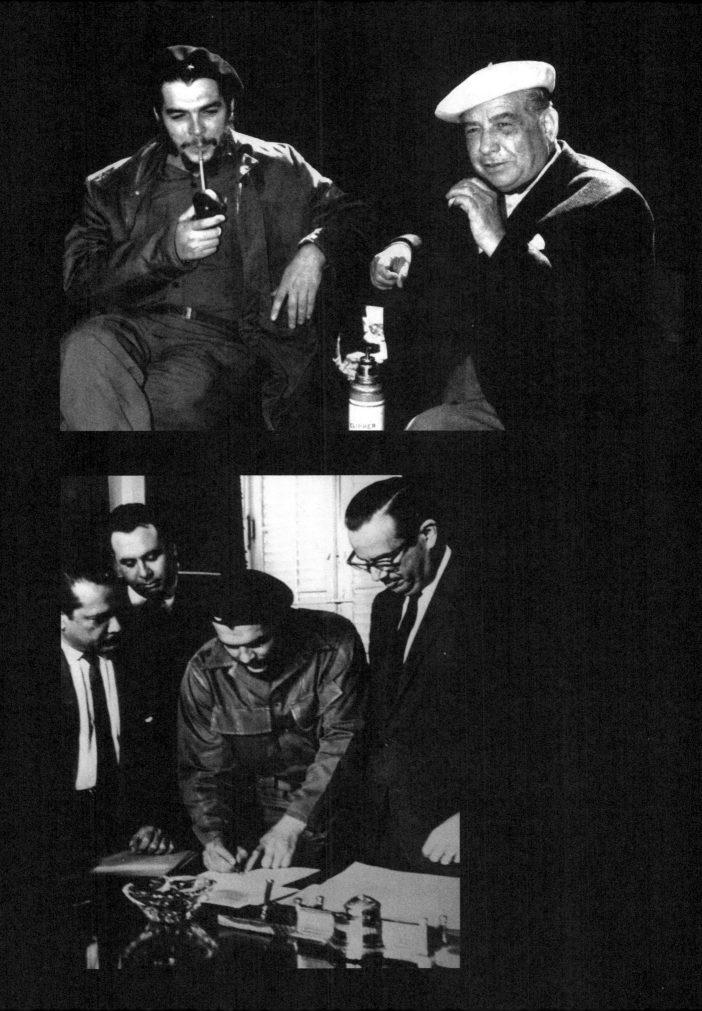

Ernesto Guevara, *Building a factory*, Cuba, 1961

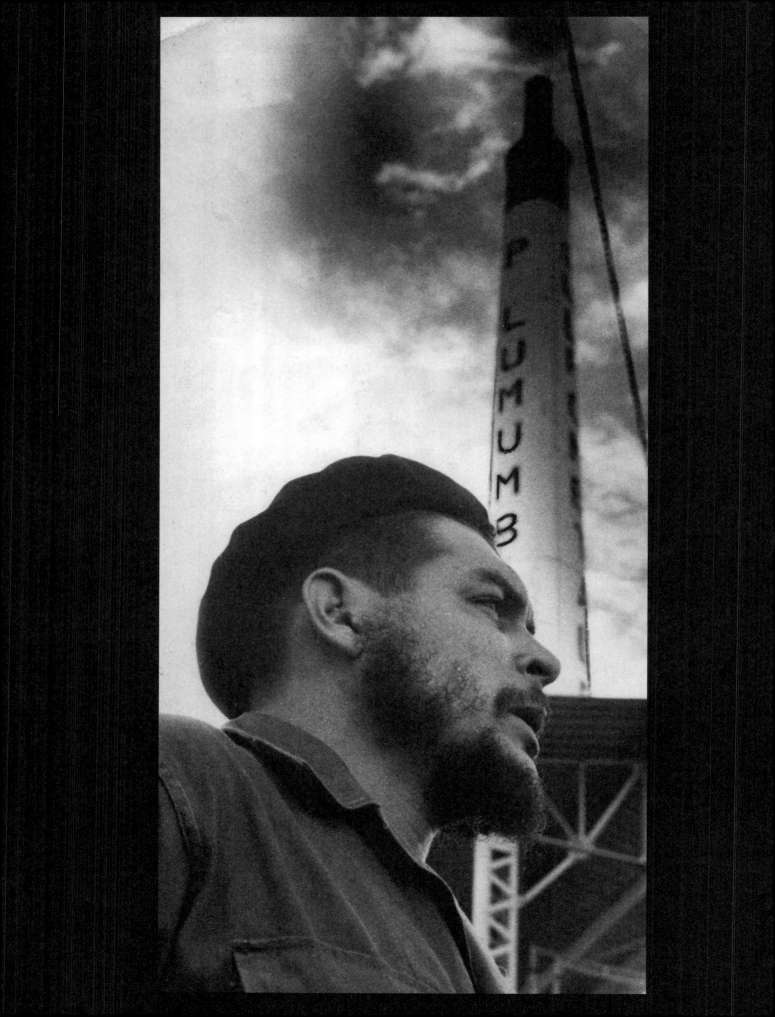

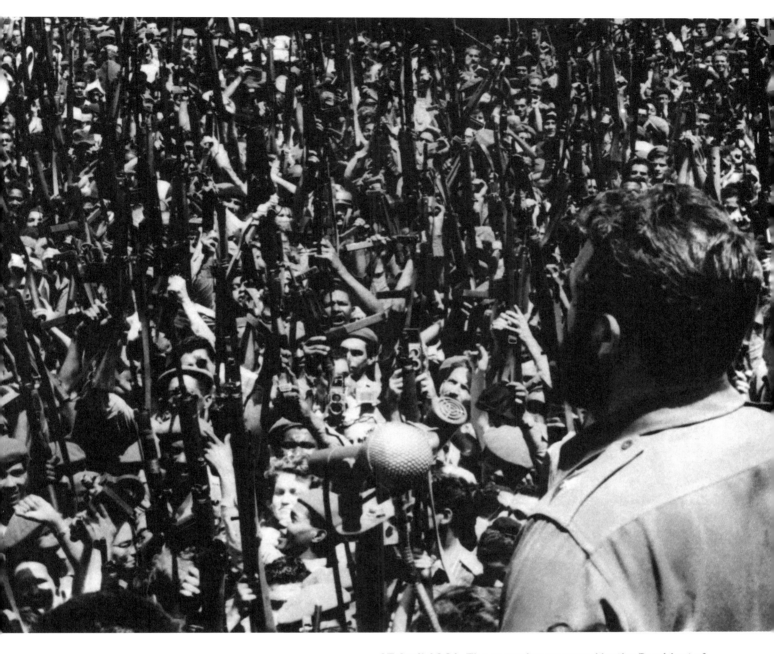

17 April 1961. The operation approved by the President of United States John Fitzgerald Kennedy begins: mercenary troops of Cuban exiles trained by the CIA in Guatemala land on the shore called Bay of Pigs. During the invasion, Che is in the province of Pinar del Río as military chief of the Western Region, where the General Staff operates. The invaders are defeated in 72 hours and the attempt turns out to be a failure: around 1,189 counter-revolutionaries are imprisoned and taken to trial.

Opening of the industrial plant dedicated to Patrice Lumumba, first Prime Minister of the Congo assassinated in January, Cuba, 1961

Fidel Castro speaking to the Cuban people on the day before the American invasion to the Bay of Pigs, Havana, 16 April 1961

For our Revolution does not just have outside enemies. [...] Each time one of you [...] thinks he is in pain, that that day he should stay home, that his work isn't important, that one extra day won't make a difference, that he's earning enough now; each time that one of you smokes a cigarette, forgetting your obligations to your work shift [...] each time you allow yourself to be overcome by the division, the intrigue, the calumny of the rogue, you will be defeated by your enemy and our Country will lose a battle against him.

Ernesto Che Guevara,
speech delivered at the opening
of the Sulfometales Patrice Lumumba plant,
29 October 1961

Che Guevara during a day
of volunteer work in a textile
factory, Cuba, 1962

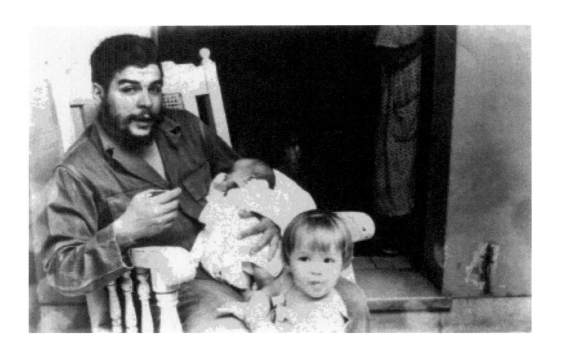

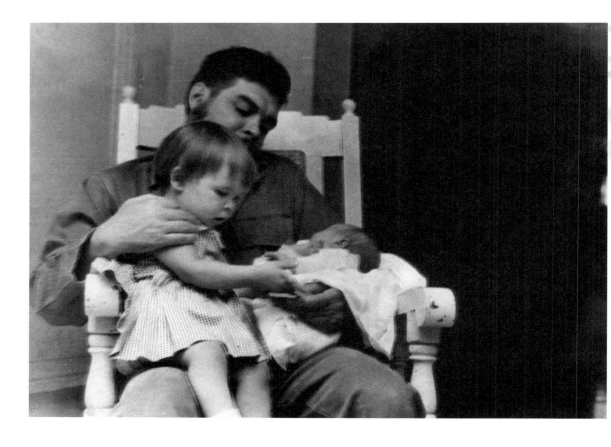

With Aleida and Camilo,
his second child born
on 20 May, Havana, 1962

During his first speech to
Cuban youth, Havana, 1962

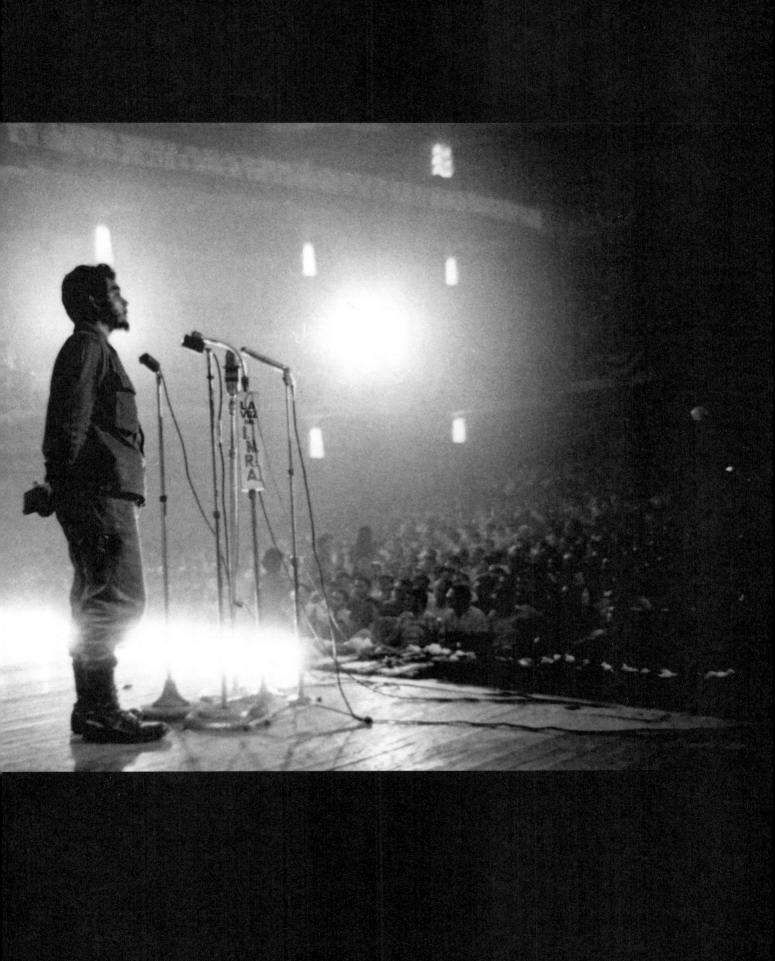

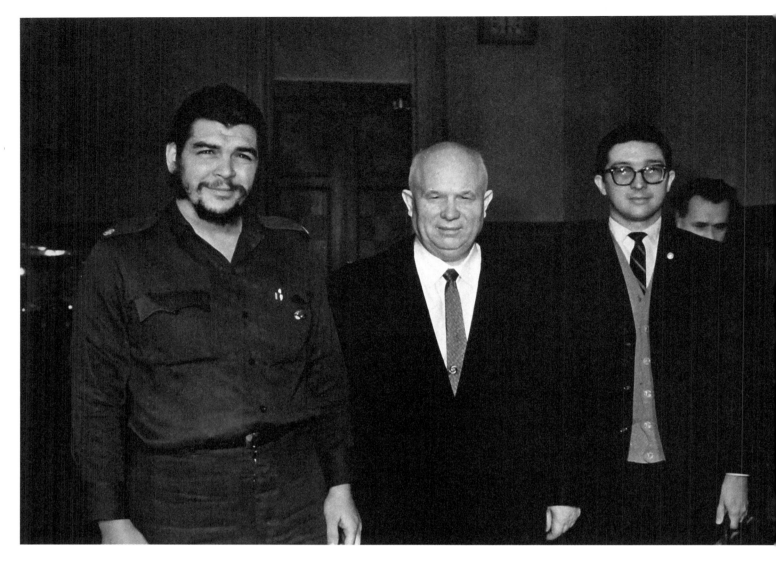

1962. Guevara arrives in Moscow where he meets Nikita Sergeyevich Khrushchev. New agreements for the economic collaboration between Cuba and the Soviet Union are signed. On that occasion, the installation of mid-range missiles on Cuban territory is decided too, with the purpose of strengthening the young Republic's defensive capacity.

On 14 October, reconnaissance flights made by American U-2 planes reveal that the Soviets are installing bases for nuclear warhead missiles. After the shooting down of a U-2 plane and the consequent naval blockade around the island, the tension between the United States and the USSR grows to the extent that the risk of a nuclear war becomes evident.

An informal agreement is secretly reached: the Russians will dismantle the Cuban missile bases, while Washington will do the same with the Jupiter missiles in Italy and Turkey, with the promise not to invade Cuba. The Russians' unilateral decision is the cause of a divergence between the Castro government and the ally. In order to resolve it, the Vice President of the Soviet Union Anastas Mikoyan reaches Havana where he stays for 24 days.

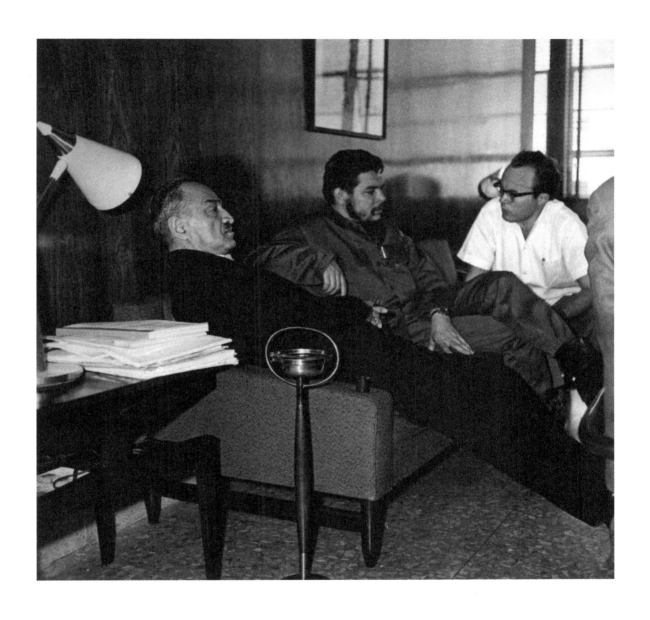

Che Guevara in an official
meeting with Nikita
Sergeyevich Khrushchev,
Moscow, 1962

Che Guevara meeting Anastas
Ivanovich Mikoyan in his office
as Minister of the Industry
during the missile crisis,
Havana, 1962

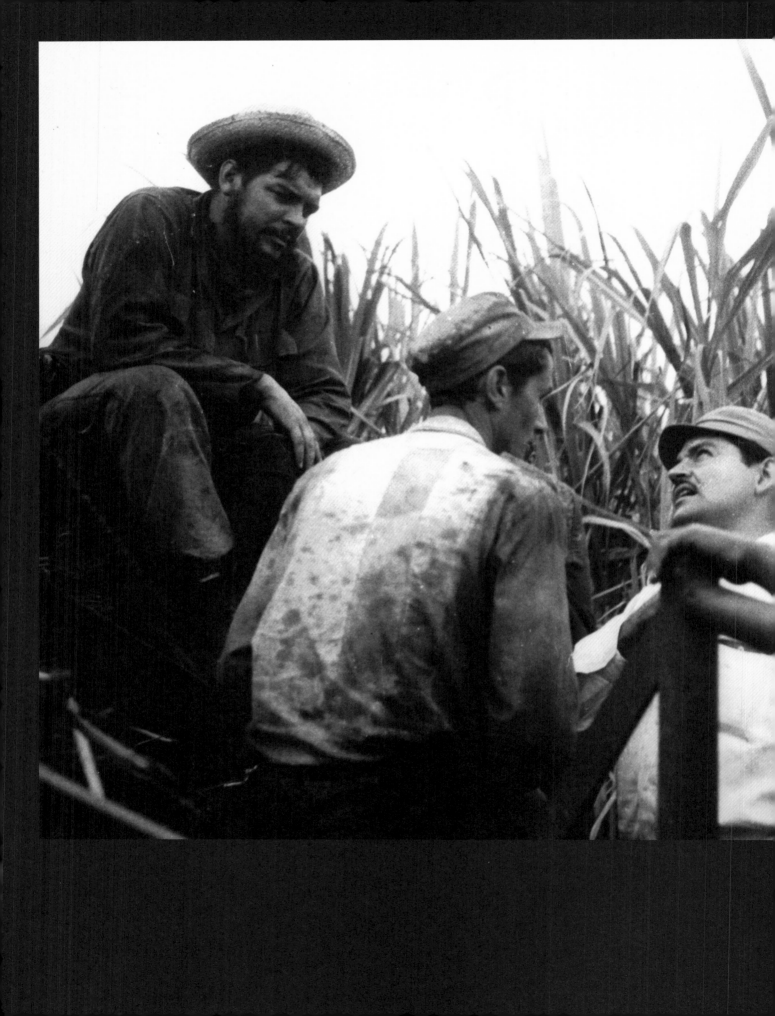

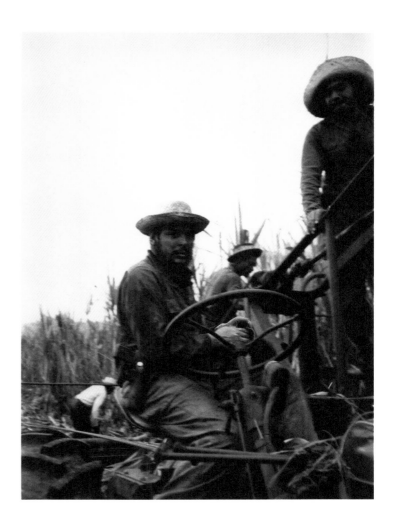

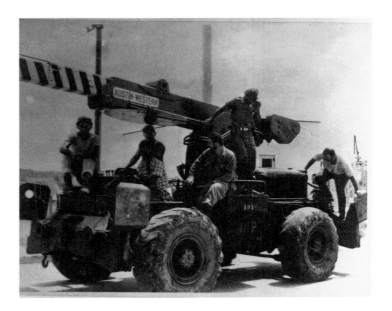

Alberto Korda, *Che in
Camagüey testing the new
machinery for the harvest
of the sugarcane*, 1963

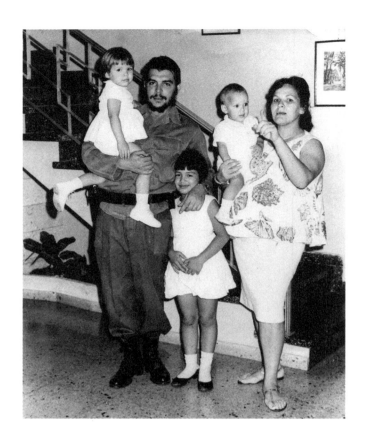

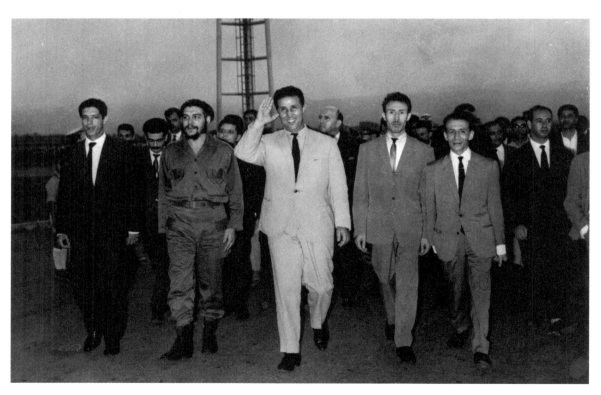

Che with his wife Aleida and
their children Aleida, Hildita,
and Camilo, Havana, 1963

Che Guevara visiting some
miners, Cuba, 1963

His first official meeting with
the President of Algeria Ahmed
Ben Bella, Algiers, 1963

Che making the speech on
the results of the sugarcane
harvesting, Santa Clara, 1963

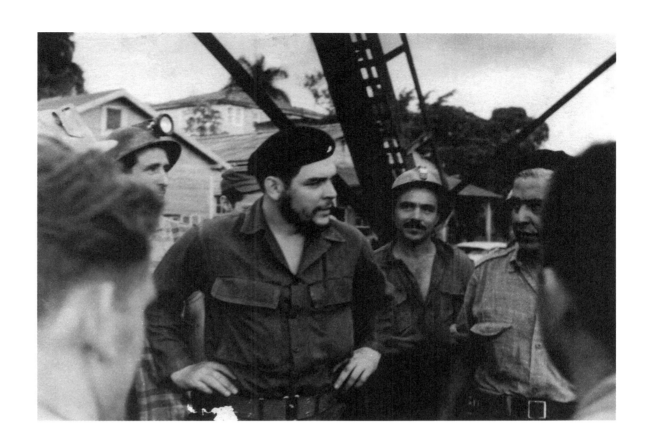

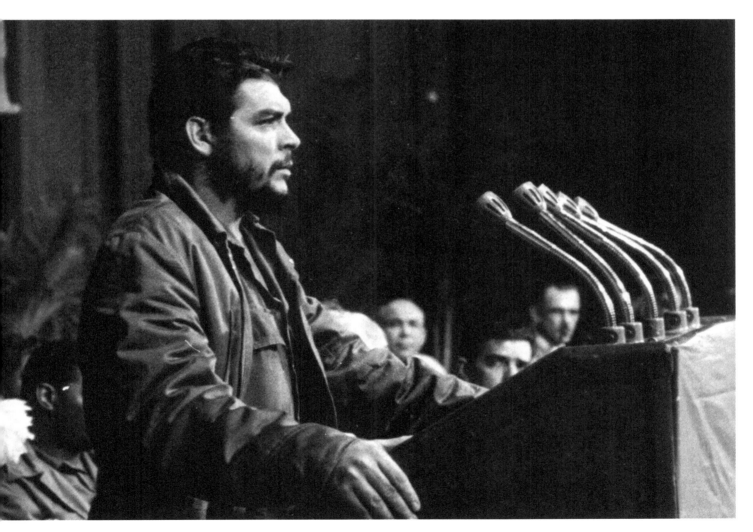

Economic socialism without a communist morality does not interest me. We are fighting against poverty, yes, but also against alienation.

Ernesto Che Guevara,
interview by Jean Daniel, in *L'Express*

René Burri, *Che Guevara, Havana*, 1963

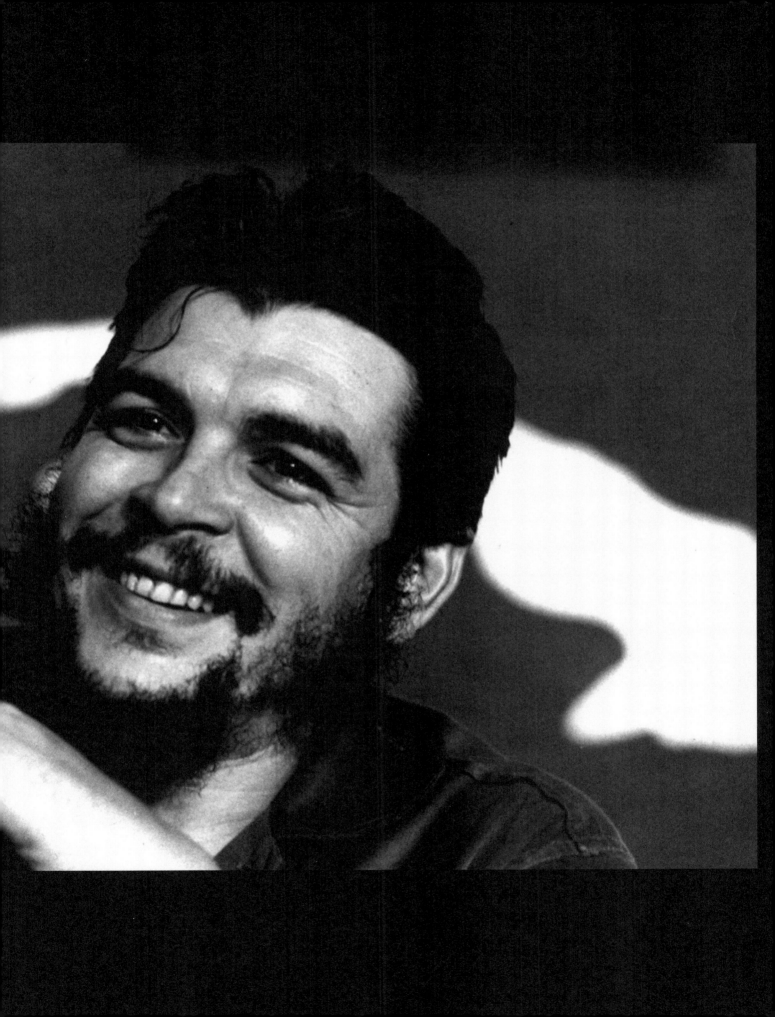

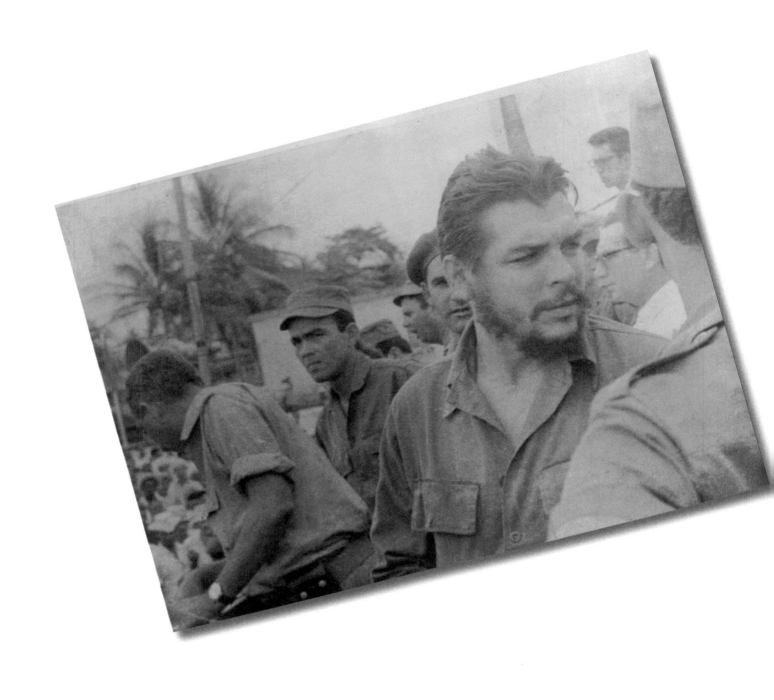

Che with a group of workers
in the year dedicated to the
economic growth the nation,
Cuba, 1964

Guevara during the first
United Nations Conference
on Trade and Development
in Geneva, Switzerland, 25
March 1964

Guevara making a speech
as Representative of Cuba
at the United Nations General
Assembly in New York, 1964

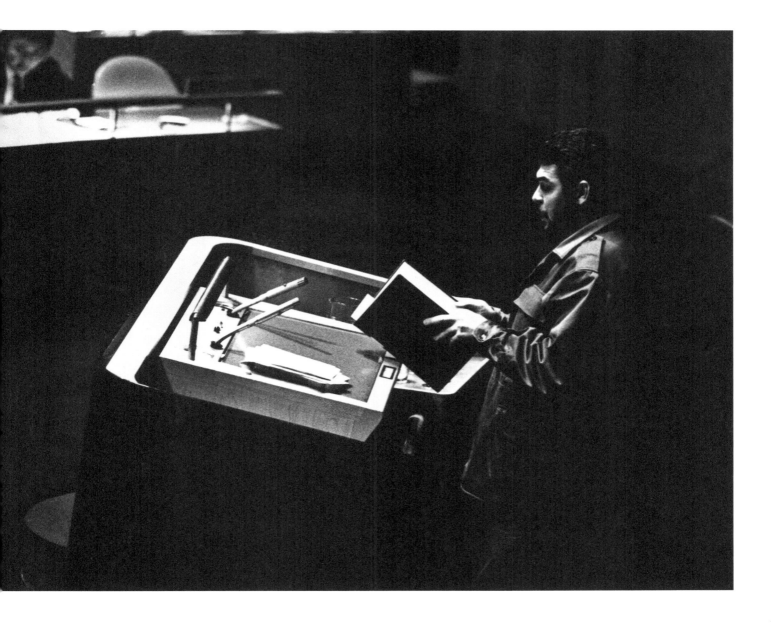

The time will come when this Assembly will acquire greater maturity and demand of the U.S. Government guarantees for the life of the blacks and Latin Americans who live in that country, most of them U.S. citizens by origin or adoption. Those who kill their own children and discriminate daily against them because of the colour of their skin; those who let the murderers of blacks remain free, protecting them, and furthermore punishing the black population because they demand their legitimate rights as free men – how can those who do this consider themselves guardians of freedom?

Ernesto Che Guevara, speech delivered to the IX Session of the General Assembly of the United Nations, 11 December 1964

The United Nations General Assembly in New York during Che Guevara's speech, 1964

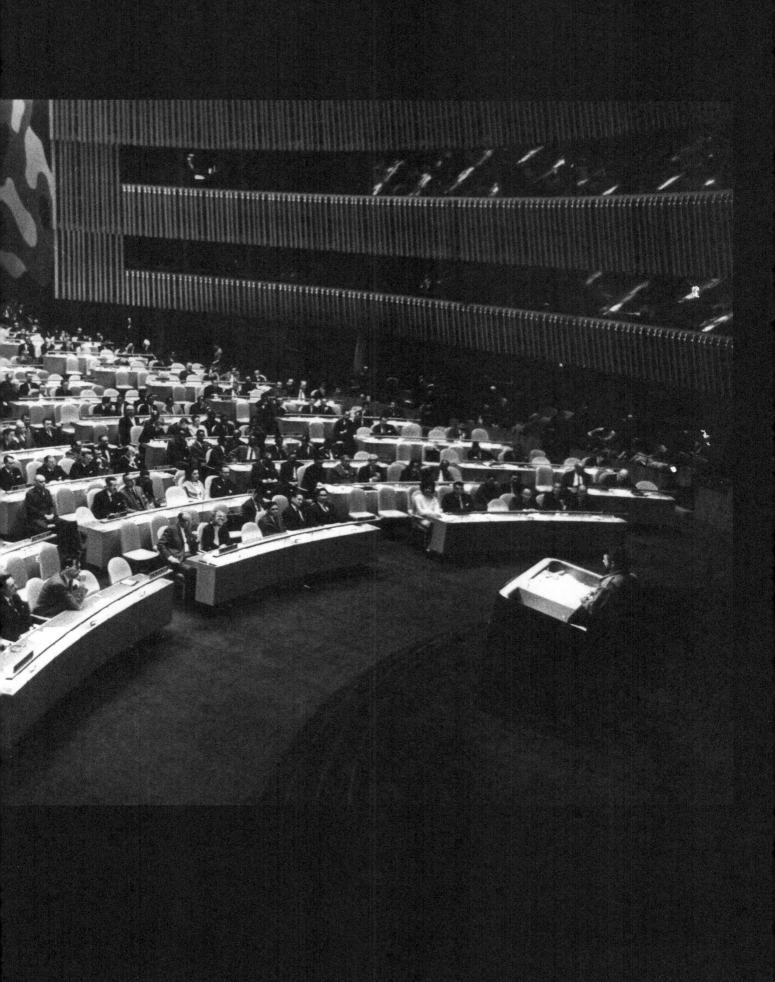

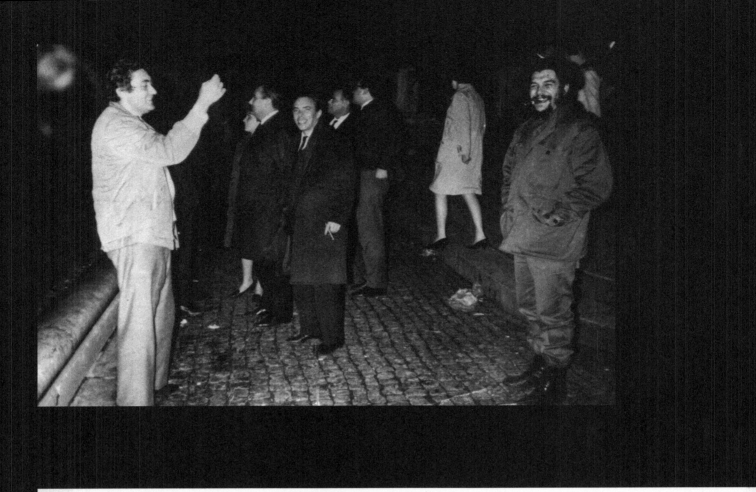

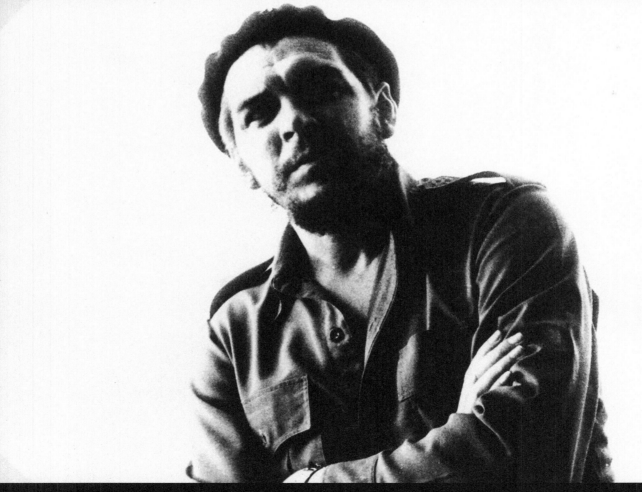

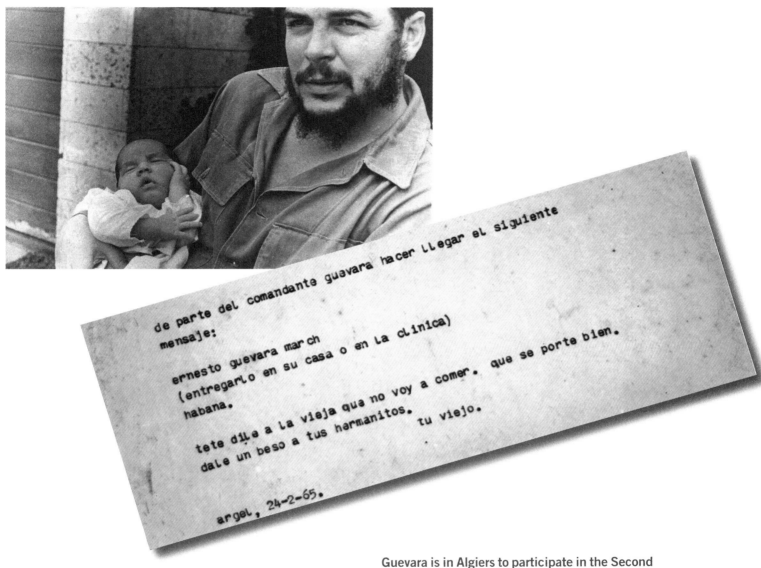

de parte del comandante guevara hacer llegar el siguiente
mensaje:

ernesto guevara march
(entregarlo en su casa o en la clinica)
habana.

tete dile a la vieja qua no voy a comer. que se porte bien.
dale un beso a tus harmanitos. tu viejo.

argel, 24-2-65.

Guevara is in Algiers to participate in the Second
Economic Seminar of Afro-Asian Solidarity.
Upon receiving the news of the birth of his last
son Ernesto, he sends his wife a telegram:

Ernesto Guevara March
(to be sent home or to the clinic)
Havana.

Tete, tell the old woman I won't be home
for dinner. Tell her to behave.
Give your brothers and sisters a kiss.
Your old man.

Algiers, 24 February 1965.

Che Guevara in front of
the Trevi Fountain in Rome,
1 February 1965

Che's portrait, Algeria, 1965

Che on the Great Wall of China
on the occasion of an official
visit, 1965

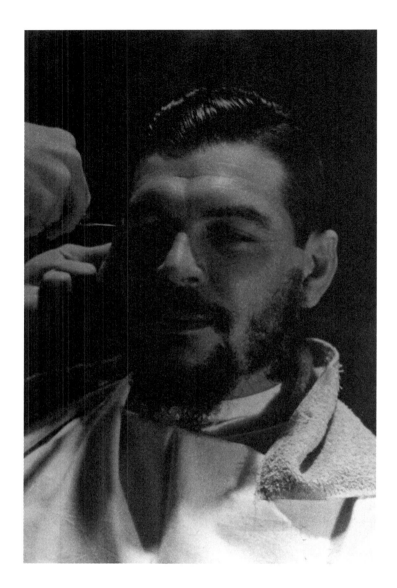

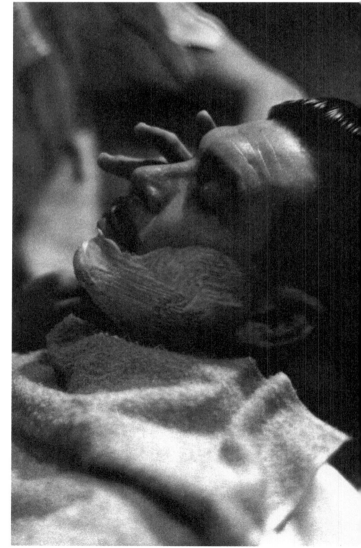

148

After about three months travelling in Africa
and China, Guevara returns to Havana.
He had already decided to support the
revolutionary movements in the Congo
and to reach Africa in incognito, he changes
his appearance.
Havana, 1965

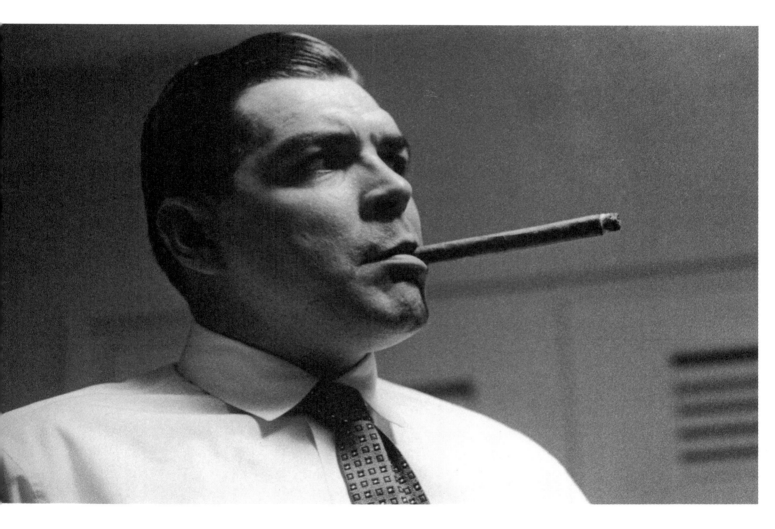

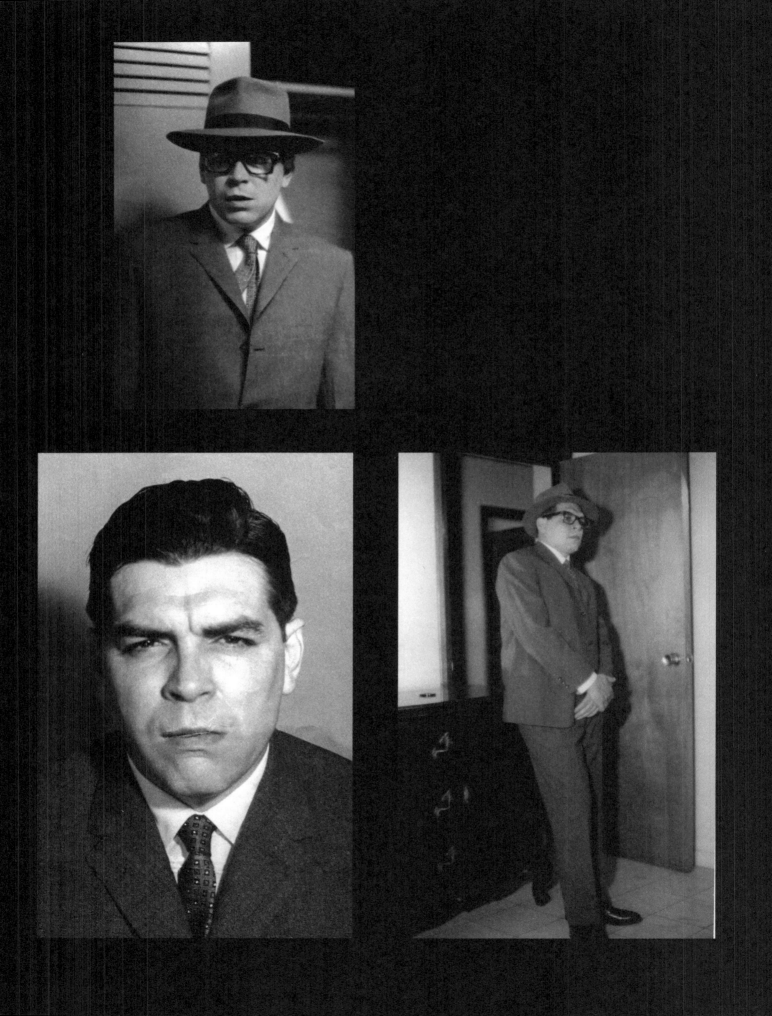

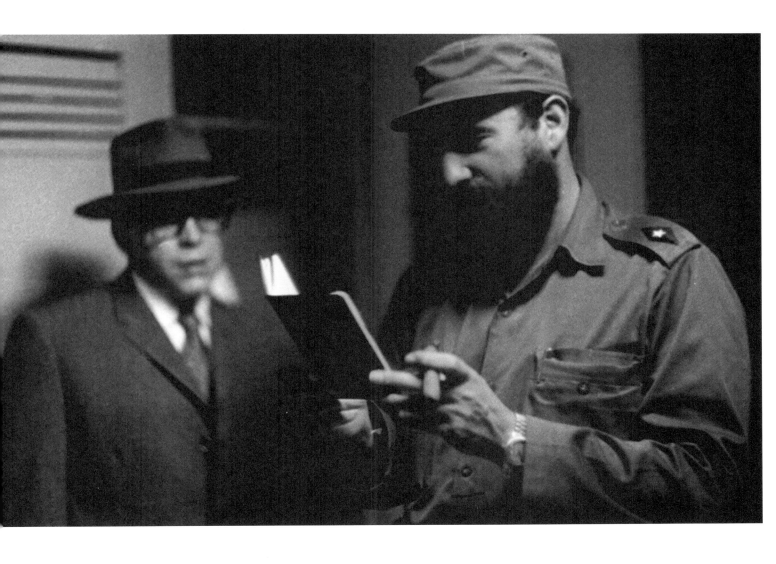

Sequence of images showing
Che's physiognomic changes
made before leaving for the
guerrilla warfare in the Congo,
Cuba, 1965

In the Congo, Guevara takes part
in the liberation fight with a group
of internationalist Cuban and
Congolese combatants.

Che's arrival in the Congo
wearing civilian clothes, 1965

With the Congolese guerrillas
in the Lumumba army
encampment, 1965

You know I'm a combination
of an adventurer and a bourgeois,
with a terrible yearning to come home,
while at the same time, anxious to
realise my dreams.

Ernesto Che Guevara,
letter to his wife, the Congo 1965

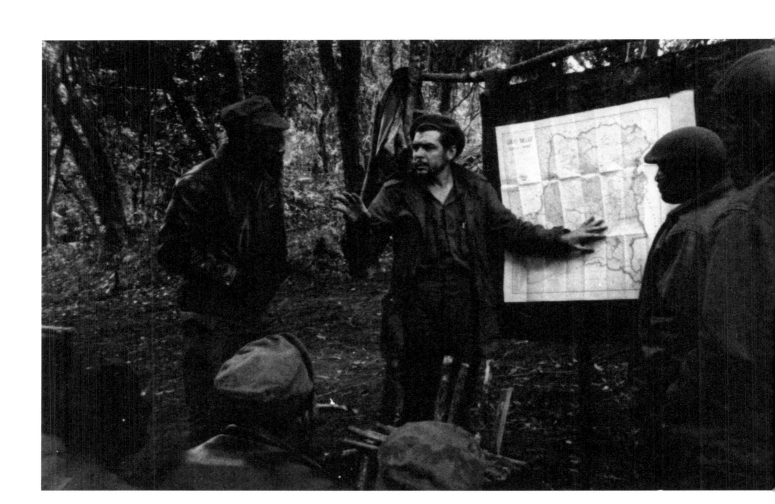

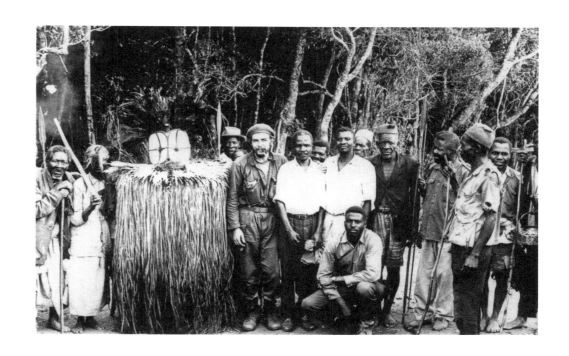

Life in the Lumumba army
encampment, the Congo, 1965

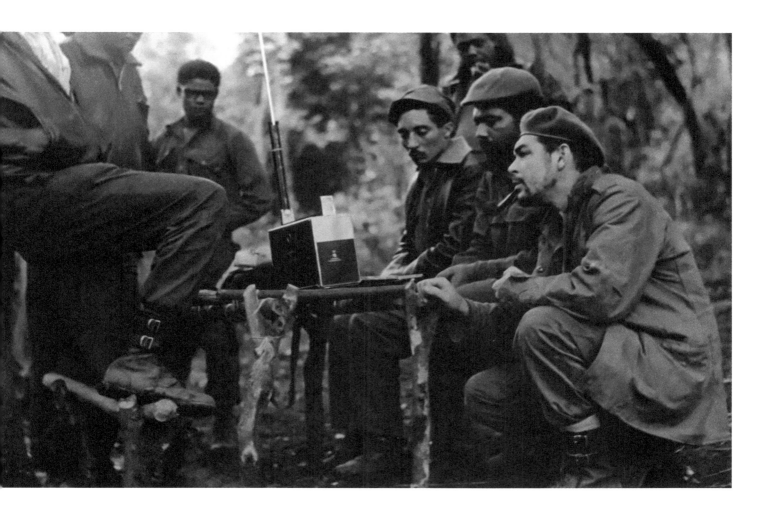

The saddest news of the whole war. Telephone calls from Buenos Aires reported that my mother was very ill, leading me to expect the worst. [...] I had brought only two small keepsakes with me into battle, the gauze scarf my wife had given me, and the keyring with the little stone in it from my mother. [...] Does one not cry because one must not or because one cannot. Is there no right to forget, even in war? Is it necessary to disguise a lack of feeling as machismo? I don't know. I really don't know. I know only that I feel a physical need for my mother to be here so that I can rest my head in her bony lap. I need to hear her call me "My son," with such tenderness, to feel her clumsy hand in my hair.

Ernesto Che Guevara, *The Stone*, 1965

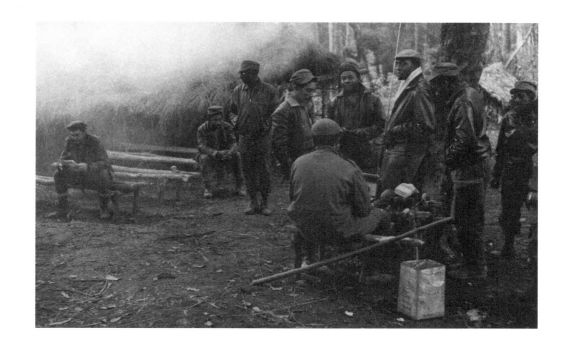

Che Guevara with the
guerrillas, the Congo, 1965

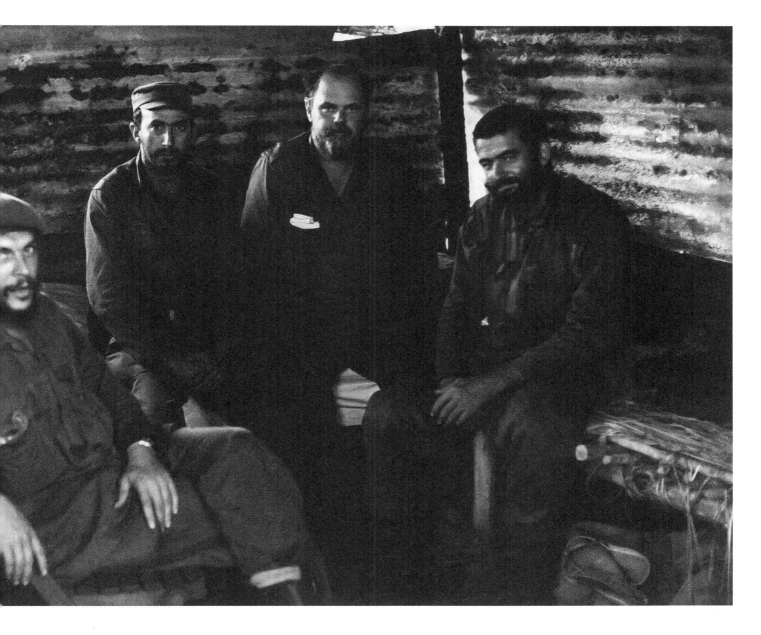

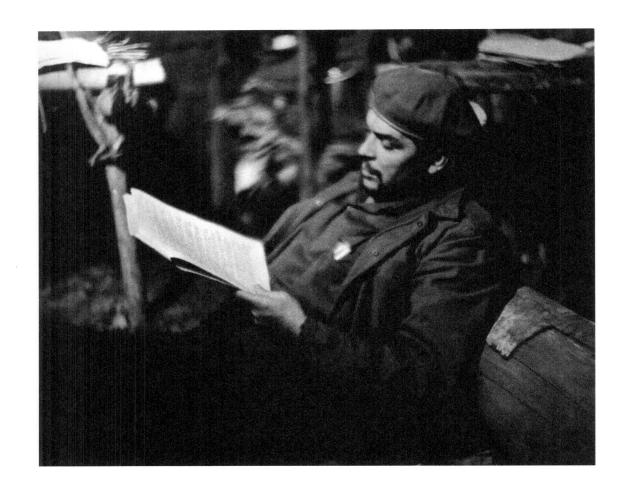

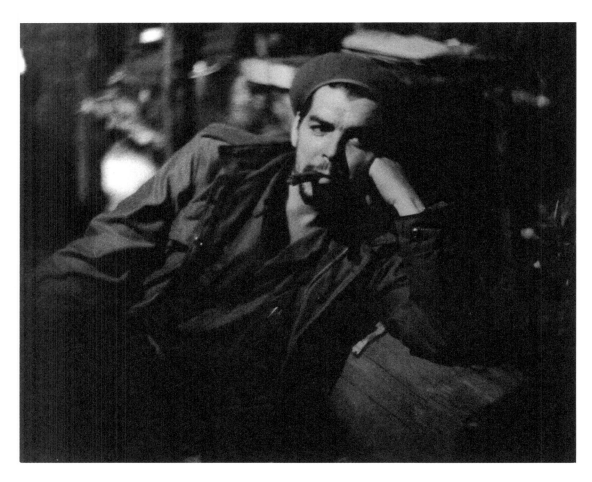

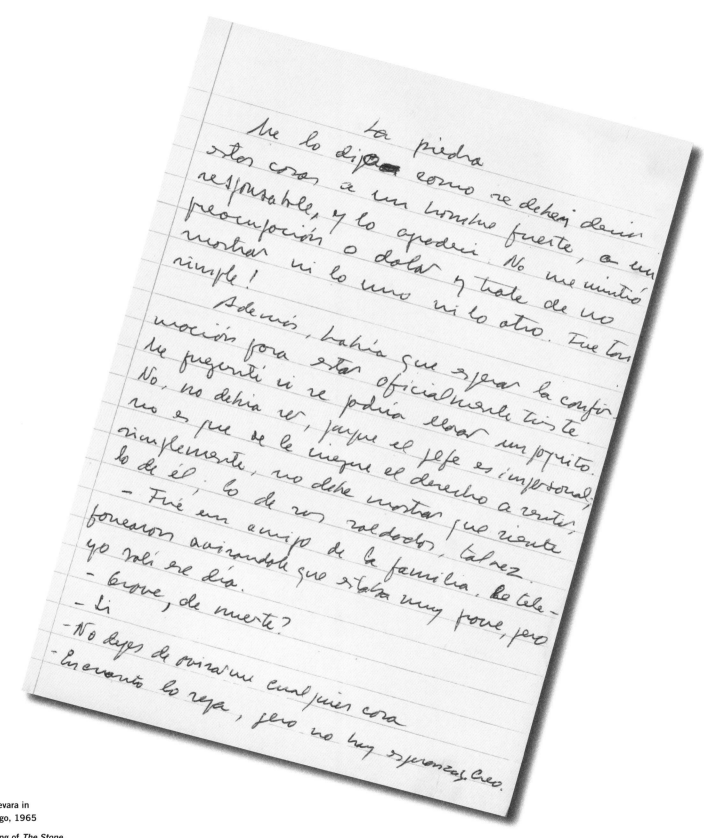

Che Guevara in
the Congo, 1965

Beginning of *The Stone*,
written upon hearing of the
death of his mother, 1965

159

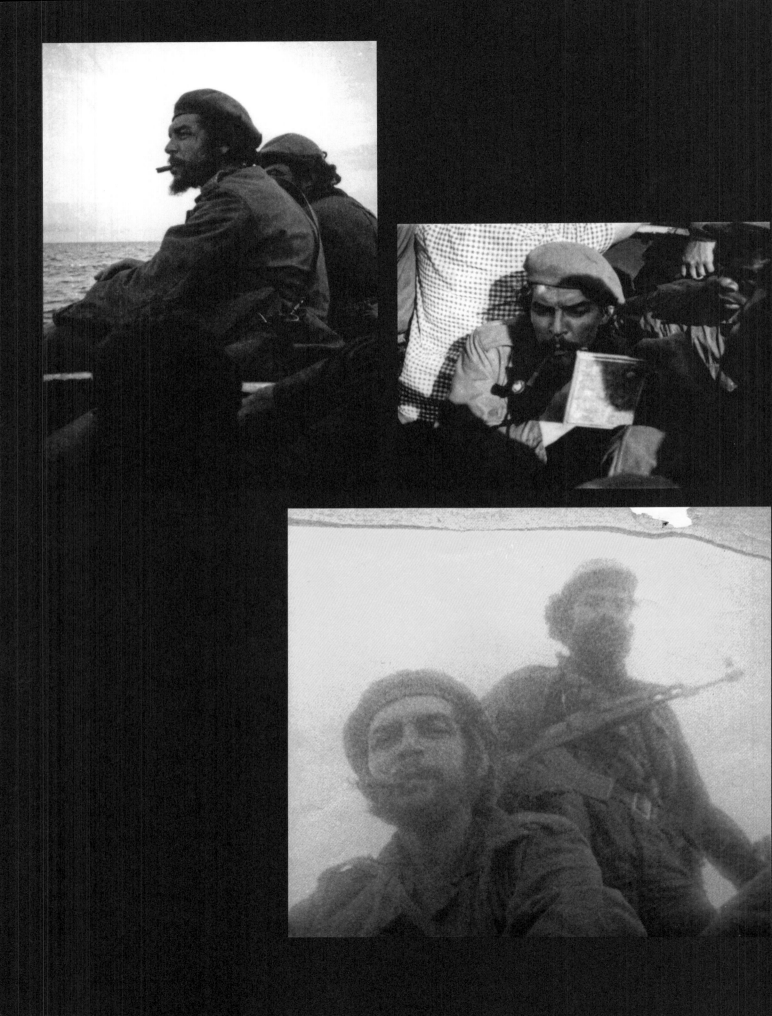

Everything turned out differently from what we had expected. I am returning, along the road of defeat, with an army of shadows. Now everything is over and the time has come for the last stage of my journey – the definitive one [...]. Now comes the truly difficult part for everyone and we must be prepared to bear it. [...] When I was a bureaucrat in my cave, I dreamt of doing what I have begun to do. Now, and for the rest of my journey, I will dream of you, while the children will inevitably grow up.

Ernesto Che Guevara, letter to his wife, the Congo, 1965

Che Guevara while crossing Lake Tanganyika on his return trip from the Congo, 1965

In 1965, in the postcard sent to his son Camilo from Tanzania, Che writes:

Camilito:

Today I spoke with my friend Pepe the Caiman and I told him that you don't like school very much and that you are a bit rowdy. I took a picture of him just as he was saying that you could come to his school and that he would teach you many interesting things.
Have a hug and a clout from your old man.

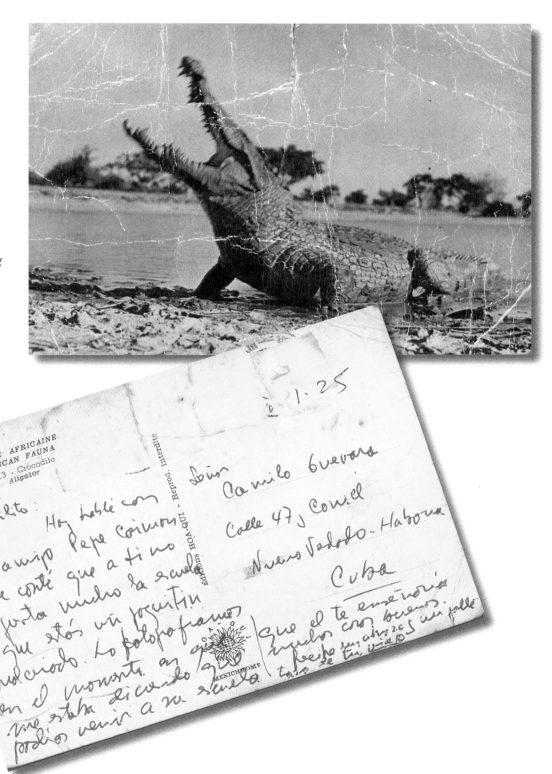

Ernesto Guevara, *Self-Portrait, Tanzania*, 1965

A Marxist must be the best, the most honest, and the most complete of the human beings, but, always, above all, he must be a human being.

Ernesto Che Guevara, preface to the book
El partido marxista-leninista (Havana: 1963)

Cover and table
of contents
of the first notebook
Marx - Engels - Lenin

1966-1967

"Mis sueños no tendrán fronteras"

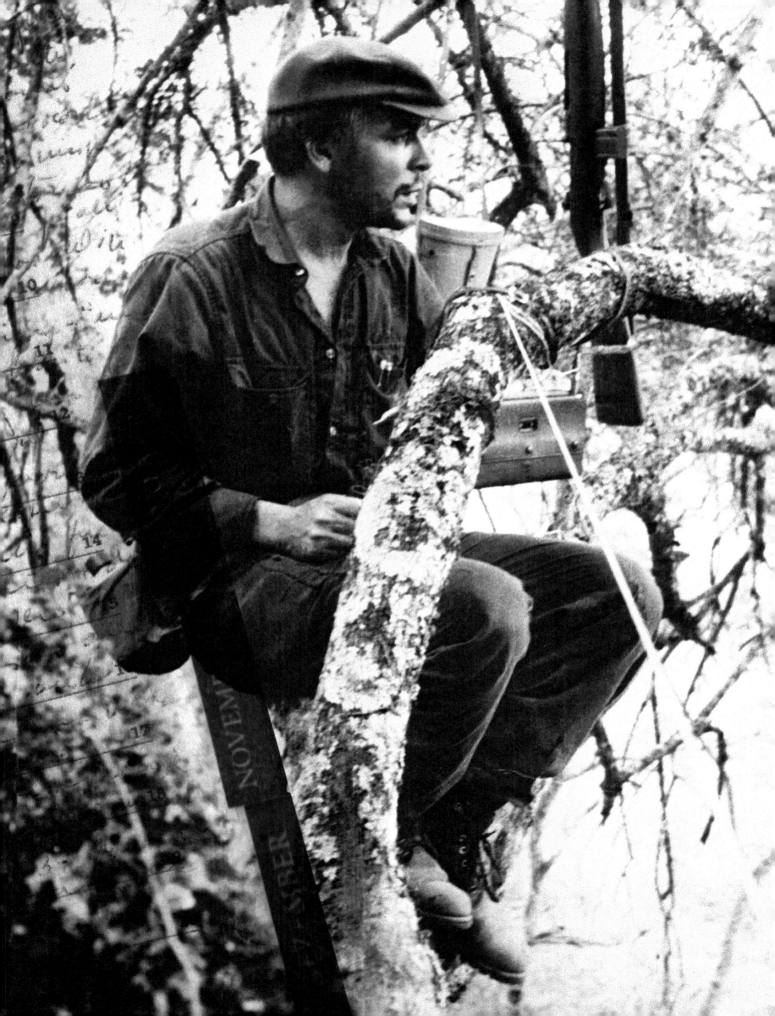

Nevertheless, I think that, seeing the delicate and worrying situation you're being forced to experience there, you should consider paying us a visit over here. I know your reluctance well. [...] Nothing prevents you from taking advantage of the objective possibility of entering and leaving Cuba, coordinating, planning, choosing, and training the rank and file. [...] I am writing to you with deep affection and sincere admiration: you know how much I appreciate your clear-sighted and noble intelligence, your dedication, your revolutionary rigor.

Fidel Castro, letter to Ernesto Che Guevara,
3 June 1966

Che with his daughter Celia, visiting him in San Andrés, Pinar del Río, where he moved after arriving in Cuba to be close by his training camp, 1966

After the unsuccessful adventure in the Congo, Che goes to Czechoslovakia. On 3 June 1966 he receives a letter from Fidel with which he wants to convince Che to return to Cuba. In July, Che secretly moves back to Havana in order to organise a new mission: bringing the guerrilla warfare to Bolivia.

During the training, Aleida pays a visit to her husband. Once again, Che has changed his appearance so as to arrive incognito in Bolivia: he wears dentures, he is clean-shaven, he smokes a pipe, and he wears tie and glasses. The name on his passport is Ramón Benítez.

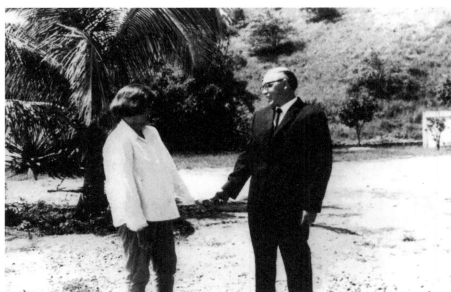

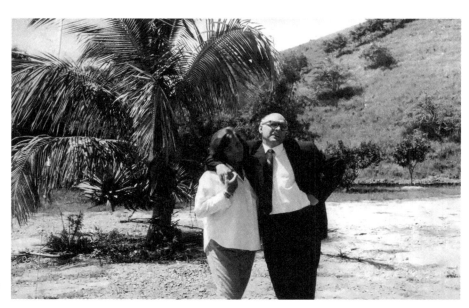

Che with his wife Aleida after transforming into Ramón Benítez, San Andrés, Cuba, 1966

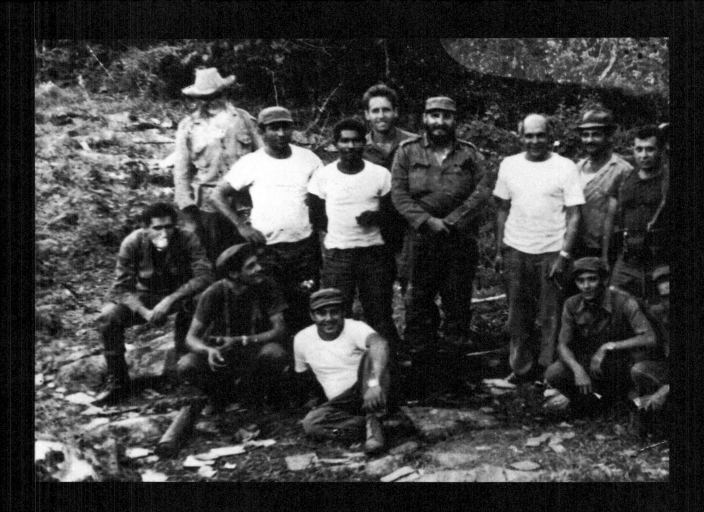

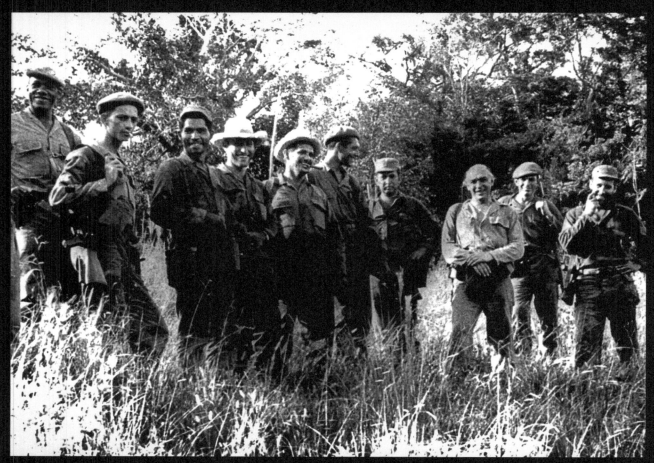

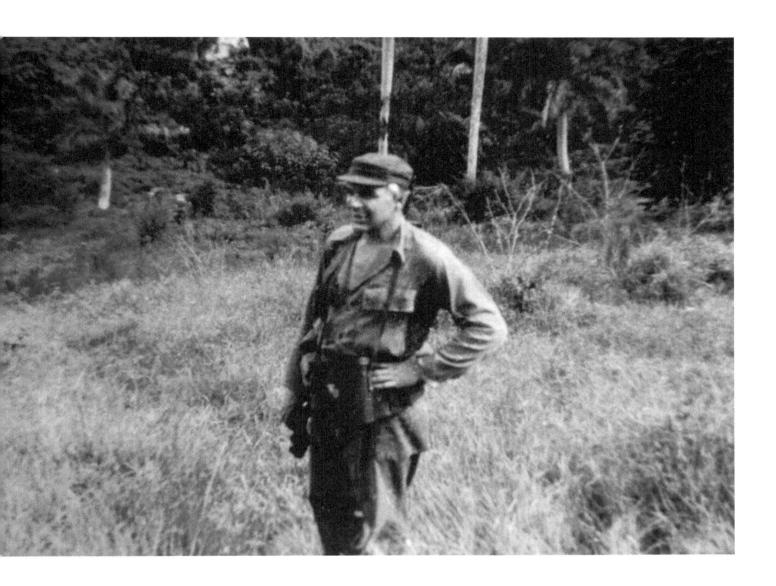

In October, Che meets Aleida and his four children, disguised as Ramón. His children don't recognise him and for Che and Aleida the meeting is very difficult and heart-rending. From this shelter Che will leave for Europe, to then leave again towards his final destination.

Fidel Castro visiting Che and the other Cuban guerrillas in the military training camp of San Andrés, Cuba, 1966

Adiós, mi única,
no tiembles ante el hambre de los lobos
ni en el frío estepario de la ausencia;
del lodo del corazón te llevo
y juntos seguiremos hasta que la ruta se esfume...

Mi única en el mundo:
a hurtadillas extraje de la alacena de Hickmet
este solo verso enamorado,
para dejarte la exacta dimensión de mi cariño.

No obstante,
en el laberinto más hondo del caracol taciturno
se unen y repelen los polos de mi espíritu:
tu y TODOS.

Los Todos me exigen la entrega total,
¡que mi sola sombra oscurezca el camino!
Mas, sin burlar las normas del amor sublimado
te guardo escondida en mi alforja de viaje.

(Te llevo en mi alforja de viajero insaciable
como al pan nuestro de todos los días)

Salgo a edificar las primaveras de sangre y argamasa
y dejo, en el hueco de mi ausencia,
este beso sin domicilio conocido.
Pero no me anunciaron la plaza reservada
en el desfile triunfal de la victoria
y el sendero que conduce a mi camino
está nimbado de sombras agoreras.

Si me destinan al oscuro sitial de los cimientos,
guárdalo en el archivo nebuloso del recuerdo;
úsalo en noches de lágrimas y sueños...

Poem written by Che before
leaving for Bolivia, dedicated to
his wife Aleida, 1966

My only one in the world:
I secretly extracted from Hickmet's [sic] poems
this sole romantic verse, to leave you with the exact
dimension of my affection.
Nevertheless,
in the deepest labyrinth of the taciturn shell
the poles of my spirit are united and repelled:
you and EVERYONE.
Everyone demands complete devotion from me
so that my lonely shadow fades on the road!

Ernesto Che Guevara, poem for his wife, 1966

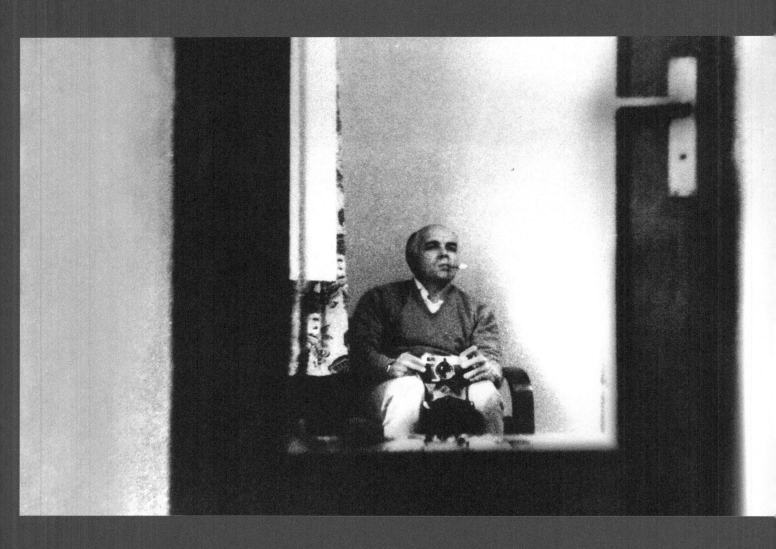

On his journey towards Bolivia, Guevara stops in Vienna, Austria, where he pretends to be a Uruguayan businessman called Adolfo Mena González, completely changing his appearance.

Ernesto Guevara, *Self-Portrait as Adolfo Mena González*, La Paz, Bolivia, 1966

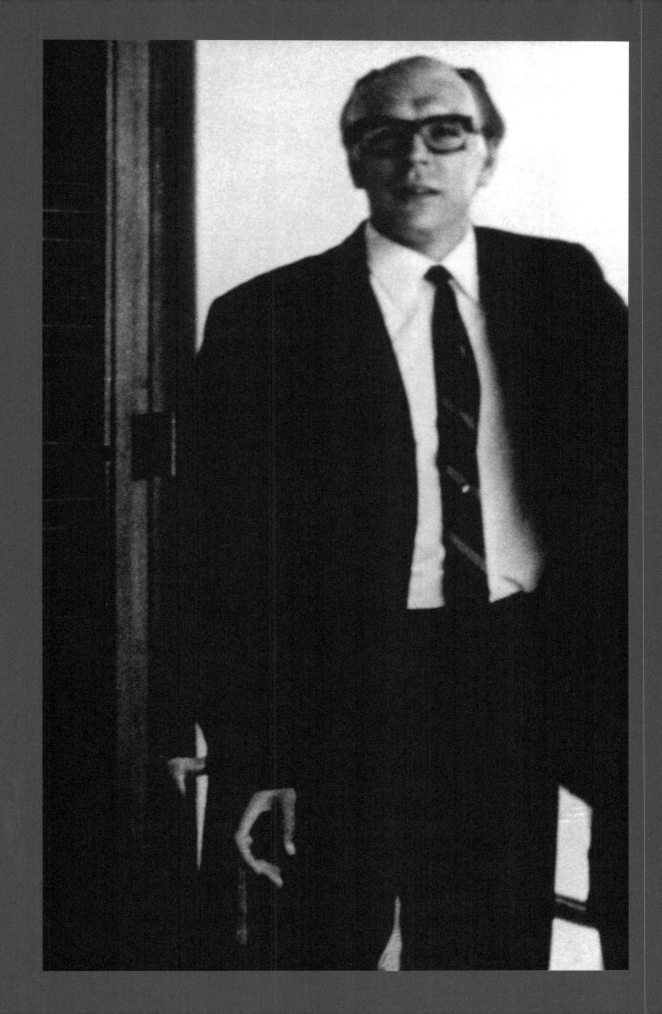

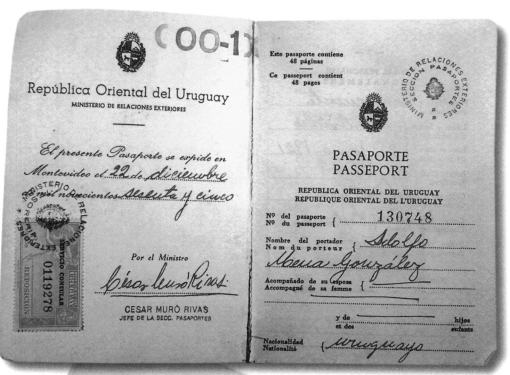

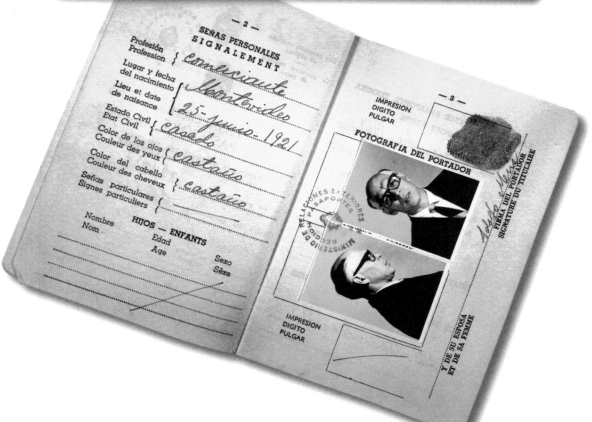

Che's passport as Adolfo Mena González, one of the alias used in Bolivia, 1966

In Ñancahuazú, Bolivia, 1966

Che with a group of guerrillas on the first days in Ñancahuazú army encampment, 1966

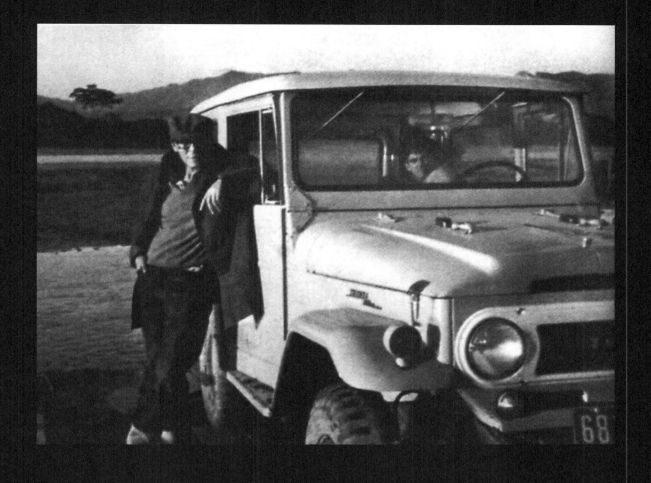

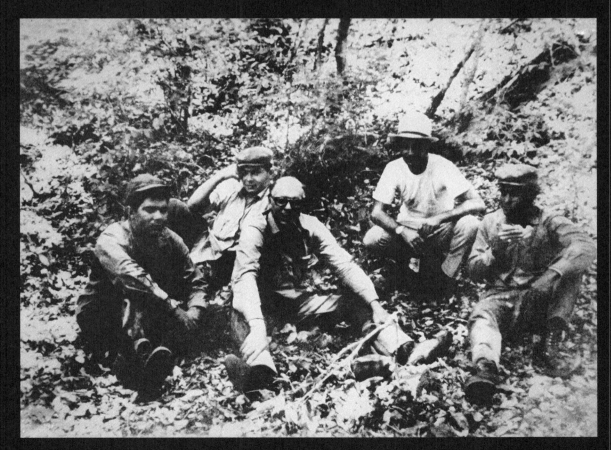

27 March 1967. [...] the deserters [...] have spoken.

28 March. We are surrounded by 2,000 men [...] and the circle is tightening [...]

May. Total lack of recruiting among the farmers [...]

14 June. I am now 39 years old and an age is approaching inexorably that forces me to think about my guerrilla future: for now, I am "all in one piece."

7 August. It is exactly nine months today since the forming of the guerrillas. Of the first six men, two have died, one has disappeared and two are injured; I have asthma that I am unable to cure.

19 September. Sign of the times: my ink has run out.

Ernesto Che Guevara, *Bolivian Diary*

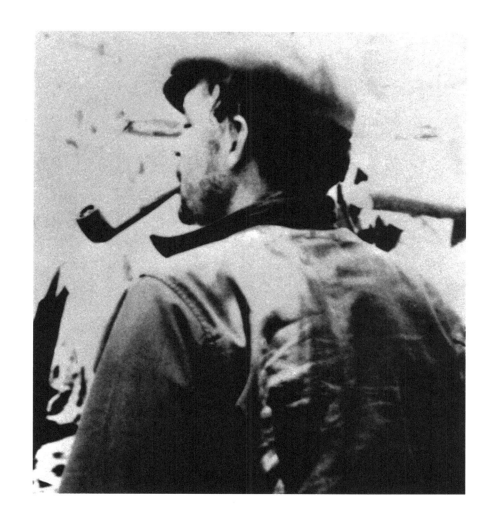

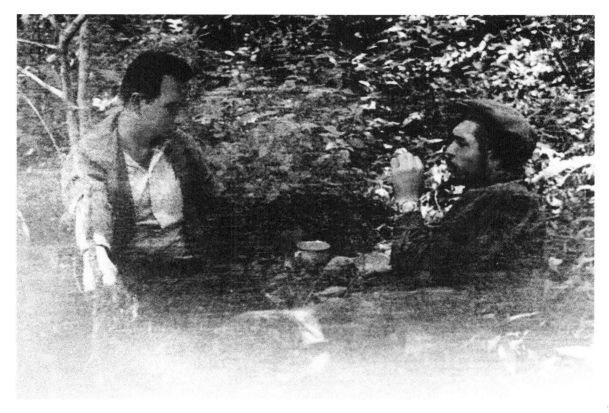

Che in Ñancahuazú, Bolivia,
1966

Che meeting the Secretary-
General of the Communist Party
of Bolivia Mario Monje, 1966

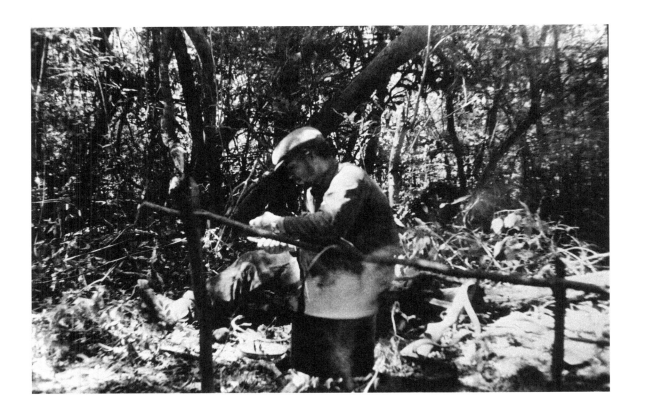

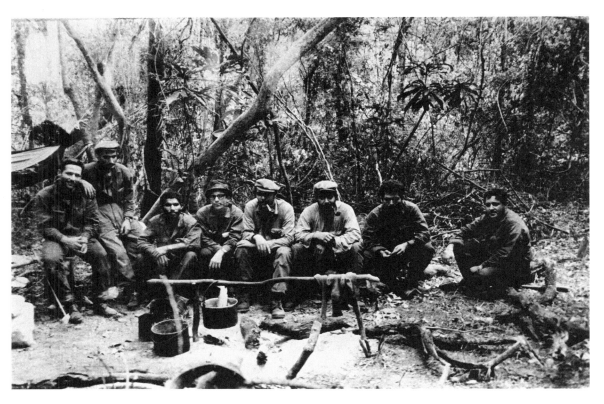

Che in the Ñancahuazú
army encampment,
Bolivia, 1966-1967

While patrolling the guerrilla
zone, Bolivia, 1967

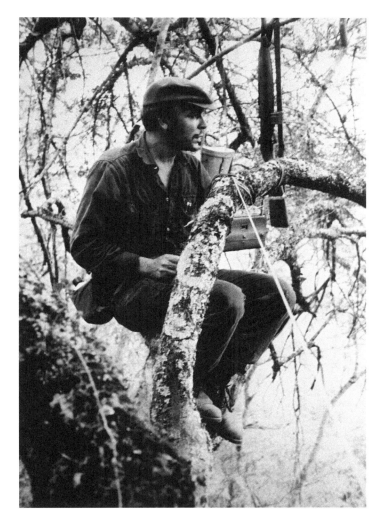

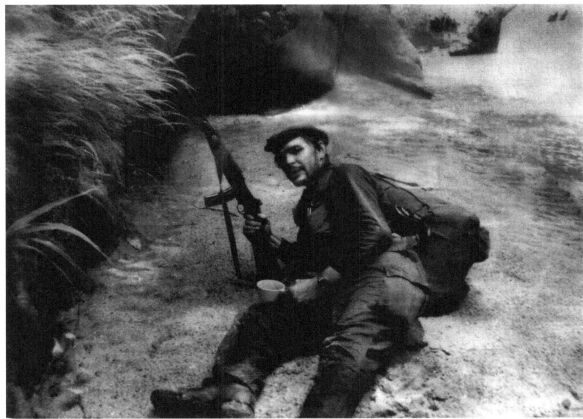

7 October. We have completed the eleventh month of our guerrilla operation: it was spent in a bucolic mood, without complications, until twelve thirty [...].

Ernesto Che Guevara,
last page of the *Bolivian Diary*

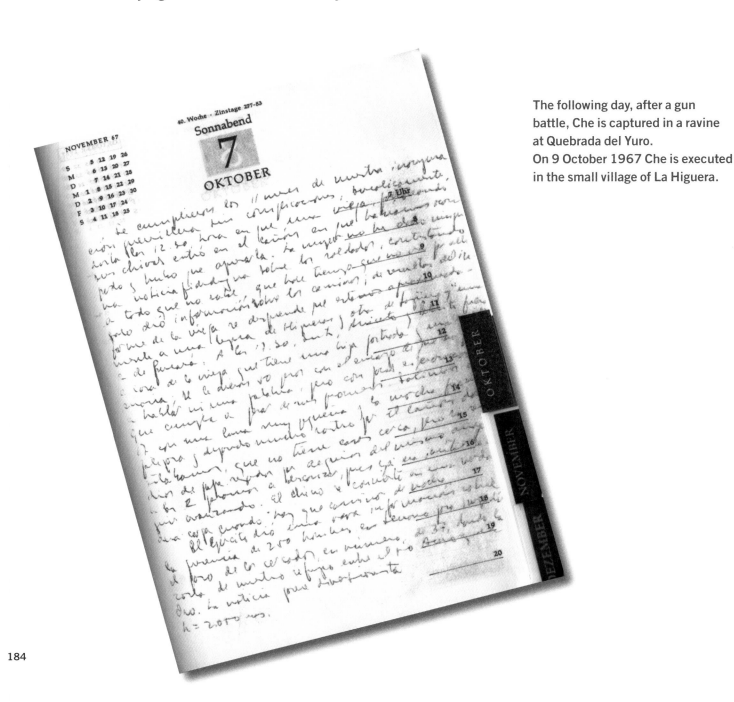

The following day, after a gun battle, Che is captured in a ravine at Quebrada del Yuro.
On 9 October 1967 Che is executed in the small village of La Higuera.

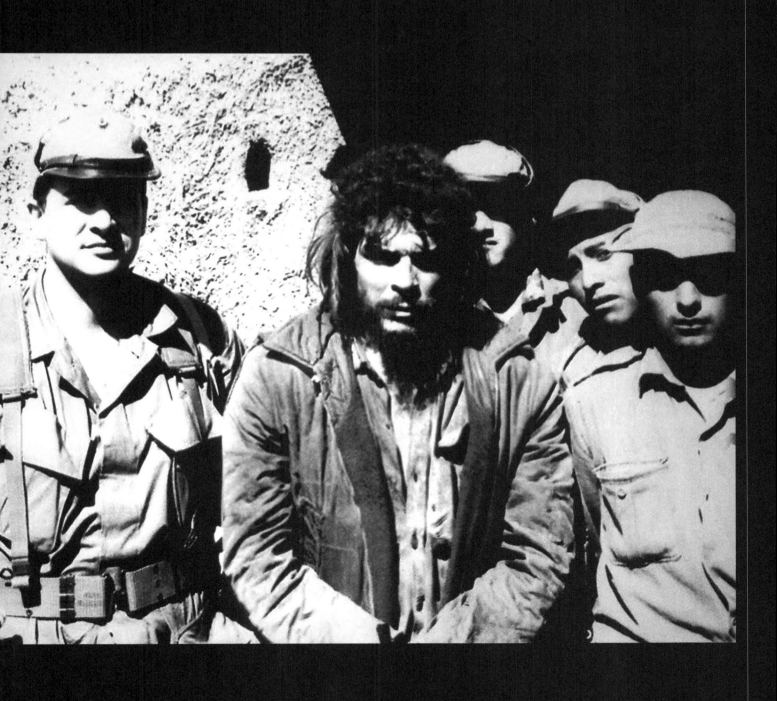

If we wish to express how we would like the men of the future generations to be, we must say: Let them be like Che! If we wish to say how we want our children to be educated, we must say without hesitation: We want them to be educated in Che's spirit! If we want the model of a man, who does not belong to our times but to the future, I say from the depths of my heart that such a model, without a single stain on his conduct, without a single stain on his action, is Che!

Fidel Castro, speech for the solemn wake in memory of Ernesto Che Guevara, 18 October 1967

Rally in Plaza de la Revolución after Che's death, Havana, 1967

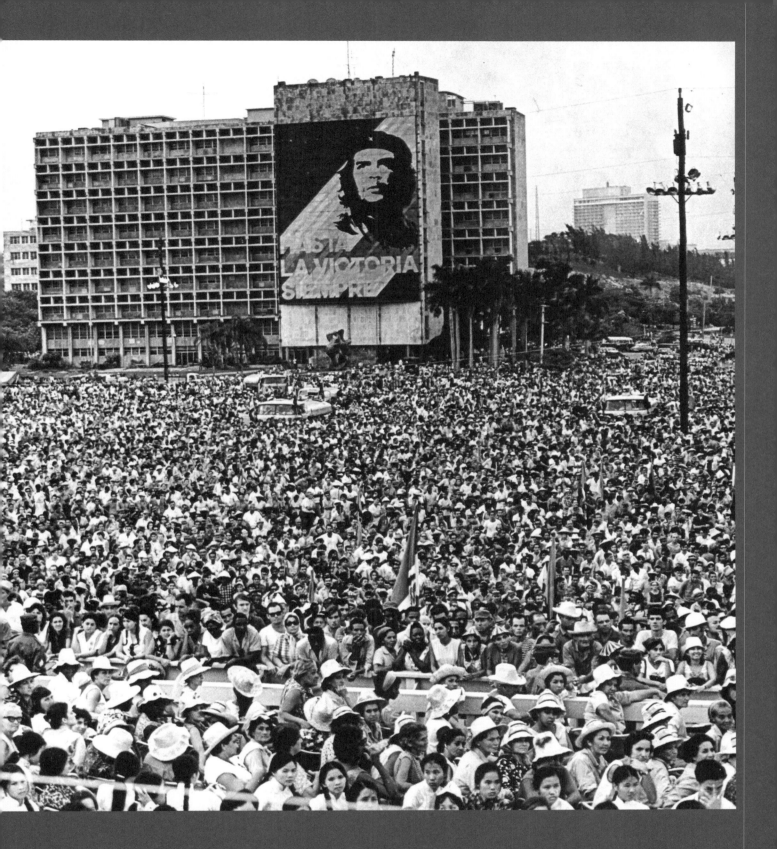

Che Guevara: biography

1928

Rosario, Argentina. Ernesto Guevara de la Serna was born on 14 June, the first son of Ernesto Guevara Lynch and Celia de la Serna.
He is followed by Celia, Roberto, Ana María, and Juan Martín.

1933

The family moves to Alta Gracia, in the province of Córdoba, for the violent asthma attacks that begin to afflict Ernesto when he is two.
He attends San Martín elementary school.

1942

Ernesto enrols at the "Deán Funes" Secondary School, in Córdoba, where he completes his secondary studies. Every day, he travels 35 km by train.

1943

The family moves to Córdoba. During his train travels, Ernesto becomes close to the Granado family, and especially to Tomás and Alberto. It is with Alberto as a companion that Ernesto will undertake his first journey across the continent. In this period, Ernesto reads a great quantity of books being literature and philosophy his favourite studies. He also practices sports.

1945

Ernesto starts drafting his *Philosophical Dictionary* (unpublished), filling up six notebooks. The extended version is completed in Mexico, between 1954 and 1956.

1946

Ernesto completes his secondary studies and passes a course as road technician. He works for the institution of roads, together with his friend Tomás Granado.

1947

His family moves back to Buenos Aires.
At the age of 19 Ernesto enrols at the Faculty of Medicine. Subsequently, he collaborates with the clinic of Dr Salvador Pisani, an eminent Argentinian allergist.

1950

Ernesto travels solo across twelve provinces in the northern part of Argentina on a bicycle modified with a small motor. He begins a relationship with a young woman from Córdoba, María del Carmen Ferreyra, known as Chichina.

1951

Ernesto travels as nurse on both merchantman and tankers arriving to São Paulo, Brazil, at first, and later to Venezuela and Trinidad, in the Caribbean.
In Buenos Aires he founds the magazine *Tackle* along with the other members of his rugby team, signing his articles with the pseudonym Chang-Cho.
In December he undertakes his first journey across Latin America with his friend Alberto Granado, on a Norton motorbike he names La Poderosa II (The Mighty One II). He starts keeping a travel diary, published for the first time in Cuba in 1993 with the title *Notas de Viaje*.

1952

Ernesto's journey across the Latin-American continent takes him to Chile, Peru, Colombia, Venezuela, and finally to Miami where he apparently stays for a month. In June he makes his return trip to Buenos Aires on a plane used for transporting horses – his only available option.

1953

Ernesto gets a degree in medicine. On 7 July he begins his second and last journey across Latin America, this time by train, with his childhood friend Carlos "Calica" Ferrer as a companion. Together they travel through Bolivia, Peru, Ecuador – where they separate to meet then again in Granado, Venezuela – and with Eduardo "Gualo" García joining them, through the Central American countries of Panama, Costa Rica, Nicaragua, El Salvador, and Guatemala. Here, they study the revolutionary process that is taking place under the guidance of Jacobo Árbenz Guzmán. As he did for his first journey, Ernesto has described his travel experience in a diary that he calls *Otra Vez*, published in 2000.

1954

Ernesto meets the group of Cuban exiles who assaulted the Moncada Barracks and he becomes close friend with Antonio "Ñico" López. Ernesto joins some of the people belonging to the Latin American intelligentsia in the country and he studies philosophy further, especially Marxism. In the same period, he meets Hilda Gadea, a Peruvian exile, who will become his first wife.
The CIA-backed mercenary armies invade Guatemala forcing Árbenz Guzmán to resign on 27 June.
In September same year, Ernesto goes to Mexico, where he works as a street photographer at first and as a physician later, as well as doing other temporary jobs.

1955

Ernesto meets his friend Ñico López who introduces him to Raúl Castro, Fidel's brother, leader of the assault at the Moncada Barracks. In July Fidel goes to Mexico and meets Ernesto, who immediately joins the group of Cuban insurgents promoting the guerrilla warfare. Ernesto and Hilda Gadea get married.

1956

Hilda Beatriz Guevara Gadea, the first Ernesto's daughter, was born.
In June, a tip-off to the police leads to Ernesto and Fidel Castro's capture.
On 25 November Ernesto leaves from Tuxpan, Mexico, with a group of 82 insurgents on the yacht Granma. On 2 December they arrive on the shore of Las Coloradas in eastern Cuba. Here the rebels are caught in an ambushed held by the troops loyal to the dictatorship in Alegría de Pío and the majority of them are killed. Che – this is the nickname he was given by his Cuban comrades in Mexico – suffers a flesh wound in his "first baptism of fire".
On 21 December, Che and the other survivors join Fidel in Sierra Maestra, where they institute the Rebel Army.

1957

The warfare begins. Che takes part to the battles, including the attacks of the La Plata army barracks and of El Uvero. In June a second column is organised, which Che is told to command. In July, Fidel names him first commander of the rebel forces.
He publishes the paper El Cubano Libre.

1958

In February Che founds Radio Rebelde.
In May the Cuban army launches an unsuccessful attack against the Rebel Army; this event marks the beginning of the rebel counter-offensive with the Battle of Jigüe, held in July.
In August, Fidel entrusts his hardened commanders Camilo Cienfuegos and Che Guevara with the invasion of western Cuba. Camilo is ordered to bring his column to Pinar del Río, while Che heads for the centre of the country, in the province of Las Villas, with the aim to gather the rebel forces together.
In October Che's Column 8 reaches the Escambray Mountains to then proceed in December with the offensive of Las Villas. The operation culminates in the historic Battle of Santa Clara, capital of the province, ended on 1 January 1959.

1959

On 1 January Fulgencio Batista leaves Cuba and Che receives orders from Fidel to advance towards Havana and to seize the fortress of La Cabaña, bastion of the dictatorship.
On 29 January he makes his first speech entitled Social Projections of the Rebel Army.
On 9 February he is proclaimed Cuban citizen by birth in recognition of his merits in the liberation struggle.
On 10 April he founds the journal Verde Olivo, named after an organ of the Revolutionary Armed Forces. His writings on the war are here published for the first time. Years later, the same writings will be collected in the book Recuerdos de Misiones. Los primeros pasos del Che (issued in English with the title "Passages from the Revolutionary War") published by the Unión de Escritores y Artistas de Cuba in 1963.
On 2 June Che gets married with the combatant Aleida March de la Torre. From 12 June to 8 September Che travels abroad for the first time as a representative of the revolutionary government, mainly to visit the countries participating to the Bandung Conference, that precedes the establishment of the Non-Aligned Movement. In September Che starts exercising his functions in the Department of Industrialisation of the National Institute for Agrarian Reform. In November Che is elected head of the National Bank of Cuba.

1960

On 16 January Che works for the first time as a volunteer in Martí, a district of Havana. This action is considered to be of great significance for the revolutionary training of the population. During this period, particularly in the months of March and August, he makes two of his most important speeches, Political Sovereignty and Economic Independence and On Revolutionary Medicine. He also publishes in Verde Olivo the article "Notes for the Study of the Ideology of the Cuban Revolution".
On 28 July he makes another speech to the First Latin American Youth Congress.
In October he begins a long journey across the Soviet Union, the German Democratic Republic, Czechoslovakia, China, and North Korea to secure diplomatic and commercial ties with the socialist countries.
On 24 November his daughter Aleida Guevara March was born. She will be then followed by Camilo, Celia, and Ernesto.
In December, Guerrilla Warfare is published for the first time, with a dedication to Camilo Cienfuegos.

1961

On 6 January Che makes an appearance on television in which he announces to the Cuban people that economic agreements have been signed between Cuba, the Soviet Union, and some other socialist countries.
On 23 February he founds the Ministry of Industry of which he will be leader until his departure for the Congo in 1965. This period represents one of the most fruitful time for the socialist transformation of Cuba, which Che promotes by being an example to people and with his strong commitment and his sharp ideas. Interventions aimed at steering the development of industrialisation are implemented, including the construction of new factories able to respond to the changes and transformations required by the modern age; similarly, a higher level of organisation of the ministerial structures is achieved. Bimonthly general meetings as well as meetings with the board of administration are of historic importance; collected in proceedings, they reveal the great relevance of the debates, both in theoretical and practical terms.
On 9 April Che publishes the article Cuba: Historical Exception or Vanguard in the Anticolonial Struggle? in the journal Verde Olivo.
On 17 April a paramilitary group backed by the United States invades the Bahía de Cochinos (Bay of Pigs). On 19 April, less than 72 hours later, the enemy is suppressed. Che takes over the command of the military forces stationed in the western province of Pinar del Río.
Che is nominated head of the Cuban delegation sent to the Inter-American Economic and Social Council held in Punta del Este, Uruguay, where he makes his official speech on 8 August.
After the meeting, the President of Argentina Arturo Frondizi invites him to Buenos Aires for a private visit. On his way back to Cuba, where he arrives on 19 August, he stops in Brazil for visiting President Jânio Quadros who awards him the National Order of the Southern Cross.

1962

From August to November, Che makes speeches and he publishes works of outstanding importance, including The Influence of the Cuban Revolution on Latin America, A New Attitude Toward Work, The Cadres: Backbone of the Revolution, What a Young Communist Should Be, and Strategy and Tactics of the Latin American Revolution.
In August he visits the Soviet Union for the second time, just a few months before the famous missile crisis that in October will bring the world to the brink of war.
Once more, Che is taking over the Cuban forces in the province of Pinar del Río.

1963

Che becomes a member of the National Direction of the Socialist Revolutionary Party in Russia.

In February he publishes an article entitled *Against Bureaucracy* and writes the prologue to the book *The Marxist-Leninist Party*.

In July he visits Algeria for the first time, where he meets the President Ahmed Ben Bella and speaks at the First Seminar on Planning.

1964

In February Che publishes an article entitled *On the Budgetary Finance System*. He contacts Tamara Bunke, known as Tania, to discuss the settlement mission in Bolivia, preamble to further interventions.

In March he participates in the United Nations Conference on Trade and Development held in Geneva, Switzerland, as representative of the Cuban delegation.

In November, he visits the Soviet Union again. On 9 December he leaves for New York as head of the Cuban delegation for the United Nations. On 11 December he makes a speech before the 19th General Assembly of the United Nations. Afterwards, he heads to Africa, where he will remain until March of the following year, for visiting Algeria, Mali, Congo (Brazzaville), Guinea, Ghana, Tanzania, and Egypt. During these months he briefly travels to China too.

1965

On 24 February, on the occasion of the Second Economic Seminar of Afro-Asian Solidarity in Algeria, he makes his last public speech.

On 12 March the Uruguayan weekly newspaper *Marcha* publishes his very famous essay *Socialism and Man in Cuba*.

On 14 March he returns to Cuba.

On 1 April he leaves on a secret mission to the Congo, where he participates with a group of Cuban and Congolese internationalist combatants to the fight for freedom, their aim being to reinforce the Movement for the Liberation of the Congo. At first, he reaches Dar Es Salaam, former capital of Tanzania, to then organise the clandestine entry in Leópoldville (Kinshasa), the Congo. Che remains in the Congolese forests until November, when the Cuban troops decide to retreat because unable to continue their fight in a territory occupied by such weak rebel forces. Che returns therefore to Tanzania, where he stays for a few months, writing *Passages of the Revolutionary War: The Congo*.

On 3 October, well in advance, Fidel reads the farewell letter that Che left him on the occasion of the presentation of the Central Committee of the Communist Party of Cuba created on 1 October. Noticing that Che is not included in the list of all members of the Central Committee and that he is not even there, Fidel decides to read the letter. In it, Che states: "Other lands of the world require my modest contribution."

1966

In January Che is joined by his wife Aleida March in Tanzania. Subsequently, he goes to Prague, an intermediate location where he can organise the armed struggle in Latin America. Once again, in April and May, Aleida decides to join her husband and travels to Prague.

In July he secretly returns to Havana to begin his military training in Pinar del Río with a small group of combatants. On 23 October, once the training is completed, he leaves Cuba and on 3 November, after a long journey through various European countries, he arrives in La Paz, Bolivia, on a Uruguayan passport. There, Che joins the Cubans Harry "Pombo" Villegas and José "Papi" Martínez Tamayo who had reached Bolivia themselves a few months earlier in order to coordinate the guerrilla warfare. On 7 November Che writes on his diary while travelling to the estate of Ñancahuasú: "Today is the beginning of a new phase." In the meanwhile, new Cuban and Bolivian combatants continue to arrive to the army encampment, from where they will gradually be transferred to a more isolated place with better conditions. On 31 December Che meets the Secretary-General of the Communist Party of Bolivia Mario Monje; irreconcilable differences arise that determine the future of the guerrilla warfare.

1967

Between February and March a long exploration with a group of combatants begins for the purpose of getting to know the area better. Numerous difficulties, in addition to the loss of two crucial Bolivian guerrilla fighters, Benjamín Coronado and Lorgio Vaca, drowned in the waters of the Río Grande, push the group to return to the army encampment, where the French Régis Debray, the Argentinian Ciro Bustos, and Tamara "Tania" Bunke have waited.

On 23 March the guerrilla warfare begins with a surprise attack to a regiment of the official army. With his *Communiqué no. 1*, Che explains what is happening to the Bolivian people, mentioning for the first time the National Liberation Army.

On 10 April, while battling against the enemy troops, the first Cuban combatant Jesús "El Rubio" Suárez Gayol dies.

On 16 April Che's famous *Message to the Tricontinental*, written during his training in Cuba before his departure for Bolivia, is published in Havana.

On 17 April the rearguard guided by the Cuban Vilo "Joaquín" Acuña receives orders to stay in the Bella Vista area until Che's vanguard can evacuate Régis Debray and Ciro Bustos. The two of them, later captured by the army in Muyupampa, will reveal precious information on the guerrilla warfare causing the impossibility of any further contact between Joaquín and Che's two columns of combatants. Battles and skirmishes continue even if the whole group experiences several desertions, fatal for the guerrilla warfare for the substantial

amount of information handed over the enemy; this to be added to the support in terms of preparation and supplies provided by the U.S. Army. This dramatic situation forces the guerrilla combatants to keep moving and leads to the death of valorous people, until Che's last battle in Quebrada del Yuro on 8 October. Che is wounded, captured, and taken to the small village of La Higuera where, on 9 October, he is executed according to the orders of the Bolivian and United States governments.

The corpses of the seven combatants fell at Quebrada del Yuro are taken to Vallegrande to be identified and on 11 October they are buried in a mass grave in the proximity of what was the airport in those days.

1968

In March, a microfilm with the pages of the *Bolivian Diary* reaches Cuba and on 1 June it is published with an introduction by Fidel Castro. This first edition is distributed free of charge to the Cuban population; later, it will be published around the world.

1997

On 17 October, after the homage paid by the Cuban people with a rally starting from the historic Plaza de la Revolución in Havana and arriving to the city of Santa Clara, the remains of Che and of his companions are laid to rest in the Che Guevara Mausoleum. The words of Fidel Castro, pronounced during his speech honouring the combatants, express the greatness of these men: "Welcome, Heroic Guerrillas of the Reinforcement Detachment!"

BIBLIOGRAPHY

• R. Accarino, *Soledad de tránsito detenido en la tierra, Il Che: le foto, gli scritti come specchio dell'anima* (Pistoia: Editrice Petite Plaisance, 2006).

• A. Ammar, *Il Che Cristo rosso* (Casale Monferrato: Edizioni Piemme, 2006).

• J.L. Anderson, *Che Guevara* (Rome: Fandango Libri, 2009).

• M.d.C. Ariet (ed.), *Apuntes filosóficos. Ernesto Che Guevara*, prologue by F. Martínez Heredia (Havana: Ocean Sur, 2012).• M.d.C. Ariet (ed.), *El Diario del Che en Bolivia. Edición autorizada*, introduction by F. Castro, prologue by C. Guevara (Havana: Ocean Sur, 2005).

• M.d.C. Ariet (ed.), *La épica del tiempo. Biografía del Che en facsimilares*, foreword by C. Guevara March (Havana: Ocean Sur, 2017).

• L. Avolio, *"Che" Guevara, il mito, la leggenda* (Resana: Mp edizioni, 2002).

• G. Bogani (ed.), *Che Guevara. Hasta siempre comandante* (Florence: Cult Editore, 2011).

• O. Borrego Díaz (ed.), *Che en la Revolución Cubana*, Tomo III, *Discursos y entrevistas (1961)* (Havana: Editorial José Martí, 2014).

• O. Borrego Díaz (ed.), *Che en la Revolución Cubana*, Tomo IV, *Discursos (1962-1963)* (Havana: Editorial José Martí, 2014).

• O. Borrego Díaz (ed.), *Che en la Revolución Cubana*, Tomo V, *Discursos (1964-1965)* (Havana: Editorial José Martí, 2015).

• O. Borrego Díaz (ed.), *Che en la Revolución Cubana*, Tomo VI, *Ministerio de industrias (1961-1965)* (Havana: Editorial José Martí, 2015).

• O. Borrego Díaz (ed.), *Che en la Revolución Cubana*, Tomo VII, *Pensamiento guerrillero* (Havana: Editorial José Martí, 2016).

• V. Casaus (ed.), *Che desde la memoria* (Havana: Ocean Sur, 2004).

• E. Che Guevara E., *Diario del Che in Bolivia*, foreword by F. Castro (Milan: Feltrinelli, 2005).

• E. Che Guevara, *Diario del Che in Bolivia* (Milan: Mondadori, 2006).

• E. Che Guevara, *Diario de un combatiente*, prologue by A. Hart (Havana: Ocean Sur, 2007).

• E. Che Guevara, *El diario del Che en Bolivia* (Havana: Ocean Sur, 2006).

• E. Che Guevara, *Latinoamericana. Un diario per un viaggio in motocicletta* (Milan: Feltrinelli, 1993).

• E. Che Guevara, *Notas de Viaje, diario en motocicleta*, foreword by A. Guevara March, prologue by C. Vitier (Havana: Ocean Sur, 2004).

• E. Che Guevara, *Otra vez. Diario inédito del segundo viaje por Latinoamérica*, prologue by A. Granado (Havana: Ocean Sur, 2007).

• E. Che Guevara, *Otra Vez. Il diario inedito del secondo viaggio in America Latina, 1953-1956* (Milan: Sperling & Kupfer, 2000).

• E. Che Guevara, *Pasajes de la Guerra Revolucionaria: Congo. Edición autorizada*, prologue by A. Guevara (Havana: Ocean Sur, 2005).

• E. Che Guevara, *Pasajes de la Guerra Revolucionaria. Edición autorizada*, foreword by A. Guevara (Havana: Ocean Sur, 2006).

• E. Che Guevara, *Passaggi della guerra rivoluzionaria*, edited by R. Massari (Rome: Erre emme, Editora Politica, 1997).

• E. Che Guevara, *Passaggi della guerra rivoluzionaria: Congo* (Milan: Sperling & Kupfer, 1999).

• E. Che Guevara, *Prima di morire, appunti e note di lettura* (Milan: Feltrinelli, 1998).

• E. Che Guevara, *Scritti, discorsi e diari di guerriglia 1959-1967*, edited by L. Gonsalez (Turin: Einaudi, 1974).

• E. Che Guevara, *Scritti scelti* (Milan: Baldini & Castoldi, 1996).

• E. Che Guevara, R. Castro, *La conquista della speranza, diari 1956-1957*, foreword by H.D. Steffan, introduction by P.I. Taibo II (Milan: il Saggiatore, 1997).

• A. Cupull, F. González, *Ernesto Che Guevara vita e morte di un rivoluzionario* (Rome: Newton & Compton, 2004).

• V.M. De Fabianis (ed.), *Storia e immagini del Líder Máximo* (Vercelli: Edizioni White Star, 2007).

• H. Gadea, *I miei anni con il Che dal Guatemala al Messico. I ricordi della prima moglie* (Rome: Erre emme, 1995).

• M. Galice, *Il mito di Che Guevara attraverso la letteratura e la musica*, graduation thesis in Comparative Literature, Università degli Studi di Roma "La Sapienza," 1998-1999.

• H. Gambini, *El Che Guevara* (Buenos Aires: Stock Cero, 2002).

• A. Granado, *Con el Che por Sudamérica* (Havana: Ediciones Abril, 2001).

• E. Guevara Lynch (ed.), *Aquì va un soldado de América. Lettere di Ernesto Che Guevara alla famiglia (1953-1956)* (Milan: Sperling & Kupfer, 1997).

• E. Guevara Lynch, *Mio figlio il Che* (Milan: Sperling & Kupfer, 1997).

• L. Huberman, P.M. Sweezy, *Cuba anatomia di una rivoluzione* (Molinella: Gingko, 2014).

• *Il Che vive! Ernesto Guevara e l'America latina nel patrimonio della fondazione Giangiacomo Feltrinelli* (catalog of the exhibition) (Milan: Feltrinelli, 2017).

• P. Kalfon, *Il Che: una leggenda del secolo*, foreword by M. Vázquez Montalbán (Milan: Feltrinelli, 1998).

• C. Loviny, A. Silvestri-Lévy, *Cuba por Korda* (Paris: Calmann-Lévy-Jazz editions, 2002).

• A. March, *Evocación. La mia vita a fianco del Che* (Milan: Bompiani, 2007).

• A. March, *Evocación mi vida al lado del Che* (Havana: Ocean Sur, 2011).

• G. Mattazzi (ed.), *Che Guevara, Breviario* (Milan: Bompiani, 2003).

• A. Monteforte (ed.), *Che Guevara: la sua vita, il suo tempo* (Rome: Savelli, 1977).

• P. Neruda, L. Felipe, N. Guillén, C. Vallejo, *Il quaderno verde del Che*, prologue by P.I. Taibo II (Milan: Tropea Editore, 2007).

• H. Oesterheld, A. Breccia, E. Breccia, *Che una vita in rivolta* (Milan: Rizzoli, 2017).

• *Paradigma* 1 (February 2013).

• *Paradigma* 2 (December 2013).

• *Paradigma* 3 (December 2014).

• *Paradigma* 5 (December 2016).

• H. Quintero Travieso, *Rebelión* (Havana: Casa Editora Abril, 2016).

• M. Rizzo, *Storia segreta di Che Guevara. L'uomo al di là del mito* (Rome: Newton Compton, 2015).

• S. Rodriguez, *Che. Una biografia a fumetti* (Turin: Einaudi, 2017).

• J. Soto (ed.), *Che Guevara. Ideario* (Rome: Newton Compton, 1996).

• P.I. Taibo II, *Senza perdere la tenerezza. Vita e morte di Ernesto Che Guevara* (Milan: il Saggiatore, 2012).

• A. Vargas Llosa, *Il mito Che Guevara e il futuro della libertà* (Turin: Lindau, 2007).

• T. Ziff (ed.) *Che Guevara: rivoluzionario e icona, the legacy of Korda's Portrait* (catalog of the exhibition) (Milan: Electa, 2007).